photographing the Jewish Nation

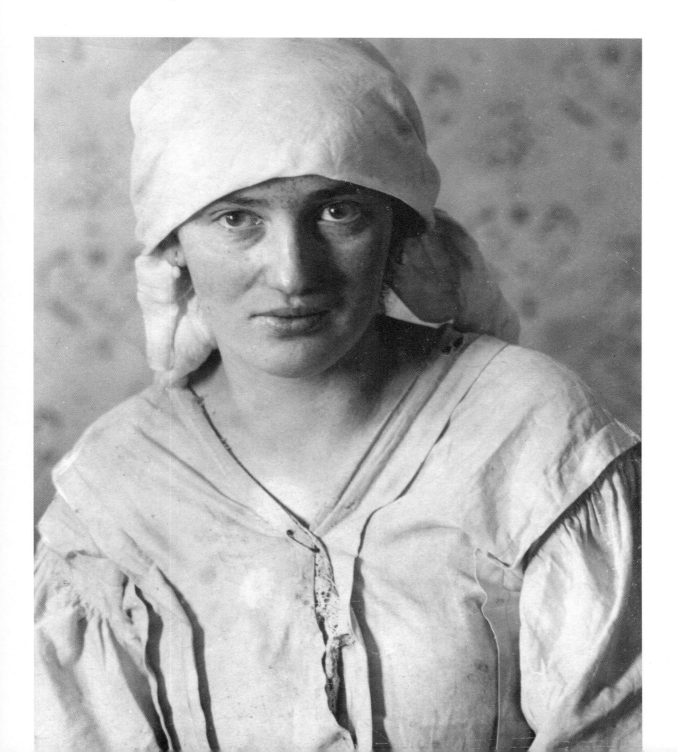

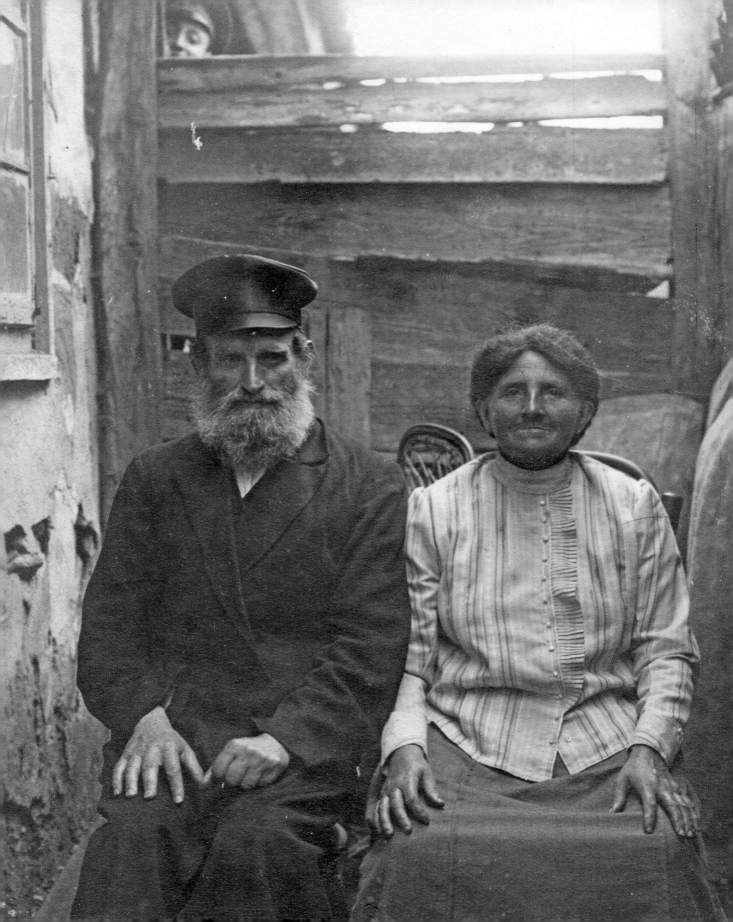

Edited by

EUGENE M. AVRUTIN

VALERII DYMSHITS

ALEXANDER IVANOV

ALEXANDER LVOV

HARRIET MURAV

ALLA SOKOLOVA

photographing the Jewish Nation

Pictures from S. An-sky's Ethnographic Expeditions

BRANDEIS UNIVERSITY PRESS

Waltham, Massachusetts

Published by

UNIVERSITY PRESS OF NEW ENGLAND

Hanover and London

BRANDEIS UNIVERSITY PRESS
Published by University Press of
New England, One Court Street,
Lebanon, NH 03766
www.upne.com
© 2009 by Brandeis University Press
First paperback edition 2014
Paperback ISBN 978-1-61168-683-8
Designed and typeset in
Arno Pro by Eric M. Brooks
Manufactured in the
United States of America
5 4 3 2 1

*This book was published with the
generous support of the Lucius N. Littauer
Foundation, Inc.*

EUGENE M. AVRUTIN is associate professor of history and Tobor Scholar in Jewish Studies
at the University of Illinois.
VALERII DYMSHITS is assistant professor of Jewish studies and director of the
Interdepartmental Center, "Petersburg Judaica," at the European University at St. Petersburg,
Russia.
ALEXANDER IVANOV is senior researcher at the European University at St. Petersburg.
ALEXANDER LVOV is assistant professor of Jewish studies at the European University at St.
Petersburg.
HARRIET MURAV is professor of Slavic languages and literatures at the University of Illinois.
ALLA SOKOLOVA is assistant professor of Jewish studies at the European University at St.
Petersburg.

The Library of Congress has cataloged the hardcover edition as follows:
Photographing the Jewish nation: pictures from S. An-Sky's ethnographic expeditions /
edited by Eugene M. Avrutin . . . [et al]. — 1st ed.
 p. cm. — (The Tauber Institute for the Study of European Jewry series)
ISBN 978-1-58465-792-7 (cloth: alk. paper)
1. Jews—Ukraine—History—20th century. 2. Jews—Ukraine—Social life and
customs—20th century. 3. Jews—Ukraine—Economic conditions—20th century.
4. Jews—Education—Ukraine—History—20th century. 5. An-Ski, S., 1863–1920.
6. Ukraine—Ethnic relations.
DS135.U4P48 2009
305.892'4047709041—dc22 2009018238

*All photographs featured in the book are reproduced from the An-sky photo-archive,
courtesy of Petersburg Judaica, European University at St. Petersburg.*

The Tauber Institute Series is dedicated to publishing compelling and innovative approaches to the study of modern European Jewish history, thought, culture, and society. The series features scholarly works related to the Enlightenment, modern Judaism and the struggle for emancipation, the rise of nationalism and the spread of antisemitism, the Holocaust and its aftermath, as well as the contemporary Jewish experience. The series is published under the auspices of the Tauber Institute for the Study of European Jewry—established by a gift to Brandeis University from Dr. Laszlo N. Tauber—and is supported, in part, by the Tauber Foundation and the Valya and Robert Shapiro Endowment.

For the complete list of books that are available in this series, please see www.upne.com

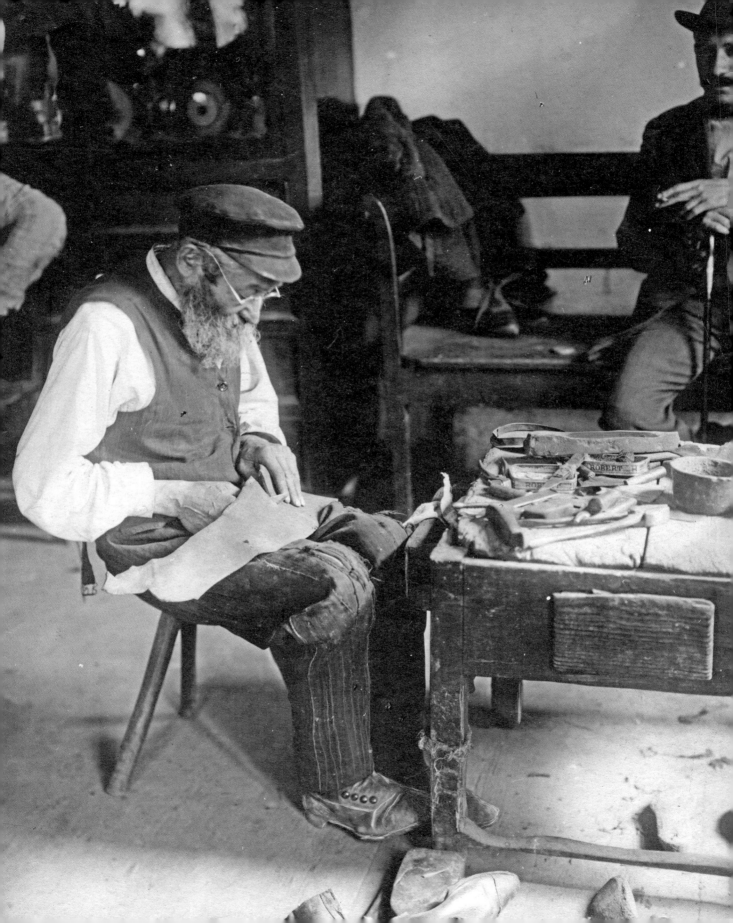

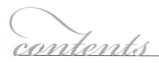

contents

A list of illustrations follows each chapter.

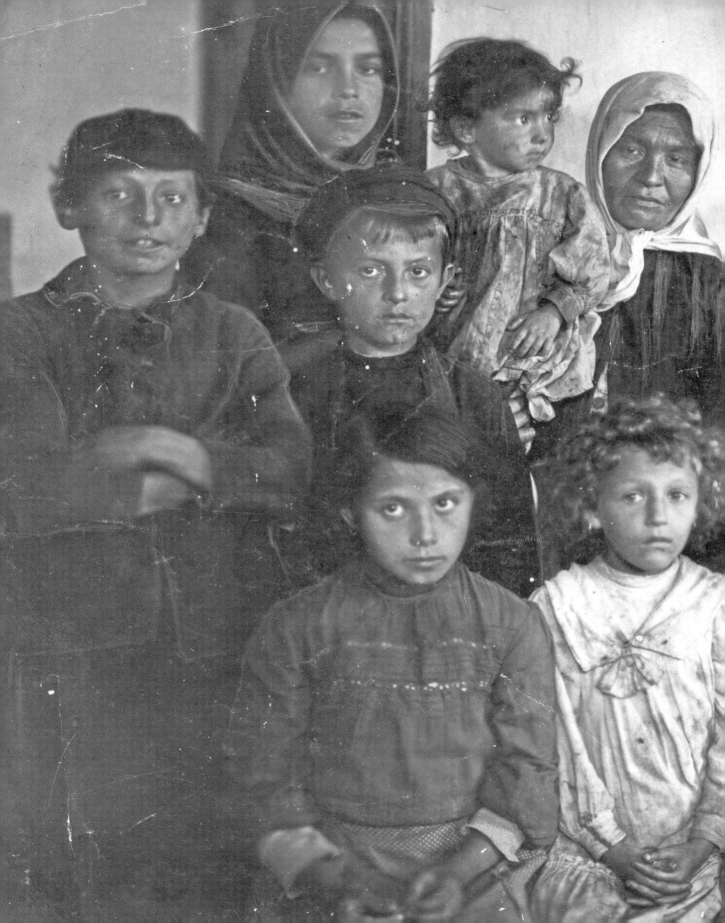

All the photographs in this volume were taken during the 1912–1914 ethnographic expeditions in Volynia, Podolia, and Kiev Provinces (see map). S. An-sky inscribed dates, places, and other comments on only a small number of the photographs. For examples of his captions, which appeared in either Yiddish or Russian, see illustrations 21b and 167b. Petersburg Judaica catalogued each photograph that appears in this book, and our captions are based on their research and An-sky's notes. When available, information about locations and dates appears in the captions.

Harriet Murav translated the essays by Petersburg Judaica, which appear in chapters 1–5. We have generally relied on the Library of Congress transliteration system for Russian, and the YIVO system for Yiddish, except for words that have anglicized forms. The transliteration of geographic names reflects their usage in their original historical context.

We would like to thank our friends and colleagues at Petersburg Judaica — Valerii Dymshits, Alexander Ivanov, Alexander Lvov, and Alla Sokolova — for the rich and rewarding collaborative experience that led to the publication of this volume. Their warmth and hospitality in St. Petersburg, and their generosity, erudition, forbearance, and wit contributed to the process in more ways than we can recount. Phyllis Deutsch supported this project from the very beginning. We are grateful to Phyllis for her editorial insights and acumen, her patience, and her immediate and positive responses to our innumerable queries. ChaeRan Freeze provided helpful and extremely knowledgeable feedback to our essays in record time. Irina Sergeeva and the remarkable staff of the Manuscript Division at the Vernadsky National Library in Kiev generously shared their knowledge of the An-sky archive and facilitated our research. We thank Jan Adamczyk, Helen Sullivan, and Suleyman Sarihan of the Slavic Reference Service at the University of Illinois for answering all of our research questions. And we are particularly grateful to

Suleyman and Merrily Shaw of the Russian, East European, and Eurasian Center at the University of Illinois for producing a wonderful map.

We would especially like to thank Dale Bauer and Matti Bunzl, the past and present directors of the Program for Jewish Culture and Society at the University of Illinois, for their incredibly generous moral and financial support of this project. We gratefully acknowledge the subvention support from the Research Board at the University of Illinois and the Lucius N. Littauer Foundation. We would also like to thank Mark Steinberg, Fred Hoxie, David Prochaska, Richard Tempest, and Volodymyr Chumachenko for their assistance with our inquiries. Yingying Guo showed remarkable patience throughout the completion of this project, and Abi provided delightful breaks from the work. Penelope and Sissela Rosenstock-Murav were enthusiastic about the idea of a photography book, as was Bruce Rosenstock. His technical know-how saved the project more than once, his good humor made things go more smoothly, and his love, warmth, and support added to the process immeasurably.

EUGENE M. AVRUTIN
HARRIET MURAV

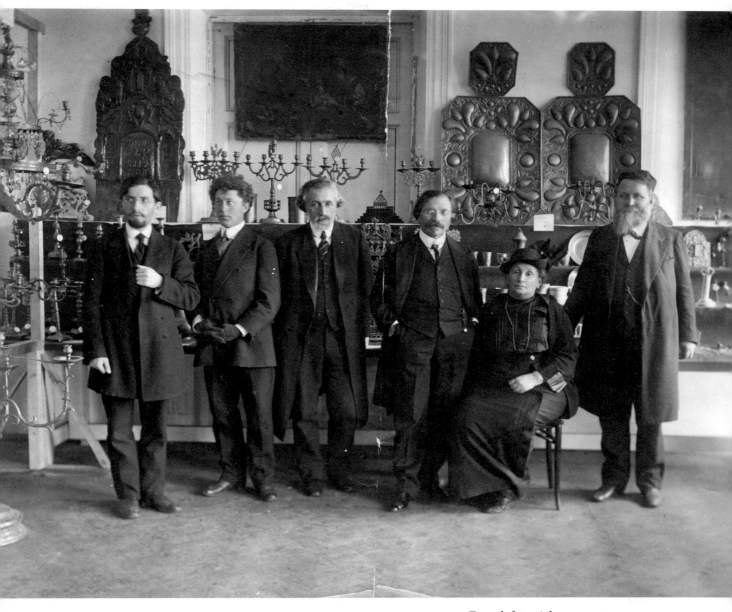

From left to right:
Abram Rechtman, Solomon
Iudovin, S. An-sky, Sholem
Aleichem, Olga Rabinovich,
M. A. Ginsburg

Volynia, Podolia, and Kiev Provinces around 1900.

Map drawn by Suleyman Sarihan, Slavic and East European Library at the
University of Illinois Urbana–Champaign, with the assistance of Merrily Shaw,
Russian, East European, and Eurasian Center at the University of Illinois
Urbana–Champaign.

Sources: Gabriella Safran and Steven J. Zipperstein, eds., *The Worlds of
S. An-sky: A Russian Jewish Intellectual at the Turn of the Century* (Stanford,
Calif.: Stanford University Press, 2006); *Entsiklopedicheskii slovar'*, 82 vols.
(St. Petersburg, 1890–1904); Paul R Magocsi, ed., *Historical Atlas of Central
Europe*, rev. ed. (Seattle: University of Washington Press, 2002).

EUGENE M. AVRUTIN & HARRIET MURAV

introduction

Photographing the Jewish Nation

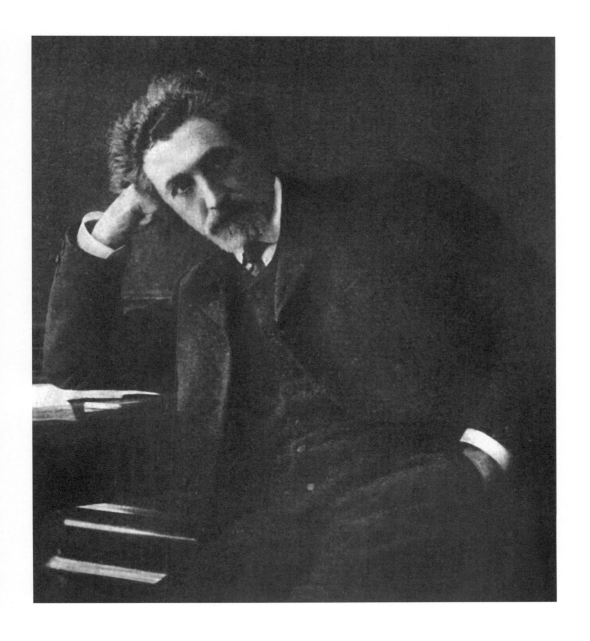

Shortly before embarking on his first ethnographic expedition in the summer of 1912, Shloyme-Zanvl Rappoport (who was known by the pen name S. An-sky) expressed anxiety not only about the success of his mission, but also about his ability to communicate with a people whose norms and sensibilities he no longer shared. In a letter to Baron Vladimir Gintsburg, the expeditions' principal financial backer, An-sky wondered how the subjects of his investigation — the Jews living in the small market towns of Volynia, Podolia, and Kiev Provinces in the Pale of Settlement — would respond to him. "Would I," he asked, "be able to earn the trust of these poor and primitive people from whose world I myself have emerged, but from whom I have become so estranged?" But even as An-sky worried, he also felt a sense of exhilaration: "There's enormous joy in my soul, because my lifelong dream will finally begin to be fulfilled."[1]

In 1915, a year after the third and final expedition, An-sky's confidence in the positive outcome of his undertaking knew no bounds. In a letter to the editors of the journal *Evreiskaia starina* (The Jewish Antiquarium), An-sky reported that the expedition had taken "more than two thousand photographs of old synagogues, and their internal decorations, Jewish historical buildings, ethnographic types, scenes from daily life" and recorded "more than 1800 folktales."[2] An-sky envisioned using the cultural artifacts collected and purchased over the course of the expeditions — the manuscripts, costumes, relics, ritual and domestic objects, photographs, oral histories, folktales, legends, and songs — as primary source material for the first systematic ethnographic study of Russian Jews. He sketched an outline for a vast and ambitious study of Jewish life and customs in the Russian Empire, a book he tentatively titled *Evrei v ikh bytovoi i religioznoi zhizni* (Jews in their Daily and Religious Life). The first chapter would begin with a discussion of Jewish beliefs about the life of the individual before birth, while the last chapter was to describe life beyond the grave. In between An-sky intended to

cover education, military service, marriage and sexuality (including cases of depravity and "fallen women"), religious life, morality, norms regarding the relation between human beings and nature, folk medicine, prayers, customs and rituals, synagogues, legal procedures, welfare societies, messianism, the Jewish enlightenment movement, Zionism, participation in revolutionary movements, art and literature in Hebrew and Yiddish, and, in a self-reflexive gesture, Jewish scholarship on Jews, thereby enshrining a place for his own work in the Jewish universe that the study was designed to embody.[3]

The book never came to fruition, but An-sky's tireless ethnographic work helped preserve fragments of a civilization wiped away by subsequent wars, revolutions, and genocide. Contemporary Ukraine has little memory of the rich cultural and religious traditions, institutions, and multiple ethnic identities that once existed within its borders.[4] Among the first representations of Jewish culture and society in pre-Revolutionary Russia, the expeditions' photographs provide visual texture of a world that has largely been erased from contemporary Ukrainian memory, offering snapshots that rarely appear in written sources: clothing customs and fashions; occupational practices and objects of ritual devotion; the poverty and squalor of small-town life; and the facial expressions and emotions of ordinary Jews. In remarkable detail, Solomon Iudovin, the young photographer who accompanied An-sky, captured the diversity of Jewish life in a rapidly changing milieu: the marketplaces where families bought and sold goods, the homes in which they lived, the prayer houses in which they prayed, and the shops, work benches, and factories in which men and women plied their trades. The photographs reflect An-sky's particular interest in the Jewish people themselves: teachers instructing students in tiny crammed *kheyders*; children playing in courtyards during school breaks; workers sewing, spinning, making rope, shaping metal, or engraving stone.

However rich and emotionally compelling the images may be, they are nonetheless the product of a specific ideological project, requiring critical reading and interpretation to understand the intellectual motivations that guided the work of the ethnographic expedition itself, as well as the broader societal changes and cultural differences captured by the photographs. An-sky departed to the provinces to uncover what he saw as an authentic Jewish past preserved in the lives and customs of provincial Jews, but he came away with something else. Like so many other European anthropologists and ethnographers of his time, An-sky felt an urgency to record, in encyclopedic fashion, an integrated, holistic, and authentic universe before it began to vanish. This desire to document an organic civilization,

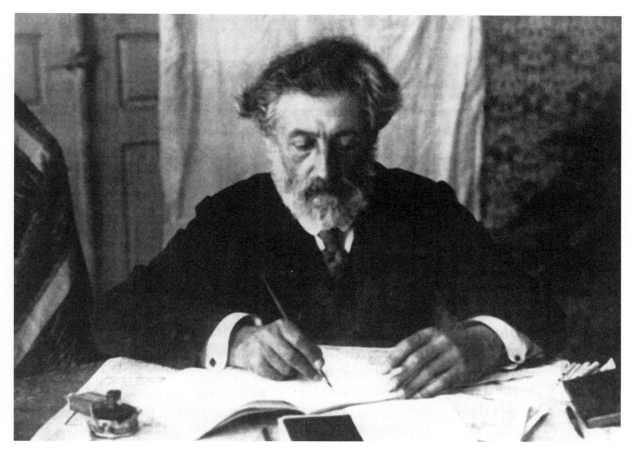

A. Expedition leader S. An-sky.

however, was also designed to transform an entire generation of assimilated Jews whom An-sky saw as alienated from all aspects of their cultural heritage. By creating a national Jewish culture in the most concrete terms, An-sky hoped to provide a cure for an "epidemic" that had left assimilated Russian Jews indifferent to their own community, religion, ways of life, and history. In our title, we use the word "nation" — implying something more than a collection of separate individuals and something less than a political entity — to suggest the ways that An-sky sought to promote cultural renewal for a people whose historical origins provided a sense of commonality.

An-sky's ethnographic work is thus caught up in the ambivalent task not only of preserving and salvaging the Jewish past, but also of depicting the ways in which Jewish life had transformed in religious, economic, and social terms. An-sky and Iudovin were clearly compelled by a powerful sense of both the fragility and the importance of the Jewish world their work sought

to capture. Their active political orientations and artistic sensibilities, along with contemporary scientific-ethnographic ideas, played key roles in the images they created. Carefully crafted and informed by a rich visual heritage, the photographs of the Jewish ethnographic expeditions can help us to critically reexamine the economic, social, and religious changes in Jewish communities around 1900: the fissures of class due to rapid economic modernization, the introduction of new fashions for women and men (see, for example, image 62), and the gradual disappearance of religious piety in urban spaces. Iudovin's woodcuts, based on images taken during the expeditions, have become emblematic of the fixed image of the shtetl Jew. The photographs themselves, however, reveal a striking tension between salvaging images for the future and documenting the need to change the social reality that gave rise to these very same images.

Ethnography and An-sky's Project of Cultural Renewal

An-sky's life unfolds in a pattern of starts and stops, zigzags, and returns, moving among various ideological, national, and personal affiliations.[5] Born to a poor family in 1863 in the small Belorussian town of Chashniki, An-sky spent the first years of his life in Vitebsk. During his teens, An-sky left home and traveled throughout the Pale of Settlement, working as a tutor to Jewish children. His early exposure to Hebrew and Russian and his early rebellion against traditional Jewish education is reflected in his Russian-language fiction, including, for example, his story "The Sins of Youth," which recounts a young man's forced removal from a Jewish community because he teaches new ideas. An-sky worked as a coal miner in the Donets region, and claimed to feel completely at home there, even though the miners did not know what to make of him. Encouraged by the writer Gleb Uspenskii, he spent a year in St. Petersburg among the major Russian intellectuals of the time; his articles on Russian peasants and coal miners started to appear by 1892. On the basis of his interpretation of Russian folk literature, An-sky claimed that the psychology of the Russian peasant was inherently collective, as opposed to the individualist psychology of the intelligentsia.[6] In 1892 An-sky left Russia for Western Europe, where he remained until 1905. In Paris, he worked as the private secretary to Petr Lavrovich Lavrov, the noted Populist revolutionary. Returning to Russia, An-sky participated in the political euphoria that stimulated so much cultural creativity in the Jewish public sphere following the 1905 revolution.[7]

The writings and enterprises that An-sky undertook on his return to

Russia reveal a marked shift toward a Jewish focus, without the framework of class and revolution that could be seen in his earlier writings (although, as Valerii Dymshits shows in his essay, "Brothers and Sisters in Toil and Struggle," An-sky's persistent attachment to the workers' cause is visible in the expedition photographs). Regardless of this shift, however, An-sky's interests in Russia and Russians remain evident in the period between the revolutions, when all of his activities had a decidedly Jewish emphasis. For example, his characterization of the psychology of the Jewish people, published in 1908, reflected his earlier writings about the Russian people.[8] But of all the dimensions of Russian culture and thought that were important to the intellectual framework of the ethnographic expeditions he conducted from 1912 to 1914, Russian Populism deserves a special discussion.

Originating in the first part of the nineteenth century from the pen of Alexander Herzen, among others, Russian Populism focused on the peasantry as the embodiment of moral perfection. Its most significant tenet, from the perspective of An-sky's ethnographic project, was the proposition that the peasantry were the locus of authentic Russian culture and Russianness. Remove the words "peasantry" and "Russian" and substitute "inhabitant of the Pale" and "Jewish" and the result is An-sky's Jewish Populism: the unassimilated Jews of the Pale were the unique locus of authentic Jewish culture and Jewishness. What is so striking about Russian Populism — and An-sky's Jewish version of it — is its self-perpetuating structure. The (Jewish or Russian) intelligentsia lamented its split with the people (Jewish or Russian), but the split nonetheless had to be maintained, otherwise there would be no need for the intelligentsia, alienated and isolated as it was. The people served as the guarantor of the intelligentsia's necessary role. Only the intelligentsia, using the proper scientific tools, could articulate who the people were. An-sky's language about the poor and "primitive" Jews in the Pale of Settlement reflects this ambivalent attitude (*temnyi*, the word we have translated as "primitive," can also be rendered as "backward" or "dark," in the sense of "obscure"). His anxiety about whether the Jews of the Pale would accept him is also an anxiety about the meaning of the difference between them: too little difference is just as problematic as too much difference. For An-sky and for other ethnographers of his time, discovering the specific contours of the people's identity was immediately connected with creating it, and at the same time, creating themselves anew. Ethnography was a key instrument in this process.[9]

Jewish ethnography was An-sky's highest priority when he returned to Russia.[10] Appalled by the intelligentsia's indifference to their own heritage,

he worked hard to create what he called *samopoznanie* (self-knowledge) of the past by collecting, analyzing, preserving, and exhibiting Jewish ethnographic and folkloric materials. "It can be safely said that there's no other nation that can talk so much about itself but has so little knowledge of itself as the Jews," An-sky wrote, at the beginning of his programmatic and highly influential essay "Jewish Folk Art."[11] Several years later, in a report on the Jewish ethnographic expedition, An-sky argued that each and every nation must acquire self-knowledge: "The principal, if not the only, means of achieving this goal is to study the life of the nation, its past and its present, its ways of life, belief systems, poetic and artistic creation." Cultured nations on both sides of the globe realized this point long ago, An-sky continued, and therefore respected the "spiritual wealth" produced by their own people over the course of decades and centuries. Governments, voluntary and scientific organizations, and individual researchers spent large sums of money conducting ethnographic work, and the more civilized nations even sponsored special scientific competitions to study the ways of life and the anthropological peculiarities of the world's so-called backward, half-civilized, and uncivilized tribes and ethnic groups. An-sky concluded that the result of all this work was the production of an enormous amount of ethnographic literature, and the establishment of a large number of ethnographic museums, all of which provided a detailed picture of the ways of life, belief systems, and cultural expressions of the *narody* (peoples) and *plemena* (tribes) who lived on this earth.[12]

Even though issues such as the meanings of Jewishness and Jewish spiritual heritage were hotly debated in the Russian-Jewish press, An-sky felt that the controversy had not yet sparked an interest in the preservation and long-term development of Jewish national culture. "All a Jew has to do," An-sky maintained, "is recite a few proverbs or anecdotes to consider himself an expert on 'Jewishness.'"[13] For An-sky, ethnography and folklore provided two of the most objective lenses through which researchers could examine not only the national characteristics and internal reflections of the Jewish people, but also their everyday psychological and emotional peculiarities — that is, those traits which helped define Jews as "Jews."

In 1909, An-sky became fully committed to the idea of conducting a special expedition to collect Jewish ethnographic and historic materials in the Pale of Settlement.[14] As a member of the executive committee of the Jewish Historical-Ethnographic Society, An-sky shared the society's conviction that history could be used to shape the present and the future. Formally established in March 1908, the Jewish Historical-Ethnographic Society aspired to

construct a national Jewish culture based on materials of historical value: manuscripts, personal recollections, communal record books (*pinkasim*), letters, folktales, songs, clothing, and ritual objects. These materials could then be used to promote historical consciousness among ordinary individuals. Following in the intellectual footsteps of the historian Simon Dubnov, one of the principal architects of the Society and a co-editor of "The Jewish Antiquarium," An-sky insisted that even the most prosaic aspects of Jewish life needed to be documented and preserved.[15]

Much like Dubnov, who saw Russian Jewry living in an era of reactionary politics, spiritual exhaustion, and generational conflict, An-sky urged the intelligentsia to help him preserve all aspects of their national cultural legacy before it vanished. Situating the spiritual alienation of Russian Jewry in the context of a European-wide belief in the decline of human progress, An-sky blamed the parting of the ways between the intelligentsia and ordinary people (*narod*) on what he called "a solid wall of mutual incomprehension and mistrust."[16] According to An-sky, spiritual exhaustion — a phenomenon he related to the rise in suicides among Russian youth — was one of the symptoms of the larger crisis of assimilation and alienation that was spreading like an epidemic among Jews.[17] Appalled by the number of Jews who had committed "national suicide" by renouncing their religion, An-sky nevertheless viewed baptism only as a formal renunciation of Judaism, and not the complete separation of Jews from their Jewishness (their everyday customs and cultural practices). "By converting to Russian Orthodoxy, Catholicism, or Islam," An-sky argued, "a Jew cannot become a Russian, Pole, or Tatar." However, those individuals who attempted to distance themselves from their own people were, in the end, left without a "living connection to the main source of cultural creativity." And herein lay the most tragic of the paradoxes An-sky had witnessed at the beginning of the twentieth century: as more and more Jews aspired to a broad cultural life and spiritual creativity, they cut themselves off from their cultural roots and became isolated from their own heritage.[18]

For An-sky, as for many other Russian-Jewish intellectuals of his time, the monumental and decisive changes that had transpired in the late imperial period — growth of antisemitic ideologies, mass emigration, and the rise in conversion rates — led to the most significant cultural break in

B. Letterhead of Jewish Historical-Ethnographic Society. Courtesy Judaica Section, Manuscript Division, Vernadsky National Library, Kiev.

modern Jewish history, shattering the foundation of Jewish civilization.[19] As Jews transformed their religious practices and modes of learning, abandoned external markers of Jewishness, and participated in Russian professional and educational institutions, they distanced themselves from their own Jewish roots. These tendencies were gradually but systematically increasing each year, An-sky observed in an alarmist tone, and would soon encompass the entirety of the Jewish people.[20] To mitigate the effects of assimilation, which was taking place from the cradle, and to create a new rapprochement between the intelligentsia and the masses, the main task of the day was cultural-national activity. It was the intelligentsia who possessed the necessary tools to unearth these "living roots" and in so doing return Jewishness to the Jewish people. An-sky thus called for a cultural movement that would one day bring cohesiveness to the two groups on either side of the split, between the provinces (where authentic Jewish culture was still being practiced) and the urban centers (where an entire generation of assimilated Jews had become indifferent to their national heritage). By going to the provinces, to the very depths of the Pale, An-sky hoped to uncover and collect the materials that would provide the basis for this newly revised national culture.[21] An-sky did not intend for "assimilated" Jews to return to "traditional" ways of life, but rather to create knowledge that would make possible new forms of Jewish identity, which would regenerate the Jews as a people.

Jewish Ethnography in the Russian Imperial Context

The ethnographic expeditions grew out of the belief that knowledge of the past could mitigate immediate concerns and shape future realities. But just as the history of Russian Jewry cannot be properly explained without a discussion of the Russian social and political context, the intellectual origins of the expeditions cannot be understood without a brief discussion of the development of ethnography and anthropology in the Russian Empire. An-sky's intellectual and political interests in conducting ethnographic work on Jews in the Pale was shaped as much by historical consciousness (using history for political purposes), as by the desire to make a lasting contribution to the science and profession of ethnography.[22]

Since the founding of the Ethnographic Division of the Russian Geographical Society in 1845, ethnographic explorations had produced a large body of knowledge, describing the imperial landscape in all of its diversity.[23] Ethnographic work benefited from the expertise of a number of social-

scientific and literary disciplines — geography, archaeology, history, statistics, philology, folklore, and anthropology — but what constituted ethnography, precisely, continued to be hard to define, even as the field began to be firmly established as a professional academic discipline. During their fieldwork, Russian ethnographers paid particular attention to the traits and everyday habits of the empire's multicultural and multi-religious population, including Jews.[24] Even though ethnographers characterized the non-Russian population (*inorodtsy*) as "crude" and "primitive," they nevertheless proclaimed their humanistic attitude towards their subjects, showing much faith in the civilizing mission.[25]

By the beginning of the twentieth century — even as the statistically oriented discipline of physical anthropology gained increasing intellectual prestige among leading Russian scientists, professionals, and academics — ethnographic work continued to flourish.[26] Ethnographic and anthropological bureaus appeared in cities such as St. Petersburg, Moscow, Kazan, Khar'kov, and Kiev. The fascination with collecting and displaying imperial diversity was reflected in the establishment of numerous regional ethnographic and archaeological museums. Count Viacheslav Nikolaevich Tenishev funded and organized one of the most ambitious expeditions to acquire ethnographic knowledge of peasant life and customs. Using a detailed questionnaire written by Tenishev himself, at least 350 local ethnographers traveled to the central provinces of the empire. Over the course of four years (1897–1901), Tenishev's Ethnographic Bureau collected responses to questions that dealt with a wide range of personal, religious, social, and economic issues: religious and linguistic practices, family life, sexuality and gender relations, marriage, the upbringing and education of children, living and household conditions, relations between peasants and their non-Russian Orthodox neighbors, and the relationship of the individual to the peasant community.[27]

An-sky's plan to collect Jewish ethnographic materials followed in the footsteps of a well-established tradition of gathering regional knowledge (*kraevedenie*) of the vast territories and peoples of the empire. Like Tenishev, who hoped to produce a synthetic work of peasant ways of life based on the materials acquired during his expeditions, An-sky strove for total mastery of Jewish life in the Pale of Settlement, as reflected in his planned book on Jewish civilization.[28] To achieve this goal, An-sky wanted to incorporate the techniques of ethnography (to amass a database of directly observable behaviors and activities), folklore (to catalog oral folktales, proverbs, and anecdotes), photography (to create a photo archive of people,

places, and objects of historical interest), anthropology (to make quantitative measurements of the Jewish body), and sound recording (to produce audio recordings of songs and melodies). Only a few weeks before the start of the first expedition, however, the highly influential physical anthropologist Samuel Weissenberg suggested revisions to An-sky's original program. Weissenberg argued that the proposed focus on physical anthropology was "unnecessary," since so much scholarly work had already been undertaken on the physical dimensions of the Jewish race, and instead encouraged An-sky to concentrate on "ethnology," that is, the examination of the everyday life practices and behaviors of the Jewish people.[29]

An-sky eventually heeded Weissenberg's advice, even though several leading Jewish intellectuals, such as the anthropologist Lev Shternberg, the historian and folklorist Saul Ginzburg, and the demographer Samuel Vermel' encouraged him to pursue quantitative work. As the plans for the second and third expeditions attest, An-sky was not completely opposed to using an anthropometric schema, but he nevertheless felt much more at ease with collecting and recording, talking and observing, rather than with taking measurements of Jewish bodies.[30] Indeed, some of the photographs reflect the underlying conceptual models of physical anthropology (see, for example, the front and profile views of women in images 2–7, which Aleksander Ivanov discusses in his essay, "The Making of a Young Photographer").

The first expedition took place between July and October 1912. Accompanied by his nephew, the photographer Iudovin, and Iulii Engel', a musicologist, An-sky traveled to places such as Ruzhin, Polonnoe, Slavuta, and Novgradvolynsk, among many others. At least initially, An-sky's anxieties about earning the trust of the locals were well founded. Notes made by Engel' on the expedition's first stop in Ruzhin (Kiev province) suggest something of the challenges the group faced. "From the moment we arrived at the station, we decided to speak only Yiddish," Engel' recalled. "It was the right thing to do, although it was hard for me, since my knowledge of the language was bookish." The wagon driver they met at the station refused to speak to them in Yiddish, while the elders of Ruzhin mistrusted the three ethnographers, mistaking them for commercial gramophone operators who caused unnecessary commotion. On the first day of the expedition, Engel' remembered how the ethnographers "met some of the children and recorded their stories and songs. They received a five-kopeck piece for each performance, so that at the end, almost all the children of Ruzhin stopped going to *kheyder* and instead mobbed our inn from the morning on."[31] Sev-

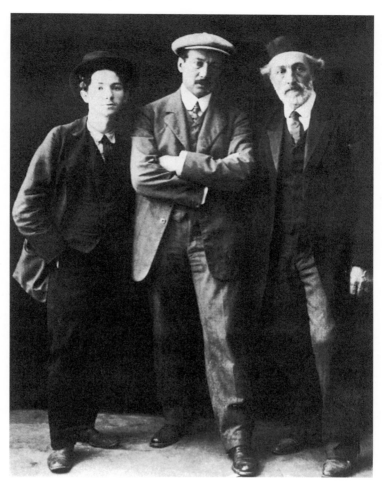

c. From left to right:
Solomon Iudovin, Iulii Engel',
S. An-sky.

eral months later, in a letter to Baron Gintsburg, An-sky also pointed out the practical difficulties of conducting ethnographic work during the holiday season. As someone who had distanced himself from religious law and the customs of Jewish life in the Pale, An-sky failed to recognize that the time from the Jewish New Year to the Yom Kippur fast would prove difficult for his ethnographic activities. "During the holidays," An-sky concluded the letter, "it is impossible to record anything or take pictures; during this time our subjects' enhanced religious mood does not incline them to sing songs, tell stories, or even recount pious legends."[32]

Like so many other ethnographers of his time, An-sky envisioned using a detailed questionnaire to help him collect ethnographic data.[33] A few months before departing on the first expedition, he reported to Gintsburg that, "At

the present moment, all of the work is concentrated on the compilation of a 'Questionnaire for the Collection of Material on Jewish Ethnography.'" An-sky observed that the word *synagogue* alone "demanded more than 100 questions," as did the word *yeshiva*.[34] With more than 10,000 possible questions — capturing all aspects of human life, from conception until existence beyond the grave — An-sky, it seems, sought to create the largest and most comprehensive questionnaire ever assembled for ethnographic work in the Russian Empire, easily surpassing Count Tenishev's ethnographic program, which totaled 491 questions. But when An-sky departed in the summer of 1912, "The Questionnaire for the Collection of Material on Jewish Ethnography" was not yet ready. Instead, An-sky relied on a much smaller questionnaire — *A ortige historishe program* (A Program of Research into Local History) — consisting of only 173 items, which were used by other members of his ethnographic team in those places where An-sky himself did not go.[35] At the beginning of 1914, Lev Shternberg edited the first volume of the full version of the 2087-question program, entitled *Dos yidishe etnografishe program: Der mentsh* (The Jewish Ethnographic Program: The Person), in time for the third expedition. The second volume was never published.[36]

"The Jewish Ethnographic Program" imagined a vast universe of belief, thought, and practice, in much the same way as An-sky's planned book, "Jews in Their Daily and Religious Life." An-sky wanted to begin with conception and trace the life of the human being until death — and indeed, beyond death, because the questionnaire also asked about life in the next world. The ethnographic program was divided into five principal sections: 1) The Child; 2) From the *Kheyder* to the Wedding; 3) The Wedding; 4) Family Life; and 5) Death. Among the questions about death, for example, are the following: "How does one ask forgiveness of the dead? Who is the first to ask forgiveness? Do you believe that when you meet a dead person you should strike him a blow in an offhand manner in order to make him disappear?"[37]

An-sky was satisfied with what he had achieved during the first expedition, but he knew he could do more. While gathering support for the 1913 and 1914 expeditions, An-sky devised a plan that detailed how the work would be conducted. The plan had an epic scale and, if carried out successfully, would improve the modest accomplishments of the first expedition. The ethnographic expeditions would investigate 240 to 250 sites of Jewish settlement (from around 1,200 in total) located in ten different provinces in the Pale, which were picked for their ethnographic and historical interest, as well as their typicality. The ultimate goal was to collect and record

all possible materials of ethnographic, folkloric, and historic interest. In order to do so, An-sky proposed to make phonographic recordings of folk and choral melodies, to take photographs of historical buildings, synagogues, and important monuments, and also to photograph people in their daily lives and at work. Furthermore, the expeditions were to collect rare objects and relics for a future Jewish museum, to take anthropological measurements, and to conduct detailed investigations of the economic and cultural life of the Jewish people, as well as of their emigration, by using a detailed questionnaire.[38]

The camera, gramophone, and questionnaire provided the technologies for acquiring and producing knowledge about the Jewish nation. The expedition leader would supervise all aspects of the collection of materials, while his personal assistant would make sound recordings and carry out quantitative anthropological research. In addition, a third layer of staff, designated as "temporary specialists," would each spend around two to four weeks in the field. An-sky envisioned that some of the most notable Jewish intellectuals, scholars, and artists of the day — such as the painter Leonid Pasternak, the poet Hayim Nakhman Bialik, the anthropologist Shternberg, and the writer Sholem Asch — would provide invaluable expertise. At each site, local staff would play an important role by acquiring written materials and ritual objects from the Jewish masses. Two photographers, one who worked in the field, and a second who printed and classified the images, would produce a rich collection of photographs of Jews and Jewish artifacts. A "permanent secretary," who remained at a fixed location, would receive the ethnographic materials and objects gathered over the course of the expeditions.[39] And finally, An-sky hoped to persuade experts in Hebrew and Yiddish to accompany the expeditions themselves.[40] An-sky himself spoke Yiddish fluently. However, his wish to include Yiddishists and Hebraists reveals his concern about the gap between unassimilated Jews of the Pale and the assimilated Jewish intellectuals who were to staff the expeditions, but who lacked the fundamental linguistic and cultural knowledge necessary to carry out successful ethnographic work.

Only a few dimensions of this elaborate plan came to fruition. Pasternak, Asch, and Bialik did not participate, nor did other prominent writers,

D. Manuscript of S. An-sky's "Jews in their Daily and Religious Life." Courtesy Judaica Section, Manuscript Division, Vernadsky National Library, Kiev.

artists and intellectuals. There was only one photographer, Iudovin, and all the extant photographs, including those in this volume, are his work. Some individuals, such as Weissenberg, had proposed joining the expedition, but dropped out at the last minute; Weissenberg on the grounds that his knowledge of Hebrew was insufficient, and furthermore, that he was not "Orthodox enough."[41] Some aspects of the plan, however, were fulfilled. Levi-Yitskhok Vainshtein, for example, served in the role of field secretary in 1913. His letters include inquiries about how much money An-sky was willing to spend on various materials, such as a book of remedies (the medical knowledge the expedition sought), and a book of Kabbala whose owner agreed only to have it recopied, but not sold.[42] By the time World War I broke out, An-sky and his team had traveled to about seventy towns which were principally, but not exclusively, occupied by Jews, and gathered the most extensive collection of materials about Jewish daily life in the pre-Revolutionary period. Even though many of his grandiose plans went unrealized, An-sky himself was quite pleased with these accomplishments.

The Photographs as Images

Our discussion thus far traces the intellectual, historical, and political background of the photographs in this volume, with a brief foray into An-sky's own life-path. A few words ought to be said about the photographs as images. Iudovin's relatively untried but nonetheless remarkable skill as a photographer produced beautiful images. In his essay, Alexander Ivanov discusses the sources and techniques of both ethnographic photography and the European artistic tradition on which Iudovin relied. His analysis helps us understand how the formal features of Iudovin's compositions, including the placement of figures and especially the play of light, lift the images out of their mere service to the science of peoples. There are other factors as well, harder to pin down, that have to do with the unpredictable and irreducible quality of emotion and expression produced by photographs of human subjects. When the young woman in image 4 looked at the camera, she was no doubt unaware that she was going to become a "female ethnographic type." In the shot of her profile (see image 4), the light illuminating her earring and her white head call to mind the portrait tradition of the European masters. The two little girls who grace the cover of this volume (see image 65) in all likelihood lived in St. Petersburg, and not the Pale. An-sky had their picture taken as an example of the "assimilation from the cradle" that his planned Jewish cultural restoration was to overcome. Their intensely seri-

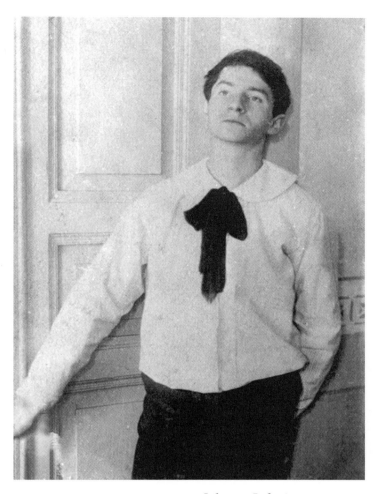

E. Solomon Iudovin.

ous expression — the much-touted, soulful Jewish look, perhaps — belies their youth.

In other photographs, as Alexander Lvov shows in his essay "The Jewish Nursery," children are most emphatically not soulful, but mischievous (see images 83 and 84). The wealthy rabbi and the poverty-stricken caretaker in these photographs are both accompanied by uninvited, but nonetheless beaming, young guests who have inserted themselves into the frame, disrupting the shot. It was this next generation, as Lvov emphasizes, that was the particular target of An-sky's project of cultural self-renewal; it was for their sake that the "academy, where folklore was to be studied," would be created. These youngsters, however, had another goal in mind — the fun of the moment. The children's disruptive intrusions reveal one of the most

important dimensions of the photographic project. An-sky himself probably did not intend to be photographed, but there he is, holding back a chandelier in a synagogue with his walking stick (image 97), and there is his umbrella performing the same function (image 106).

Synagogues had a special place in An-sky's project of Jewish cultural self-renewal. As Alla Sokolova explains in her essay "The Space of Jewish Tradition," An-sky wanted to find houses of worship that could be considered valuable examples of Jewish cultural heritage. Many of the photographs in chapter 4 reveal the romance of the ruin. The problem was in how to affirm the value of these structures — which were found in the poorest and most decrepit settings — and, at the same time, avoid the possible accusation that Jewish civilization was intractably backward. (An-sky himself had used a similar label to characterize the unassimilated Jews of the Pale, as we discussed earlier.)

In one sense, the children mentioned above recall the ongoing present inserting itself into the monument to a disappearing world, sometimes in ways that could not have been predicted in advance. In another, they remind us of the unforeseeable future, a future that paid little attention to An-sky's abstract ideological schemes. Considering a photograph of a synagogue caretaker with a laughing child (image 84) or of children in the muddy town square of Shepetovka (image 114), their presence also helps to reveal a tension between the picturesque aura of poverty and its negative implications for the photograph's subjects. The five essays in this book all emphasize the contradictions inherent in a project that involves preserving, dismantling, and remaking the culture of the past.

The tension between valuing the past and building a bridge to the future was at the heart of An-sky's plan to create a network of Jewish museums (see Lvov and Dymshits for a discussion of this goal and its partial realization before 1929). This tug-of-war between preservation and renewal also emerges in the photographs of new and traditional professions, and An-sky's particular emphasis on Jewish workers, as Dymshits points out. Just as Russian ethnographers saw revolutionary potential in the traditional collective labor practices of Russian peasants, An-sky and his staff saw socialist potential in traditional Jewish labor practices. The big, burly blacksmith, seated with his mallet in his hand, looks out confidently from the frame of the photograph (image 28); he is a man you would want on your side.

It is striking that in the period following World War II, the expeditions' photographs became place markers of an unchanging past. As Ivanov mentions, Iudovin transposed the images of a shoemaker and a boy with a ciga-

rette into woodcuts. These and other woodcuts based on his photographs of the Pale entered the iconography of the shtetl. One of them even illustrates the entry for "shtetl" in the *New Standard Jewish Encyclopedia* (1970). On the other side of the Atlantic, the painter Natan Al'tman used some of the photographs as the basis for his illustrations of a Russian edition of Sholem Aleichem's stories, published in 1957. The subsequent use to which these images were put — their afterlife — obscures the intensely dynamic quality of the blacksmith, the laughing children, and An-sky himself. Somehow, the products of great intellectual, political, and artistic ferment became relics of the past. Nonetheless, it is our hope that these images, and a reconsideration of the project that produced them, will provoke new inquiry about the past that will have implications for the present.

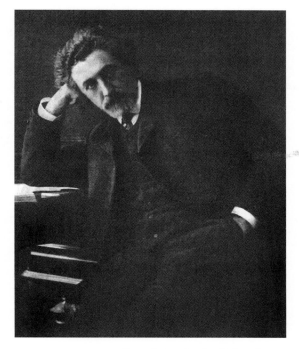

F. Expedition leader S. An-sky.

The Genesis of a Book

The story of how the photographs survived the twentieth century has many twists and turns. The outbreak of World War I disrupted the expeditions, and An-sky was compelled to remove the materials he had collected to the greater safety of Kiev and what was then called Petrograd. During this time, An-sky himself initiated and led aid efforts for the victims of wartime pogroms. In 1914, on his return to Petrograd, he helped to establish the Museum of the Jewish Historical-Ethnographic Society, which was charged with housing and exhibiting the objects and documents acquired during the expeditions.[43] The collection remained there until 1929, when the Soviet government closed the museum.

At this point, the story gets murkier. It is likely that Iudovin gave a portion of the photographs to Natan Al'tman for safekeeping. Some photographs also were given to what is today called the Russian Ethnographic Museum in St. Petersburg. When Al'tman died in 1970, Aleksander Pasternak, a prominent theatrical designer in St. Petersburg, inherited Al'tman's studio, and with it that part of the photographic collection which remained on the premises. In 2001 Alina Orlov, who was then writing a thesis on Al'tman at the University of Southern California, met Pasternak, who showed her a package of old "Jewish" photographs and enlisted her help in finding someone who could read the Yiddish notes that were written on them. Viktor Kel'ner

and Valerii Dymshits, both at Petersburg Judaica, an institute for Jewish studies presently affiliated with the European University at St. Petersburg, realized that these photographs had significant artistic and historic value, and acquired the collection (around 350 photographs) for the center.[44]

After the collapse of the Soviet Union, at a time when most researchers had abandoned ethnographic techniques, including oral history, on the assumption that there was no Russian-Jewish culture left to document, the researchers at Petersburg Judaica initiated remarkable work that continued in the tradition of An-sky's expeditions. They traveled to the same regions of Ukraine as An-sky, and used some of the same questions that he had developed to ask Jewish residents about how they define a Jewish space, how holidays and life-cycle events are marked, and how memories are preserved. Their teaching, exhibits, and scholarly publications — along with their very presence — demonstrate the persistence of Jewish culture in the Soviet and post-Soviet periods. *Photographing the Jewish Nation* is based on a limited edition of photo albums published by Petersburg Judaica from 2005 to 2007.[45] The members of the Petersburg Judaica research team, including Valerii Dymshits, its director, Alexander Ivanov, Alexander Lvov, and Alla Sokolova, researched and catalogued each image. Their essays offer interpretations of the key themes and goals of the ethnographic expeditions: Ivanov on Iudovin's photographic art, Dymshits on Jewish workers, Lvov on the education of the next generation, Sokolova on the Jewish architectural heritage, and Dymshits on the history of the first Jewish museum in the Russian Empire. Each author has a distinct orientation and emphasis. Some, for example, are more interested in the photographs as historical documents, others in the photographs as works of art; all explore the various dimensions of An-sky's project of Jewish national renewal.

Working together with Petersburg Judaica, we have now made available the most comprehensive pictorial representation of Jewish culture and society in the Pale of Settlement.[46] This volume offers English-language audiences their first look at a set of recently rediscovered photographs of Russian-Jewish life. Taken at the beginning of the twentieth century, these photographs marked a new chapter in the history of how Jews in the Russian Empire visually represented themselves — using the relatively new medium of photography for political ends.[47] The essays included in this volume suggest just some of the ways the images can be read and analyzed; they do not attempt to provide the final word on the subject. We hope that these photographs — as visual documentary sources — open new scholarly directions in the history and culture of Russian Jewry from a diverse array of

perspectives, including, for example, gender, economics, popular religion, and cultural criticism. Furthermore, the images in this volume invite broad comparative study with West European, North American, and colonial photographic work by August Sander and Edward S. Curtis, among others.[48] At the turn of the twenty-first century, we hope that *Photographing the Jewish Nation* will serve not merely as a monument to a world that no longer exists, but to stimulate new thinking and research in the field of Russian-Jewish cultural studies.

Notes

1. "Perepiska Semena Akimovicha An-skogo s Vladimirom Goratsevichem Ginstburgom," in *Arkhivna spadshchyna Semena An-s'kogo u fondakh natsional'noi biblioteky ukrainy imeni V. I. Vernads'kogo*, ed. Irina Sergeeva (Kiev: Dukh i litera, 2006), 437.

2. S. An-sky, "Pis'mo v redaktsiiu (o rabotakh etnograficheskoi ekspeditsii)," *Evreiskaia starina* 8 (1915): 239.

3. For An-sky's plan of "Evrei v ikh bytovoi i religioznoi zhizni," see Judaica Section, Manuscript Division, Vernadsky National Library, Kiev (IR IFO NBUV), f. 339, ed. khr. 11, ll. 1–6.

4. Omer Bartov, *Erased: Vanishing Traces of Jewish Galicia in Present Day Ukraine* (Princeton, N.J.: Princeton University Press, 2007).

5. For a discussion of the return paradigm, see David Roskies, "S. Ansky and the Paradigm of Return," in *The Uses of Tradition*, ed. Jack Wertheimer (New York: Jewish Theological Seminary of America, 1992), 243–60; and Sylvie Anne Goldberg, "Paradigmatic Times: An-sky's Two Worlds," in *The Worlds of S. An-sky: A Russian Jewish Intellectual at the Turn of the Century*, ed. Gabriella Safran and Steven Zipperstein (Stanford, Calif.: Stanford University Press, 2006), 44–52.

6. An essay on An-sky's readings of Russian folklore in the context of Russian Populism can be found in Chaim Zhitlovsky, *Zikhroynes fun mayn lebn*, vol. 1 (New York: Posy-Shoulson Press, 1935), 43–56.

7. For a chronology of An-sky's life, see Gabriella Safran, "Timeline: Semyon Akimovich An-sky/Shloyme-Zanvl Rappoport," in *The Worlds of S. An-sky*, xv–xxix.

8. On the significance of Populist social thought, see Roskies, "S. Ansky and the Paradigm of Return," 243–60; and Brian Horowitz, "Spiritual and Physical Strength in An-sky's Literary Imagination," in *The Worlds of S. An-sky*, 103–18.

9. For a discussion that links Russian Populism with ethnography, see Alexander Etkind, "Whirling with the Other: Russian Populism and Religious Sects," *The Russian Review* 62, no. 4 (2003): 565–88.

10. For the most extensive analysis of An-sky's ethnographic activities, see V. M. Lukin, "Ot narodnichestva k narodu (S. A. An-skii — etnograf vostochno-evropeiskogo evreistva," in *Evrei v rossii: Istoriia i kul'tura*, ed. Dmitrii A. Eliashevich

(St. Petersburg: Peterburgskii evreiskii universitet, 1995), 125–61; and Lukin, "'An Academy Where Folklore Will Be Studied': An-sky and the Jewish Museum," in *The Worlds of S. An-sky*, 281–306.

11. S. An-sky, "Evreiskoe narodnoe tvorchestvo," *Perezhitoe* 1 (1908): 276.

12. Institute for Jewish Research, New York (YIVO), RG 1.2, Box 6, Folder 77 (Dokladnaia zapiska. Po povodu Evreiskoi Etnograficheskoi Ekspeditsii imeni barona G. O. Gintsburga)

13. An-sky, "Evreiskoe narodnoe tvorchestvo," 277.

14. Lukin, "An Academy Where Folklore Will Be Studied," 282–87.

15. On the Jewish Historical-Ethnographic Society, see Jeffrey Veidlinger, *Jewish Public Culture in the Late Russian Empire* (Bloomington: Indiana University Press, 2009), chap. 9.

16. S. An-sky, "Provintsial'naia zhizn'," *Evreiskoe obozrenie*, no. 3 (1910): 28–29.

17. On suicides in the Russian Empire, see Irina Paperno, *Suicide as a Cultural Institution in Dostoevsky's Russia* (Ithaca, N.Y.: Cornell University Press, 1997); and Susan K. Morrisey, *Suicide and the Body Politic in Imperial Russia* (Cambridge: Cambridge University Press, 2007). For a general treatment of progress and degeneration in its pan-European context, see Daniel Pick, *Faces of Degeneration: A European Disorder* (Cambridge: Cambridge University Press, 1989).

18. S. An-sky, "Paradoksy zhizni i smerti," *Evreiskii mir*, no. 1 (1910): 18–20. In the 1860s and 1870s, prominent Russian writers such as Dostoevsky lamented similar paradoxes with regard to Russian intellectuals and their fatal attraction to the culture of Western Europe.

19. Although conversions, from Judaism to Russian Orthodoxy, remained small, they did rise in the last years of the old regime. In 1905 and 1907, for example, only 685 and 579 Jews converted, whereas 1,128 Jews converted in 1909 and 1,299 in 1910. For an analysis, see Eugene M. Avrutin, "Returning to Judaism after the 1905 Law on Religious Freedom in Tsarist Russia," *Slavic Review* 65, no. 1 (Spring 2006): 90–110; and John D. Klier, "State Policies and the Conversion of the Jews," in *Of Religion and Empire: Missions, Conversion, and Tolerance in Tsarist Russia*, ed. Robert P. Geraci and Michael Khodarkovsky (Ithaca, N.Y.: Cornell University Press, 2001), 109.

20. S. An-sky, "Natsionalizm tvorcheskii and natsionalizm razgovornyi," *Evreiskii mir*, no. 19/20 (1910): 13–14.

21. S. An-sky, "Kolybel'naia assimiliatsiia," *Evreiskii mir*, no. 23/24 (1910): 20–21; and An-sky, "Paradoksy zhizni i smerti," 18–20.

22. For a recent discussion of An-sky's influence on Jewish ethnography, see Jack Kugelmass, "The Father of Jewish Ethnography," in *The Worlds of S. An-sky*, 346–59.

23. On the development of ethnography in the imperial Russian context, see Nathaniel Knight, "Science, Empire, and Nationality: Ethnography in the Russian Geographical Society, 1845–1855," in *Imperial Russia: New Histories for the Empire*, ed. Jane Burbank and David Ransel (Bloomington: Indiana University Press, 1998),

chap. 5; and Knight, "Ethnicity, Nationality, and the Masses: Narodnost' and Modernity in Imperial Russia," in *Russian Modernity: Politics, Knowledge, Practices*, ed. David Hoffman and Yanni Kotsonis (New York: Palgrave Macmillan, 1999), 41–66.

24. For earlier ethnographic descriptions of Jewish communities in the Pale of Settlement, see, for example, M. I. Berlin, *Ocherk etnografii evreiskogo narodonaseleniia v Rossii* (St. Petersburg, 1861); and A. A. Alekseev, *Ocherki domashnei i obshchestvennoi zhizni evreev: Ikh verovaniia, bogosluzhenie, prazdniki, obriady, Talmud, i kagal*, 3rd ed. (St. Petersburg, 1896).

25. On the civilizing mission in mid-nineteenth century Russia, see Paul W. Werth, *At the Margins of Orthodoxy: Mission, Governance, and Confessional Politics in Russia's Volga-Kama Region, 1827–1905* (Ithaca, N.Y.: Cornell University Press, 2002), 124–46; Yuri Slezkine, *Artic Mirrors: Russia and the Small Peoples of the North* (Ithaca, N.Y.: Cornell University Press, 1994); Willard Sunderland, *Taming the Wild Field: Colonization and Empire on the Russian Steppe* (Ithaca, N.Y.: Cornell University Press, 2004), 166–67. For an account of the social engineering program of Nicholas I that stressed "gradualism" with regard to Jews, see Michael Stanislawski, *Tsar Nicholas I and the Jews: The Transformation of Jewish Society in Russia, 1825–1855* (Philadelphia: Jewish Publication Society of America, 1982).

26. On the rise of physical anthropology in the imperial Russian setting, see Marina Mogil'ner, *Homo imperii: Istoriia fizicheskoi antropologii v Rossii* (Moscow: Novoe literaturnoe obozrenie, 2008); and Eugene M. Avrutin, "Racial Categories and the Politics of (Jewish) Difference in Late Imperial Russia," *Kritika: Explorations in Russian and Eurasian History* 8, no. 1 (2007): 13–40.

27. On Tenishev's ethnographic expeditions, see B. M. Firsov and I. G. Kiseleva, eds., *Byt velikorusskikh krestian-zemlepashtsev: Opisanie materialov etnograficheskogo byuro kniazia V. N. Tenisheva (na primere Vladimirskoi Gubernii)* (St. Petersburg: Izdatel'stvo evropeiskogo doma, 1993). Tenishev published a detailed questionnaire, consisting of 491 questions, which was used by his research team as they conducted their work. See V. N. Tenishev, *Programma na osnovanii soobrazhenii izlozhennykh v knige V. N. Tenisheva deiatel'nost' cheloveka* (Smolensk, 1897).

28. Tenishev planned on using the materials to write a book entitled "Byt velikorusskikh krest'ian-zemlepashtsev," but he died unexpectedly in 1903, before he had a chance to write it.

29. IR IFO NBUV, f. 339, ed. khr. 213 (letter from Weissenberg to An-sky, June 10, 1912). On Weissenberg, see John M. Efron, *Defenders of the Race: Jewish Doctors and Race Science in Fin-de-Siècle Europe* (New Haven, Conn.: Yale University Press, 1994), chap. 5.

30. Lukin, "Ot narodnichestva k narodu," 132.

31. Iulii (Yoel) Engel', "Jewish Folksongs: The Ethnographic Expedition," in *The Upward Flight: The Musical World of S. An-sky*, 4–6, addendum to *The Worlds of S. An-sky*.

32. Sergeeva, ed., *Arkhivna spadshchyna Semena An-s'kogo*, 439.

33. For a list of twelve other questionnaires used during ethnographic expeditions in the second half of the nineteenth century, see Firsov and Kiseleva, eds., *Byt velikorusskikh krestian-zemlepashtsev*, 9–10.

34. Sergeeva, ed., *Arkhivna spadshchyna Semena An-s'kogo*, 431.

35. Lukin, "Ot narodnichestva k narodu," 136–37.

36. S. An-sky, *Dos yidishe etnografishe program: Der mentsh*, vol. 1, ed., Lev Shternberg (Petrograd, 1914). For a discussion of the projected second part of the questionnaire, see Lukin, "Ot narodnichestva k narodu," 139.

37. David Roskies, "Introduction," in *The Dybbuk and Other Writings* (New York: Schocken, 1992), xxiv–xxv. On the construction of the questionnaire see Lukin, "Ot narodnichestva k narodu," 139; and Nathaniel Deutsch, "An-sky and the Ethnography of Jewish Women," in *The Worlds of S. An-sky*, 275–80.

38. YIVO, RG 1.2, Box 6, Folder 76 (Plan i predvaritel'naia skhema raskhodov po "Evreiskoi Etnograficheskoi Ekspeditsii imeni barona G. O. Gintsburga").

39. Ibid.

40. YIVO, RG 1.2, Box 6, Folder 76 (Protokol soveshchaniia predstavitelei Kievskoi, Moskovskoi, i Peterburgskoi grupp sodeistviia "Evreiskoi Etnograficheskoi Ekspeditsii imeni barona G. O. Gintsburga").

41. IR IFO NBUV, f. 339, ed. khr. 213 (letter from Weissenberg to An-sky, June 10, 1912).

42. IR IFO NBUV, f. 339, ed. khr. 203 (letter from Vainshtein to An-sky, September 24, 1913).

43. Valerii Dymshits's essay "The First Jewish Museum in Russia" describes the first exhibit.

44. Alina Orlov, "From Zero to Ten: Discovering Yudovin's Photographs in Post-Soviet Russia," and V. A. Dymshits, "Lost and Found: The Yudovin/An-sky Photographs," *East European Jewish Affairs* 35, no. 1 (2005): 3–6, 7–12. For a discussion of how the Russian Ethnographic Museum in St. Petersburg obtained its collection of the An-sky materials, see Dymshits' essay "The First Jewish Museum in Russia," as well as Igor Krupnik, "Jewish Holdings of the Leningrad Ethnographic Museum," in *Tracing An-sky: Jewish Collections from the State Ethnographic Museum in St. Petersburg* (Zwolle, Netherlands: Waanders, 1992), 16–23.

45. Petersburg Judaica, *Fotoarkhiv ekspeditsii An-skogo*, 5 vols. (St. Petersburg, 2005–2007).

46. For a brief history of Jewish photography, see David Shneer, "Photography," in *The YIVO Encyclopedia of Jews in Eastern Europe*, 2 vols. (New Haven, Conn.: Yale University Press, 2008), 2: 1351–53. For two well-known photographers of East European Jewish life in the interwar period, see Alter Kacyzne, *Poyln: Jewish Life in the Old Country* (New York: Holt, 1999); and Roman Vishniac, *A Vanished World* (New York: Farrar, Straus and Giroux, 1983). See also Lucjan Dobroszycki and Barbara Kirshenblatt-Gimlet, *Image Before My Eyes: A Photographic History of Jewish Life in Poland, 1864–1939* (New York: Schocken, 1977).

47. For a discussion of the use of visual culture for political ends, see Michael Berkow-

itz, "Religious to Ethnic-National Identities: Political Mobilization Through Jewish Images in the United States and Britain, 1881–1939," in *Practicing Religion in the Age of the Media: Explorations in Media, Religion, and Culture*, ed. Stewart M. Hoover and Lynn Schofield Clark (New York: Columbia University Press, 2002), 305–27.

48. For an insightful analysis of how the visual can open fresh lines of analysis in Russian history and culture, see Valerie A. Kivelson and Joan Neuberger, eds., *Picturing Russia: Explorations in Visual Culture* (New Haven, Conn.: Yale University Press, 2008). On the colonial dimensions of photography, see, for example, Eleanor M. Hight and Gary D. Sampson, eds., *Colonialist Photography: Imag(in)ing Race and Place* (New York: Routledge, 2002); Elizabeth Edwards, ed., *Anthropology and Photography, 1860–1920* (New Haven, Conn.: Yale University Press, 1992); and Christopher Pinney, *The Coming of Photography in India* (London: The British Library, 2008). On the photographic work of the American Indian by Edward S. Curtis, see Mick Gidley, *Edward S. Curtis and the North American Indian, Incorporated* (Cambridge: Cambridge University Press, 1998). On the work of the German photographer August Sander, see August Sander, *Citizens of the Twentieth Century: Portrait Photographs, 1892–1952*, ed. Gunther Sander (Cambridge, Mass.: MIT Press, 1986).

The Making of a Young Photographer

From Ethnography to Art

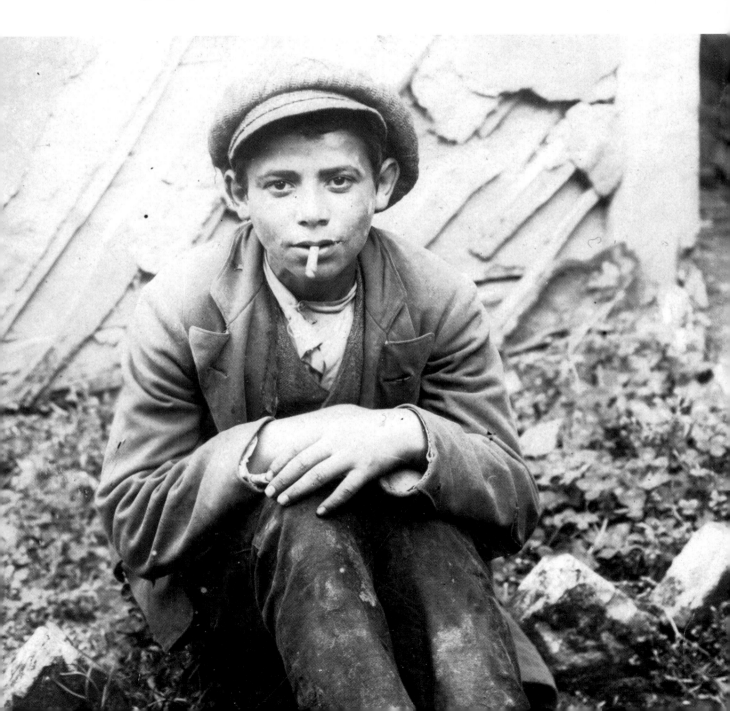

"The three of us set out on the journey: An-sky, the Jewish writer, poet, and ethnographer, myself, and a young man [Solomon Iudovin]. An-sky collected tales, legends, proverbs, and noteworthy artifacts, my interest was music, while the young man took photographs."[1] This is how the well-known composer and music critic, Iulii D. Engel', described the members of the first Jewish historical-ethnographic expedition.

These words suggest that the eminent ethno-musicologist condescended to the young Iudovin and thought little of his role in the expedition. Engel' implies that Iudovin would take pictures of what he was told to take pictures of. Perhaps Engel' would have respected the photographer more if he knew that the young man would one day become a famous artist, whom critics would call "a great and original master who has made an important contribution to the history of Soviet graphic art."[2]

A photograph of the three men has survived from the 1912 expedition: Engel' stands at the center, with S. An-sky on the right, and An-sky's nephew Iudovin, "the young man who took pictures," on the left. Everything in Iudovin's appearance speaks to his desire to look older than his years. He had not yet turned twenty (see image c).[3] An-sky, however, entrusting the young man with the important task of taking pictures and making sketches, had little doubt that Iudovin would be able to fulfill his responsibilities.

Iudovin grew up in the Belorussian town of Beshenkovichi and was only beginning his career as an artist at the time. He had studied drawing at a local art school under the supervision of the famous artist Yehuda Pen, who also taught Chagall. To make ends meet, he had learned how to take pictures while working as a photographer for studios in Vitebsk.[4] An-sky thought that the ethnographic expedition would play a formative role in the artistic development of the young photographer. He also believed that the materials collected in the Pale of Settlement would play a formative role

among the next generation of Jews, that they would inspire young Jewish writers, composers, and artists, who would no longer have to borrow from other aesthetic traditions and "wander like pale shades among other people's creations."[5] For this reason, An-sky tried, without much success, to recruit important Jewish artists and intellectuals for the expeditions: the poet H. N. Bialik, the writer Sholem Asch, and the painter Leonid Pasternak.[6]

There is little doubt that participating in the ethnographic expeditions significantly influenced Iudovin's subsequent artistic work. The photographs helped him define his own sphere of images, connected to everyday life in the shtetl. For decades afterward, images of the shtetl were a major theme of his work.

Iudovin's Photographs in Historical Context

Many of Iudovin's photographs depart from the framework of ethnographic photography of the late nineteenth and early twentieth centuries. Examples of the standard ethnographic photography of the time can be seen in the work of Ivan Raul' (also known as Jean Raoult), who took ethnographic pictures in the 1870s, and Mikhail Greim, who worked in the latter part of the nineteenth century. Bound in leather and decorated in gold lettering, these ethnographic albums were usually preserved at the Academy of Sciences, the Imperial Geographic Society, and the Russian National Library of St. Petersburg, among other institutions and depositories.

The model for expedition photography was based on the idea of the "applied" and secondary role of photographs in the service of ethnographic science.[7] As a rule, primary attention was given to portraits of the so-called "types" among the local population. According to the anthropological norms of the time, such portraits were taken from two angles: the profile and the front view. In addition, it was customary to photograph so-called genre scenes (scenes of everyday life), characteristic buildings, homes, household items and utensils, and national costumes.[8] The photographers thus aspired to freeze the most typical cultural characteristics of a group's daily activities. These "typical" characteristics, however, essentially consisted of all kinds of ethnic exotica. By dressing their subjects in "national costumes" and placing in their hands some uncivilized "domestic utensil" or "work instrument," expedition photographs helped to construct the very "national" or "ethnic" types they were supposed to capture. According to S. Morozov, photographers "picked the background in order to introduce into the shot the most representative aspects of the locality: age-old trees of various girths, shrubs,

the leafy incline of the hills . . . as well as showing ethnic costumes, head gear, shoes, weapons, and even patterns on woven cloth."[9]

In compliance with these practices, Iudovin photographed the profiles and front-views of "Jewish types," and An-sky's archive contains several examples of such images (see illustrations 2–7). For the most part, however, Iudovin's work moves beyond the normative ethnographic photography of the early twentieth century. This type of photography favored scrupulous exactitude and insistence on detail, resulting in static images. Typical ethnographic photographs of the time resembled exhibits displayed at museums, with the living subjects bearing a striking resemblance to museum mannequins. In contrast, the reality represented in Iudovin's photographs often lacks the Jewish exoticism for which learned gentlemen with cameras left the capital and headed for the provinces.

The difference between typical ethnographic photography and Iudovin's practice may be seen, for example, in "Wedding in Polonnoe" (image 1). Iudovin attempted to capture that special moment when the bride and groom were to stand under the *khupa*, and thereby record one of the most characteristic "scenes of Jewish life." To achieve this aim, however, he did not use the devices of staged photography widely employed at the time. The photograph's composition permits us to assume that Iudovin wanted to convey the scale that such an important event encompassed: his chosen point of view allows as many people as possible to enter the frame. The alternation of white and black — women's blouses and men's coats — creates a pulsing movement, as if waves were rippling out from the center of the *khupa*. Rather than conveying the static quality of a museum exhibit, Iudovin's portrait emphasizes the dynamic, joyous activity of the wedding celebration.

In occupying himself with similar artistic experiments, Iudovin departed from the primary tasks of ethnographic photography and, at the same time, came close to fulfilling the ultimate goal of his patron and mentor An-sky: to create a living "portrait of the people." Such a portrait could only be achieved by artistic means and Iudovin approached his work with all the tools of photographic art available to him at the time.

Several of Iudovin's expedition photographs represent magnificent examples of a type of pictorial photography popular in Russia in the late nineteenth and early twentieth centuries. The appeal of "pictorialism" or, as it was also called, "photo-impressionism," was closely connected with a radical change in Russian attitudes toward photography. Soon after the turn of the century, the major problems of photographic technique and picture

processing had been resolved, and society began to develop an understanding of photography as "high art."

The photographer N. A. Petrov, editor of the Moscow journal "Photography Herald," head of the Kiev photo-society "Daguerre," and organizer of many exhibitions of pictorial photography, was the recognized leader of the pictorialists in Russia. Other well-known photographers, including A. Grinberg, B. Pashkevich, M. Sherling, S. Lobovikov, A. Mazurin, S. Ivanov-Alliluev, Iu. Eremin, and N. Svishchev-Paola also contributed to this fashionable trend in photographic art. Petrov succeeded in establishing a pictorialist movement that received the name "Young Art"; the works of its most famous representatives — A. Trapani, N. Murzin, and S. Savrasov — "resembled works of art both in their subject matter and formal features."[10]

The goal of pictorialism was to grant photography the status of art by using techniques, or "pictorial effects," that made photographs resemble paintings. Like Impressionism, from which it drew inspiration, pictorial photography emphasized atmosphere and mood over the details of subject or scene. The rejection of documentary detail and the heightening of emotion sharply distinguished pictorial photography from the standard ethnographic photography of the time.

At least two factors account for the popularity of pictorialism. As O. Sviblova points out, "its orientation toward canonical oil painting, and its interest in the unpredictability and uniqueness of the photograph, which would be produced in the course of a complicated technological processing of the negative and of the positive image, were surprisingly resonant in the atmosphere of the 'silver age' and the mystical mind-set so characteristic of Russia at the turn of the century."[11] In addition, Russian pictorial photography of that period often depicted village landscapes and scenes of peasant life — a reflection of the democratic ideals of its leading artists, who moved in the same circles as the Populist-inspired intelligentsia. This characteristic of pictorialism — its positive valuation of both mysticism and Populism — can also be found in An-sky's writings. The work that best incorporates his impressions from the ethnographic expeditions is the lyric-epic drama *Between Two Worlds: The Dybbuk*, based on Hasidic mystical legends. This work stands out from the rest of An-sky's writings, which for the most part consist of populist sketches and tales written in a realistic manner.

Iudovin's chief accomplishment resides in his synthesis of the principles of ethnographic photography with the artistic methods of pictorialism. Only a few ethnographic photographs of the time can be considered in the same context as Russian art photography. But the best of Iudovin's expe-

dition photos are undoubtedly included in this category. On occasion his approach is radical, demonstratively ignoring the accepted capacity of photography to clearly and exactly "reproduce everything that had been created in the world."[12] In photographing the rabbi's family in Ostrog (image 10), for example, Iudovin re-examined the conventions of the formal family portrait — the most widespread and conservative genre of the time. Deliberately ignoring the rules of studio photography, he arranges the light so that the masculine half of the frame is submerged in darkness, while the feminine is brightly illuminated. A little boy in a light suit occupies the composition's center, signifying his temporary status as a member of both worlds: the female and the male. Although divided between these two poles of family, he simultaneously reconciles them, uniting them all into one whole. The rabbi himself is dressed entirely in black and therefore barely visible against the dark background. Only the big bulging eyes can be made out in his domineering face. No doubt arises in the viewer as to who is the head of the family.

Iudovin often took photographs of elderly men during the expeditions. In accordance with the aesthetic of pictorialism, these are often stylized portraits in the manner of oil paintings or other graphic works. Set against a fantastical play of chiaroscuro, his images of bearded old men — handsome, wise, and "Biblical" — call to mind the works of the Old Masters, primarily Rembrandt. Yehuda Pen, Iudovin's former teacher, was a master of genre painting and a passionate devotee of the great Dutch artist. Clearly Pen's lessons influenced his student. As a leading art historian observes, "Pen sought and found Rembrandt types in the concrete ethnographic environment."[13] Judging from such photographs as "In the Old People's Home" (image 9) and "Preacher" (image 12) the young Iudovin was similarly preoccupied. In the photograph of an old weaver making a *talis* (image 14), Iudovin even employs Rembrandt's well-known method of illumination, though in an unusual way. The old man's face is deliberately left in shadow; the bright contrasting light, which comes from the window behind him, runs along the contour of his face and beard, forming a diffuse bright patch in the dark space.

Iudovin's meticulous attention to detail is perhaps best represented in the photo-novella "Weaver" (image 18). The contrast of the harsh light from the window, dispersing the thick semi-darkness under the rafters, gives the frame an ominous tension, anticipating the aesthetic of 1920s German expressionism. In the depths of the frame is an emaciated man, confined within a complicated structure of wood and rope, more reminiscent of a

cage than a loom. The weaver resembles a marionette, as if the loom operates him, and not he the loom. In this composition, Iudovin seems to forget the ethnographic task of depicting a characteristic scene of Jewish traditional handicraft, becoming wholly absorbed in the artistic task of creating a powerful image.

Two photographs that share the title "Baking Matzo" (images 15 and 16) are also linked by format, tone, and style. A rectangular piece of sacking occupies almost a third of the first photograph. The sacking screens off a cupboard where, in all likelihood, dishes are stored: the dishes used during the rest of the year, and therefore not kosher for Passover. The covered cupboard that dominates the frame is a significant image, symbolizing the coming of the holiday. A bearded man standing to the left of the cupboard kneads the dough for the matzo. A boy with a jug stands next to him, ready to pour water into the dough. To the right are a group of boys, who came to look at the baking of the matzo. In this scene, there are spectators and actors (and someone else, in a white shirt, whose shoulder and arm intrudes on the camera eye). The sacking divides one group from the other, like a curtain. In the lower left-hand corner of the picture, the contours of a basket containing flat white matzos can be discerned. (A man carrying a similar basket on his shoulders, filled to the top with matzos, appears in "Matzo Carrier" [image 17]). The protagonist in the second photograph is a baker in a white shirt. With his sleeves rolled up, he removes freshly baked matzo from the oven. The contours of his busy figure blur slightly in the bright waves of hot air from the oven, imbuing the image with the joyful anticipation of the coming holiday. Looking closely at the pleats of his shirt and the rolled-up sleeve, we can see that it is this baker whose shoulder and arm appears in the previously mentioned scene.

The pictorialists devoted considerable attention to photographic printing, a complicated and labor-intensive process at the time. To print "Lathe Operator" (image 20), Iudovin used the so-called oil method, in which paint is applied directly to the photographic paper, then removed. A comparison with the first print (image 19) from the photographic plate permits us to judge the results of this complicated "alchemical" process. Iudovin has succeeded in giving the image a painterly quality: the sepia tones seem to be brushed on a light background; the background swirls, thickens, then disperses, revealing the priming. The uneven affect makes the space seem nervous and strained.

Iudovin's deliberate use of a broad arsenal of artistic devices and techniques shows that he considered himself more than a mere recorder of

images. He understood that his task included not only the photographic documentation of ethnographic reality, but also the creative generation of his own impressions. The juxtaposition of his expedition photographs and his graphic work, produced in the 1920s and 1930s, confirms that this experience became an extremely valuable source of material, providing the artist with themes and images for many decades.

In some instances, Iudovin practically reproduced the subject of a photograph in a woodcut. In "Portrait of an Old Man" (image 23), for example, we recognize the one-eyed character from the photograph "Jewish Coachmen" (image 22). In the majority of this later work, however, Iudovin re-examines his pre-war impressions of life in the shtetl. In revisiting the images of the expedition, Iudovin intensifies their meaning and emotional weight. Proceeding from photograph to woodcut, pathos is transformed into something grotesque, and the impressionistic lack of explicitness into a succinct expressionistic message.

The photograph "Shoemaker" (image 24) and an engraving of the same name from the series "The Past" (image 25) demonstrate the results of this reconsideration. The cheerful photograph shows an elderly shoemaker at work. He looks experienced, wise, and friendly. In contrast, the mood of the woodcut — using almost exactly the same subject matter — is heavy and oppressive, emphasized by the semi-darkness that dominates the workshop. Iudovin introduces some different details, such as the underwear hung up to dry, resembling white flags of surrender before the misery and destitution of the surroundings. The shoemaker himself looks twenty years older than in the photograph. Furthermore, he is alone, as if everyone else has forgotten about his existence. This picture is one of the most striking embodiments of "the death of the shtetl," a theme promulgated in Soviet graphic art in the 1920s and 1930s.

Iudovin's expedition photographs also provided inspiration for his illustrations to the books of Mendele Moykher Sforim, David Bergelson, and other Jewish writers, as well as his artistic direction for theatrical performances staged in the *Evdomprosvet* (Jewish Center for Enlightenment) in Leningrad.

Beginning in the 1920s and continuing through the 1960s, Iudovin's graphic works were regularly exhibited in the USSR and other countries. The Soviet press published many articles and monographs about his art.[14] His photographic work has received far less attention. Even today, only a fraction of his nearly 1500 photographs from the ethnographic expeditions have ever been published. This fact may be blamed in part on An-sky's failed

plans to publish a five-volume "Album of Jewish Artistic Heritage," which was to include around 700 photographs. Even so, it is hardly surprising that Iudovin's widely distributed woodcuts, which brought him global renown, have overshadowed his photographic output. Although Abram Rechtman, the expedition's folklorist, rightly named Iudovin an "outstanding photographer" in the introduction to his 1958 book, *Jewish Ethnography and Folklore*, his evaluation was not considered authoritative. Only now, nearly a century after the expeditions, can we agree completely with Rechtman's evaluation and place Iudovin's name among the best known Jewish photographers, including, for example, Alter Kacyzne and Roman Vishniak, without whom it would be impossible to imagine the photographic art of the twentieth centuy.[15]

Notes

1. Iu. Engel', "Evreiskaia narodnaia pesnia: Etnograficheskaia poezdka," *Paralleli: Russko-evreiskii istoriko-literaturnyi i bibliograficheskii al'manakh*, no. 4–5 (Moscow: Dom evreiskoi knigi, 2004), 287.

2. I. Ioffe and E. Gollerbakh, *S.B. Iudovin: Graviury na dereve* (Leningrad, 1928), 3.

3. Scholars working on Iudovin give two different dates for his birth: 1892 and 1894. It is therefore possible that during the first expedition Iudovin was only eighteen. See Iu. Gerchuk, "Solomon Iudovin," *Paralleli: Russko-evreiskii istoriko-literaturnyi i bibliograficheskii al'manakh*, no. 2–3 (Moscow: Dom evreiskoi knigi, 2003), 682.

4. V. Brodskii and A. Zemtsova, *Solomon Borisovich Iudovin* (Leningrad, 1962), 7.

5. V. M. Lukin, "Akademiia, gde budut izuchat' fol'klor," in *Evreiskii muzei*, ed. V. A. Dymshits and V. E. Kel'ner (St. Petersburg: Simpozium, 2004), 72.

6. V. M. Lukin, "Ot narodnichestva k narodu (S. A. An-skii — etnograf vostochno-evropeiskogo evreistva)," in *Evrei v rossii: Istoriia i kul'tura* ed. Dmitrii A. Eliashevich (St. Petersburg: Peterburgskii evreiskii universitet, 1998), 136.

7. T. Saburova, "Relikvii otechestvennoi istorii: Iz fondov gosudarstvennogo istoricheskogo muzeia," in *Russkaia fotografiia: Seredina xix-nachala xx veka* (Moscow: Planeta, 1996), 29.

8. V. Nikitin, *Rasskazy o fotografakh i fotografiiakh* (Leningrad: Lenizdat, 1991), 37–38

9. S. Morozov, *Russkaia khudozhestvennaia fotografiia. Ocherki iz istorii fotografii 1839–1917* (Moscow, 1961), 44.

10. E. Barkhatova, "Nauka? . . . Remeslo? . . . Iskusstvo!" in *Russkaia fotografiia: Seredina xix-nachala xx veka* (Moscow: Planeta, 1996), 17.

11. O. Sviblova, "Introduction," in *Alexandre Grinberg* (Paris: Carré Noir, 1996), 3.

12. This judgment on the nature of photography by the well-known Russian art critic V. Stasov is cited by Saburova, "Relikvii otechestvennoi istorii," 29.

13. G. Kazovskii, *Khudozhniki Vitebska: Yehuda Pen i ego ucheniki* (Moscow: Imidzh, 1993), 49.

14. Besides Ioffe and Gollerbakh's and Brodskii and Zemtsova's monographs mentioned above, see for instance: I. Furman, *Vitsebsk u graviurakh S. Iudovina* (Vitebsk, 1926); Gr. Sorokin, *Graviury na dereve S. Iudovina* (Leningrad, 1941).

15. Alter-Sholem Kacyzne (1885–1941) was a Jewish writer and photographer. As a photographer, Kacyzne traveled around Poland, Palestine, and North Africa, capturing images of Jewish life. These photos were published throughout Europe and in America in the Yiddish daily *Forward*. Perhaps Kacyzne's most memorable work will be the haunting masterpiece preserved on film — his screenplay of An-sky's *The Dybbuk*.

illustrations

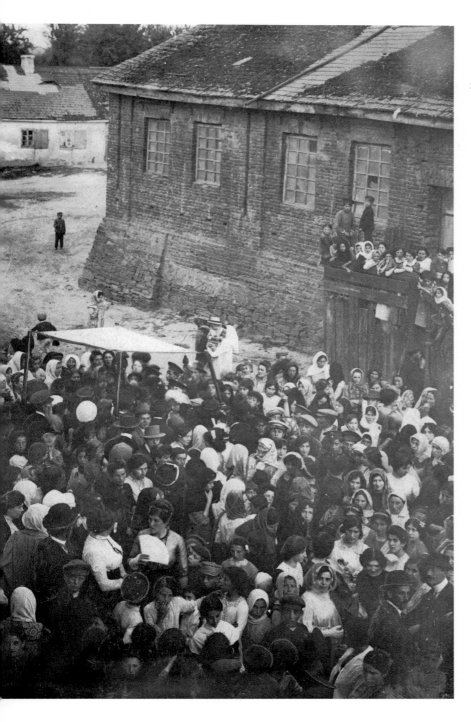

1. Wedding in Polonnoe, 1912.

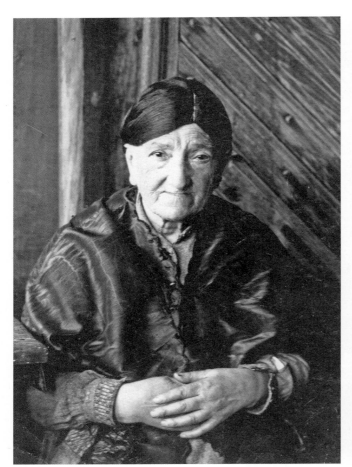 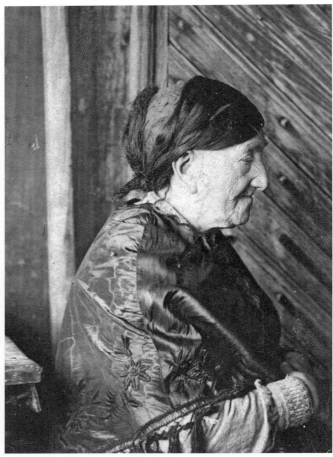

2 (left) and 3 (right). From the series, "Female Anthropological Types."

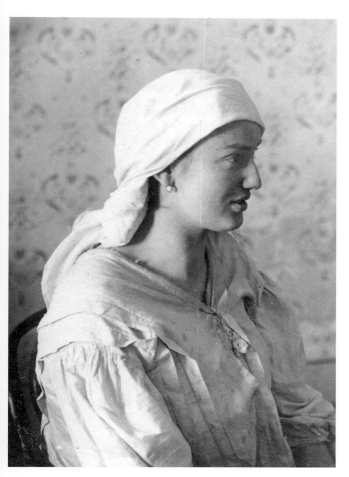 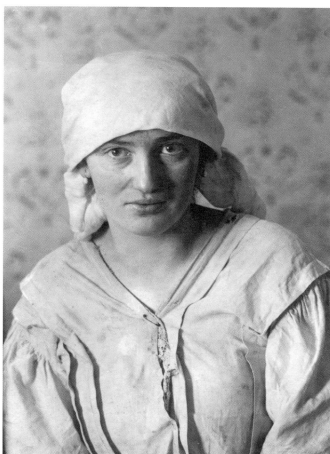

4 (left) and 5 (right). From the series, "Female Anthropological Types."

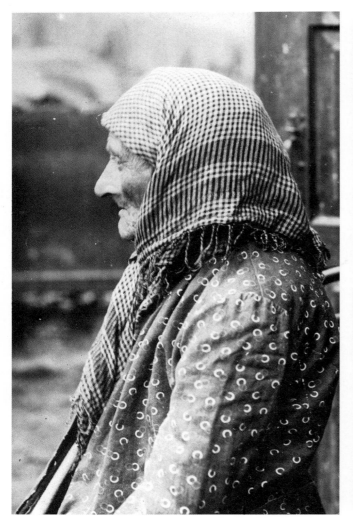 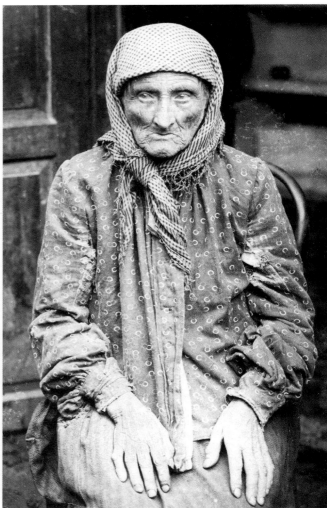

6 (left) and 7 (right). From the series, "Female Anthropological Types."

(opposite)
8. Male anthropological type.

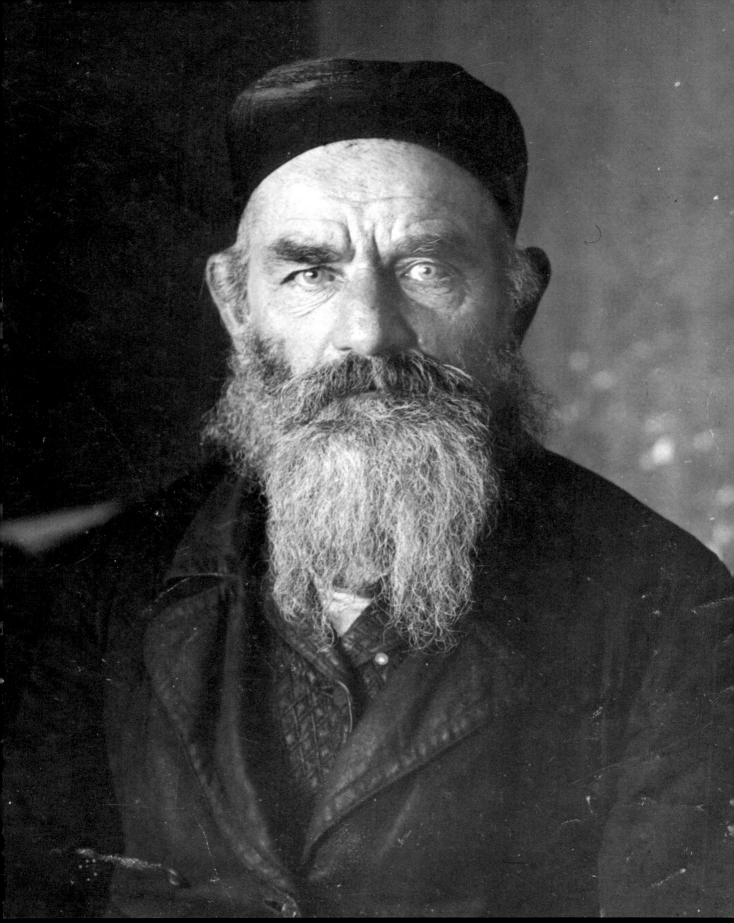

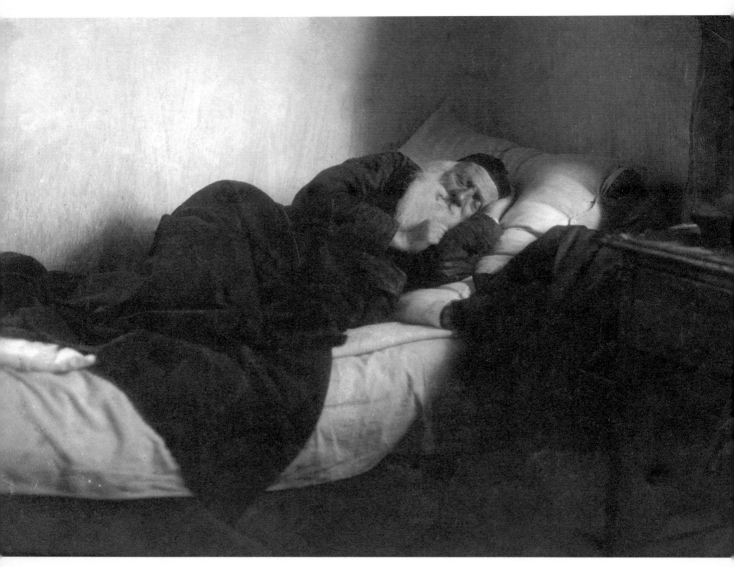

9. In the old people's home,
Proskurov, 1913.

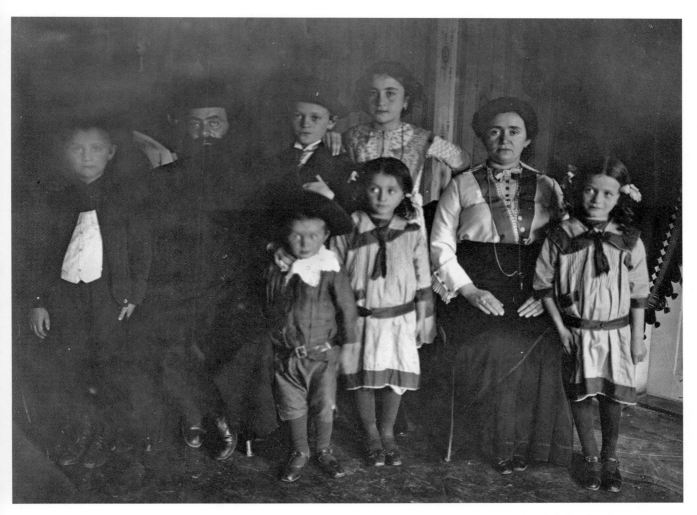

10. Rabbi's family, Ostrog.

11. Tavern-keeper, Letitchev.

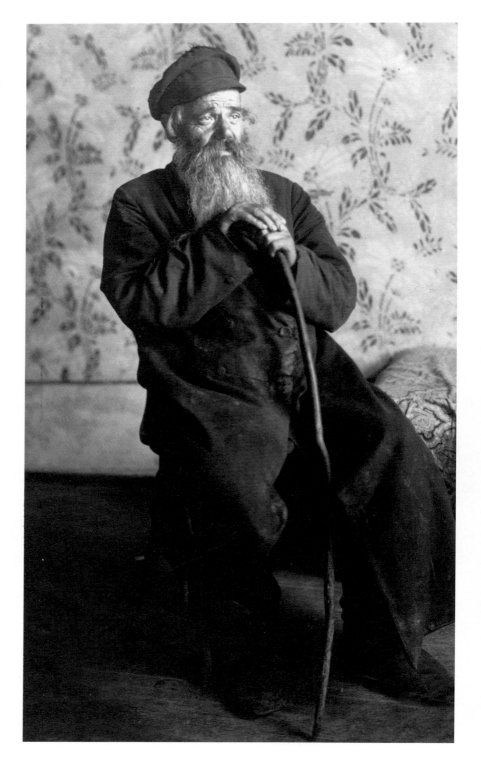

(*opposite*)
12. Preacher, Letichev, 1913.

46

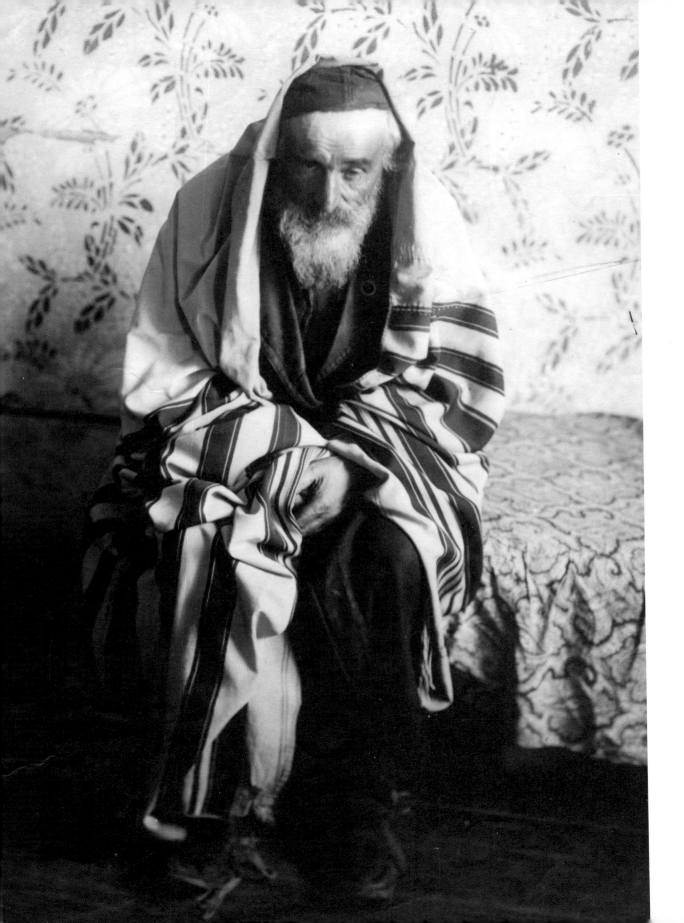

13. Old man counting change.

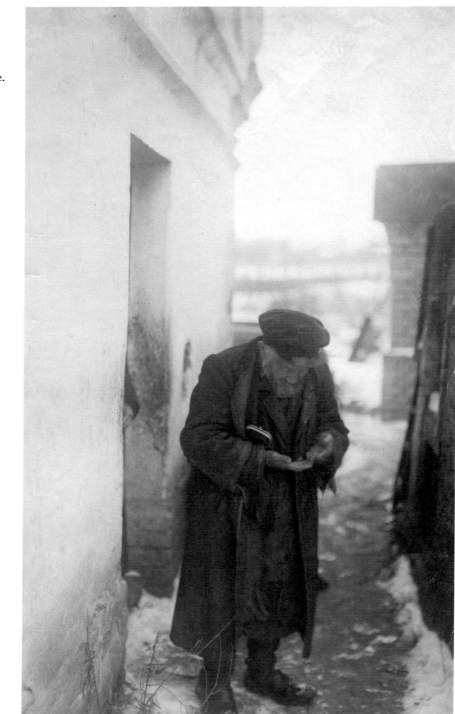

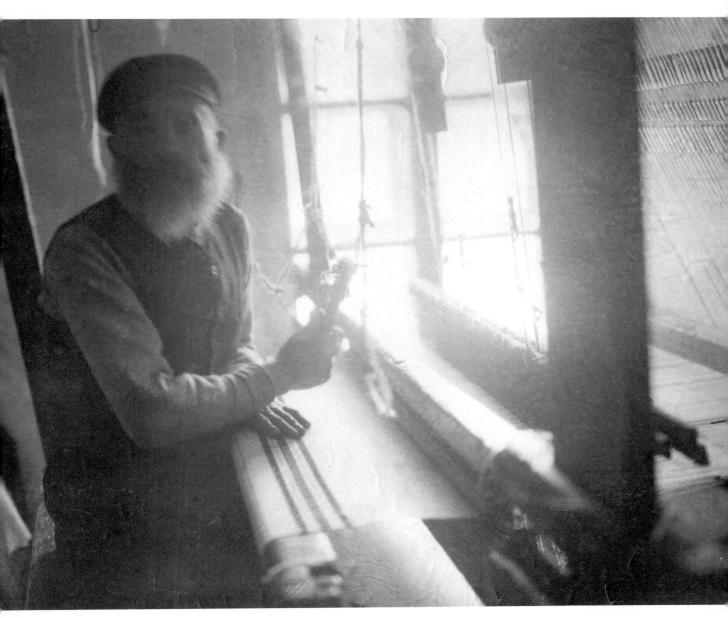

14. Old man weaving a *talis*.

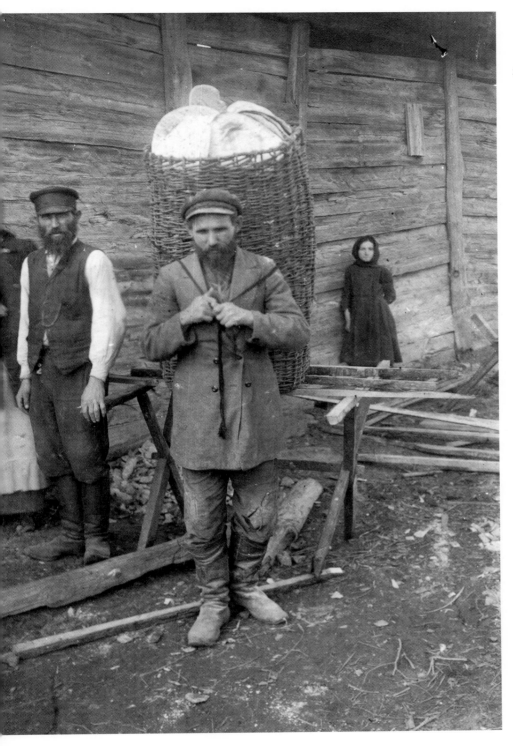

17. Matzo carrier.

(opposite)
15 & 16. Baking matzo.

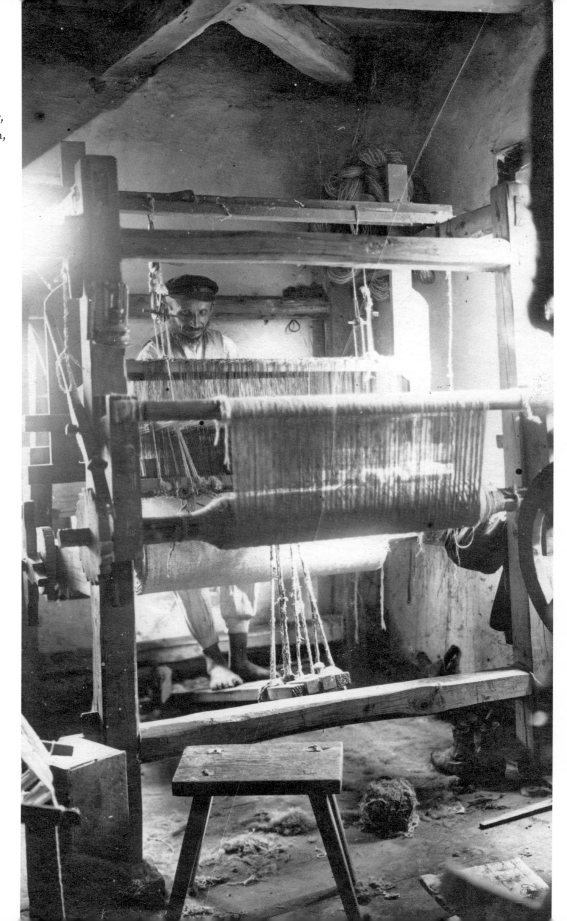

18. Weaver,
Mezhirech,
1912.

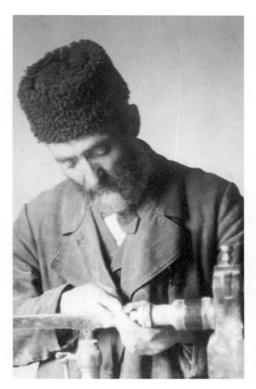

19. Lathe operator
(test print from negative).

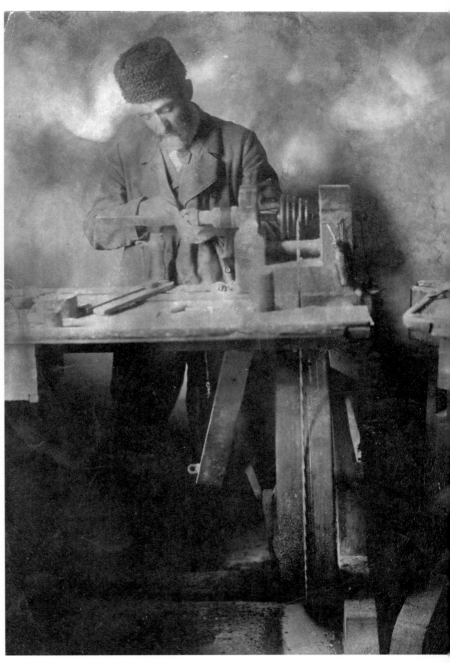

20. Lathe operator
(printed using oil method).

21a. "Shoemaker who looks like Nicholas II."

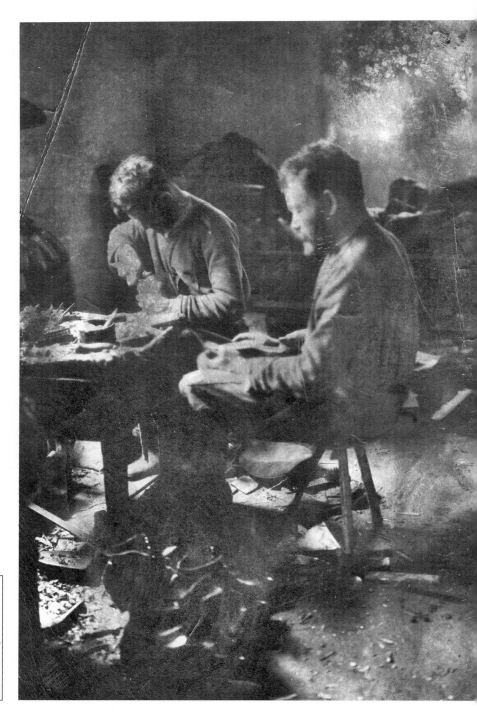

21b. An-sky's note about the shoemaker in Russian.

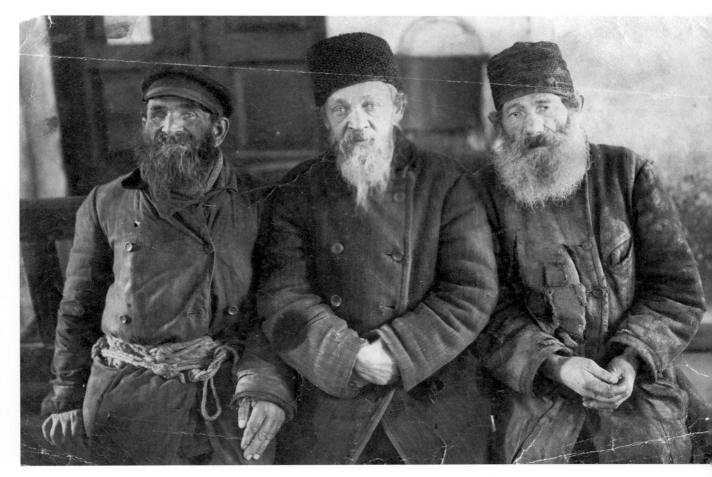

22. Jewish coachmen, Korets, 1912.

23. Woodcut by Solomon
Iudovin, "Portrait of an Old
Man," 1922. I. P. Furman,
Vitsebsk u graviurakh S. Iudovina
(Vitebsk, 1926).

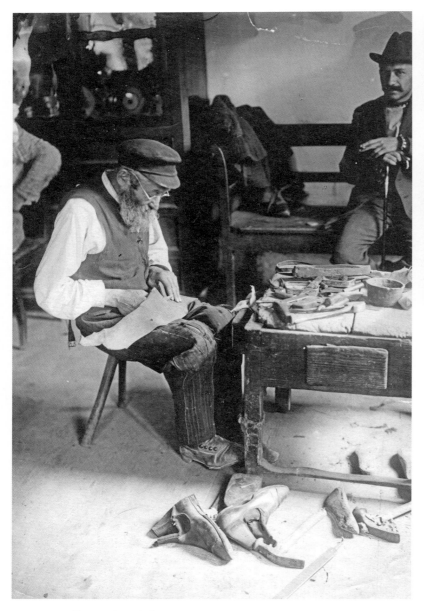

24. Shoemaker, Polonnoe, 1912.

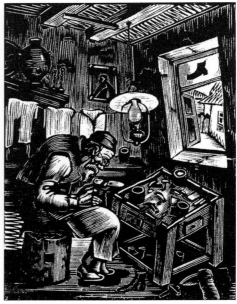

25. Woodcut by Solomon Iudovin, from the series "The Past." I. Ioffe, *Graviury na dereve* (Leningrad, 1928).

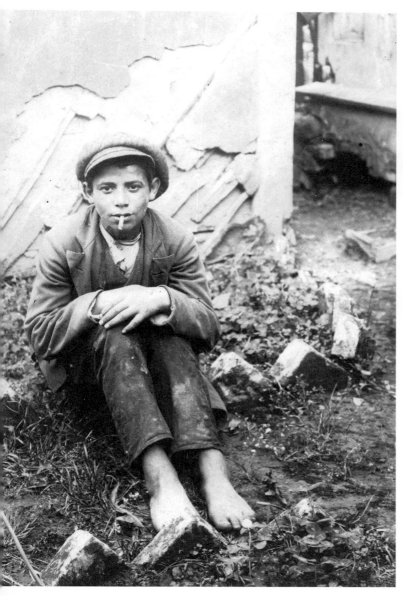

26. Boy with a cigarette.

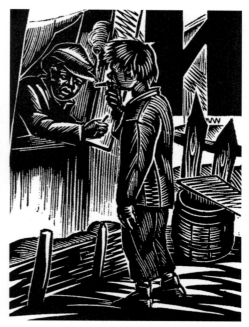

27. Illustration by Solomon Iudovin
for Leontii Rakovskii's novel, *Bludnyi
bes* (Leningrad, 1931).

chapter 2

"Brothers & Sisters in Toil & Struggle"

Jewish Workers and Artisans on the Eve of Revolution

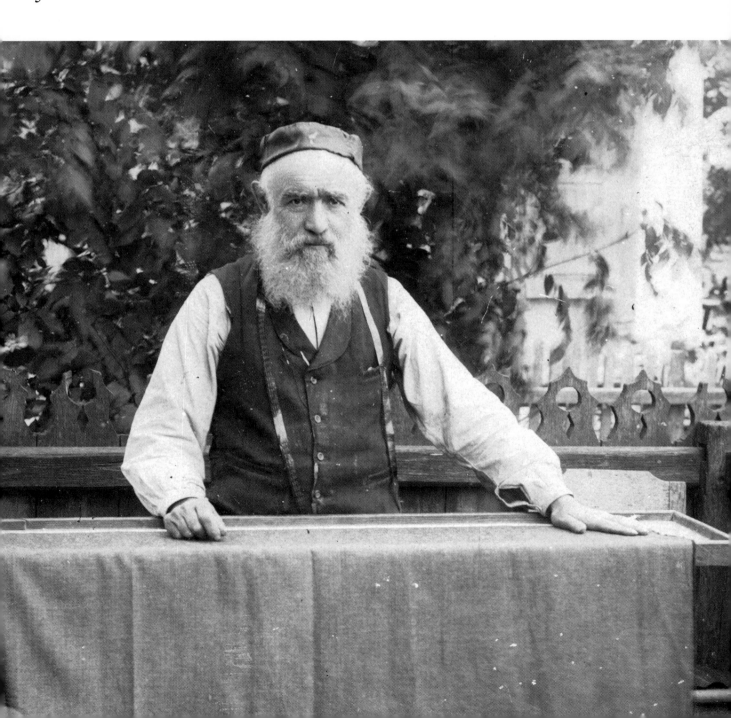

Top Secret

To the head of the Kiev Gendarmes provincial administration:

On August 5, the head of the St. Petersburg Department of Police informed me by telegram that a certain Rappoport needs to be placed under surveillance. Also known by the nickname An-sky, Rappoport is a townsman from Chashniki (Vitebsk province) and a member of the Socialist Revolutionary Party, who has recently left St. Petersburg for Berdichev.

Intelligence information has revealed that Rappoport owns photography studios in Volynia province, in the town Starokonstantinov and the shtetl Polonnoe, where Solomon Iudovin serves as his apprentice. Secret agents have observed that Rappoport is a member of the central committee of the Socialist Revolutionary Party who travels from town to town on organizational business. Recently, he visited St. Petersburg and then left for Vil'na, where a meeting of Socialist Revolutionaries was taking place.

Rappoport maintains his permanent place of residence in Vil'na, but since local administrators know him there for his political activities, he decided to relocate to Polonnoe, where no one knows him, and open an art studio, which he hopes will help mask his political activities. According to the same intelligence report, Iudovin also belongs to the same Socialist Revolutionary organization.

Iudovin makes special trips to Berdichev in order to acquire glass for artwork.[1]

This is how the intelligence report provided by the Department of Police described An-sky's first ethnographic expedition during the summer of 1912. From the gendarmes' point of view, the man who traveled around

Volynia that summer was not a well-known writer and ethnographer, but a prominent *narodnik* (populist) whose warrant for arrest was first issued in 1894, the former personal secretary to Petr Lavrov, and one of the founding members of the Central Committee of the Socialist Revolutionary Party.

Yet no matter how absurd the intelligence observation may have appeared, there was some justification for the suspicion. An-sky's "apprentice," Solomon Iudovin, needed the glass to take photographs of Jewish artisans and workers, under the supervision of his alleged master, not only for purely ethnographic reasons, but for political purposes as well. The photographs were not simply a collection of ethnographic types nor were they a catalogue of traditional Jewish occupations or work instruments. Rather, the photographs represent a deliberate attempt to create a portrait of Jewish workers from a political point of view.

Scholars are correct to label An-sky as the "father of Jewish ethnography and folklore." An-sky's intellectual interests in these two fields were quite broad, but the working class always remained an important theme of his scholarly and creative endeavors. An-sky had a longstanding interest in the everyday life and popular culture of workers. In his youth, An-sky spent quite a bit of time among coalminers in the Donets region of the Russian Empire, and wrote a series of essays on working-class life and culture. An-sky's first publication devoted to workers' folksongs appeared in 1887 ("Miners' Songs").[2] He then went on to write a number of important essays on the worker question and translated the "Internationale" into Yiddish.

An-sky was quite proud that his poem *Di shvue* (The Oath) — which has often been referred to as the "Jewish Marseillaise" — became the anthem of the Jewish Labor Bund:

Brothers and sisters in toil and struggle
All who are dispersed far and wide
Come together, the banner is ready
It waves in anger, red with blood!
Swear an oath of life and death.

Heaven and earth will hear us
The bright stars will bear witness.
An oath of blood, an oath of tears,
We swear, we swear, we swear![3]

In 1906, An-sky wrote a novella, *V novom rusle* (The New Way), which describes the activities of the Bund, focusing on the 1905 Revolution on the "Jewish street" and the revolutionary underground movement.[4] An-sky was not a Social Democrat. It was not the Marxist program of the Bund that attracted him, but the possibility that political work would enable large numbers of Jewish workers to regain their human dignity.

An-sky criticized the Bund for attempting to impose revolution on the masses, the so-called people, according to the rigid rules of Marxist ideology and party discipline. As a devout Socialist Revolutionary, An-sky did not believe that revolution would come from the coordinated actions of party ideologues, but rather as the result of a spontaneous messianic impulse towards freedom. Revolution would come for the sake of a Russia which, according to An-sky, was "both Russian and Jewish" — a unity that he was not able to divide in his own mind, because it had emerged from the very depths of the people.[5] This is how An-sky describes a demonstration in his hometown Vitebsk in "The New Way":

> For about a minute a seemingly disorderly movement could be discerned in the crowd, but then, without any leadership, ranks began to form spontaneously. The most energetic, courageous, and passionate elbowed their way forward, to the vanguard.
>
> "We place our right hand on our heart. And take a solemn oath!" Suddenly the anthem of the Bund, "Di shvue," could be heard.
>
> And as if in response to the anthem of the Bund someone started to sing: "You have fallen victim in the fatal struggle."
>
> Amidst the double choral singing, slowly and solemnly a procession started to move along the wide street. And with each step forward the crowd began to grow, attracting passersby with its mesmerizing force. Men and women, adults and youths, intellectuals and workers, Jews and Russians left their houses, ran through the streets and alleys hurriedly and cheerfully joining the demonstration.[6]

This idealized image of Russian and Jewish unity emerged from An-sky's fundamental ideas about what constituted national life. The populist belief in a people's spontaneous, healthy foundation — and the necessity to uncover this foundation — constituted the very basis of An-sky's work as an ethnographer. An-sky thought that the Jewish people were in need of salvation, and that the Jewish people would find the means for salvation within themselves, in the "healthiest" part of the people, namely, among

Jewish workers. The task of salvation thus became the starting point of the ethnographic expedition. In 1905, shortly before returning to Russia from abroad, he wrote to his close friend, the revolutionary and journalist Khaim Zhitlovsky:

> For the Jews to have a healthy life what is needed is not territory, but a healthy national-state organism. There is no peasantry among them, nor a proper working class; they lack the institutions of national life. Until recently the Talmud and messianism have bound Jews together around a single national idea, which prevented disintegration. However, one can't substitute one steel corset for another, that is to say, Palestinian messianism or territorialism. We must cultivate the national idea in the people. And only then, as with any healthy organism, the desire for their own land and national life will come from the people itself.[7]

From An-sky's point of view, the ethnographic studies and collections of folklore were to serve the goal of creating a national life in the entirety of the Jewish people. Remaining true to his populist past, An-sky intended to "cultivate the national idea" during the ethnographic expeditions by drawing on organic forms of popular socialism — the customs, traditions, social practices, and folklore of the Jewish people. Just as Russian Populists saw elements of socialism in the Russian agricultural community, An-sky saw elements of the socialist movement of his time in the traditional Jewish artisans' guilds. For example, analyzing the *pinkasim* (records of Jewish communal organizations) of the tailors' guild in Lutsk, Abram Rechtman, a member of the expedition staff, wrote: "The workday was regulated as we do nowadays. According to the statutes of the *pinkas*, no one, even the boss, was allowed to work late."[8] Apparently, the traditional laws of the medieval guilds, created to fight against competition, were interpreted as a prototype of the eight-hour workday.

One of the most important goals of An-sky's expedition was to investigate the social and political conditions of Jewish artisans and workers. In his questionnaire "A Program of Research into Local History," written in 1913, alongside questions on cultural artifacts and Hasidic *tsadikim* (spiritual leaders), An-sky asked the following questions:

159 What Jewish worker guilds does your community have? How long have they been established?

160 How many individuals belong to the guilds, and what is their income?

161 What political organizations formed in 1905?

162 Did you have strikes? How many workers went on strike?

163 How many artisans do you have in your community? What are their specializations? How many artisans work in each distinct specialization?

164 Do you have any factories? What do they manufacture?

165 Do Jewish workers work in the factories? If so, how many?

166 Have you witnessed any political demonstrations?[9]

By asking questions about traditional artisans' guilds together with questions about political parties, An-sky was clearly attempting to discover progressive work practices in the heart of Jewish tradition.

An-sky analyzed folk songs (a subject of great interest to ethnomusicologists at the time) as a barometer of social change in the community. In his programmatic essay "Jewish Folk Art" (1908), An-sky wrote:

> If we turn to the folk art of recent times, we will find the same contempt towards authority and abuse of the powerful and the rich. The only thing that sharply distinguishes the new art from that which was created in the past is that this new art pulsates vividly and strongly with an awareness of civic life; [and from this new art] there emerges a consciousness of human dignity and a readiness to defend it with weapons. In place of the former crestfallen and powerless prayer and lamentation, the modern folk song boldly trains its listeners to action:
>
> > If someone insults you, my son
> > With spittle
> > Then respond with self-dignity:
> > Spit back with bullets.[10]

An-sky also quotes this stanza in his story "The New Way." Everything that he created and experienced — as a writer, journalist, revolutionary, and ethnographer — coexisted in a unified whole.

An-sky's interest in the working class, and his belief that the working class represented the healthiest part of the Jewish people, had direct consequences for the ethnographic expeditions. Solomon Iudovin produced dozens of photographs of workers and laborers. Iudovin not only took photographs of artisans engaged in traditional Jewish trades, but also of proletarians working in modern factories, who did not resemble standard images of Jews in the Pale of Settlement. In the photographs of artisans, Iudovin produced some of his most vibrant and artistically successful por-

traits. These include, for example, the portraits of a lathe operator (image 20) and a *talis* weaver (images 14 and 18). Iudovin's photographs of workers, including the daring revolutionary metalworker (image 32) and a God-fearing, elderly carpenter (image 34), represent what might be called "literary portraits" or photographic narratives. Many of these photographs could have served as illustrations to An-sky's "The New Way," written before the expeditions. The novella documents its author's idealized projections about the socialist potential of the Jewish people; Iudovin's photographs of workers embody similar political ideals.

These photographs, however, did not accurately reflect the full reality of Jewish economic life. More than half of the Jewish population was engaged either in small-scale trading or the distribution of alcoholic beverages. Nevertheless, photographs of traders (image 55), tavern-keepers (image 56), and marketplaces (image 57 and 58) are quite rare, especially in relation to the number of photographs of factory workers and artisans.

The photographs of blacksmiths occupy a special place in Iudovin's portraits of workers. In the beginning of the twentieth century, the word "blacksmith" was loaded with significance in Russian revolutionary literature. A blacksmith was a worker par excellence, and the hammer — with its capacity to simultaneously create and destroy — served as the very symbol of revolution. Iudovin's photographs of blacksmiths are some of the most carefully staged of the expedition, showing a deliberate use of the aesthetic language of socialist propaganda (image 28).

An-sky and Iudovin also took special interest in photographs of *artels* (worker cooperatives) and factories. Influenced by Marxist ideology, Jewish socialists paid particular attention to the nearly complete absence of a Jewish industrial working class in the Pale of Settlement. Because Jews in the Pale were more likely to work in various handicraft professions, they were less likely to become conscious revolutionaries, to organize strikes, or to contribute to the development of the revolutionary movement. Although An-sky did not adhere to Marxist ideology, he nevertheless regarded collective labor, like most other communal activities, as an important conduit for the development of worker consciousness. It is for this reason that rope-producing cooperatives (images 43–45), cigarette manufacturers (image 41), and weavers (image 42) attracted his particular attention. No matter how small the match factory in Rovno, for example, it was the subject of detailed photographic investigation (images 51–54).

Although the majority of the photographs of artisans and workers were taken during the first expedition, in 1912 An-sky continued to be fascinated

by this aspect of Jewish life. He considered workers and artisans not only as people worthy of study but also as his ideal audience — his "Brothers and Sisters in Toil and Struggle" — until his death.

Notes

1. V. M. Lukin, "Akademiia, gde budut izuchat' fol'klor," in *Evreiskii muzei*, ed. V. A. Dymshits and V. E. Kel'ner (St. Petersburg: Simpozium, 2004).
2. N. Alekseeva, "G. Uspenskii, russkaia narodnaia pesnia i ee sobirateli," *Uchennye zapiski LGU, Seriia filologicheskikh nauk* 12, no. 122 (1949).
3. Slightly adapted translation from *The Upward Flight: The Musical World of S. An-sky*, 36, addendum to *The Worlds of S. An-sky: A Russian Jewish Intellectual at the Turn of the Century*, ed. Gabriella Safran and Steven Zipperstein (Stanford, Calif.: Stanford University Press, 2006).
4. S. An-sky, "V novom rusle," in *Pervyi evreiskii sbornik* (Moscow, 1907).
5. Lukin, "Akademiia, gde budut izuchat' fol'klor."
6. An-sky, "V novom rusle."
7. Lukin, "Akademiia, gde budut izuchat' fol'klor."
8. Abram Rechtman, *Yidishe etnografye un folklor: Zikhroynes vegn der etnografisher ekspeditsye ongefirt fun Sh. An-ski* (Buenos Aires: YIVO, 1958).
9. S. An-sky, *A ortige historishe program* (St. Petersburg, 1913).
10. S. An-sky, "Evreiskoe narodnoe tvorchestvo," *Perezhitoe* 1 (1908): 276–314.

illustrations

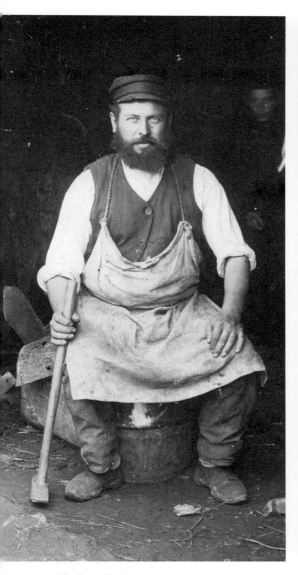

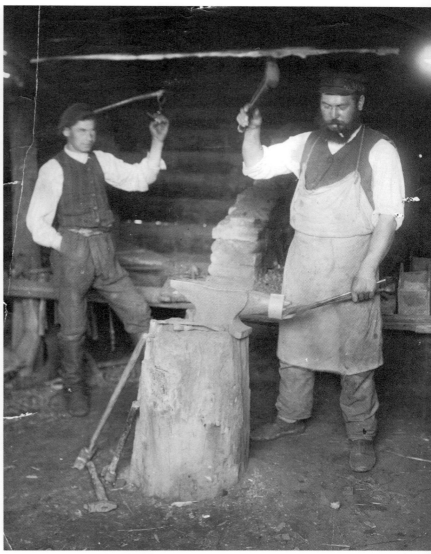

28. Blacksmith, Korets, 1912.

29. Blacksmiths, Korets, 1912.

"Walking past one of the benches she saw a worker — broad-shouldered, with soft features, with gray eyes, and hair in a fringe on his forehead. He was relaxed, cracking nuts, apparently, not thinking about anything, but completely devoting himself to rest. He was strong and well liked by his comrades. Among the workers he was known by the nickname "Bear" for his strength." — *from S. An-sky's "The New Way" (1907)*

30. Hammerer, Slavuta.

(opposite)
31. Blacksmith, Shepetovka, 1912.

32. Metalworker, Slavuta, 1912.

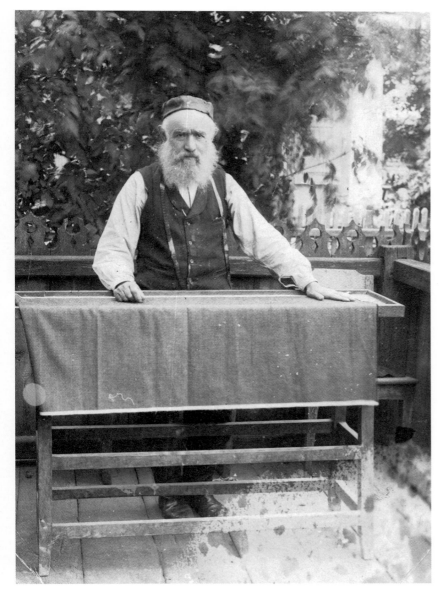

33. Tailor, Polonnoe, 1912.

"Suddenly he heard someone calling him and he turned around and saw a young man, clean-shaven and with a thin, muscular face, strong and nervous. This was a representative of one of the Bundist circles, the metalworker Meyer." — *from S. An-sky's "The New Way" (1907)*

34. Carpenter, Polonnoe, 1912.

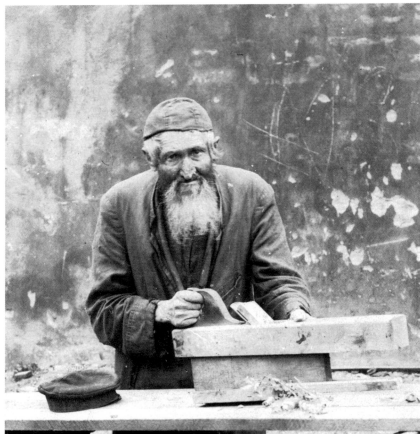

(opposite)
35. Tombstone engraver.

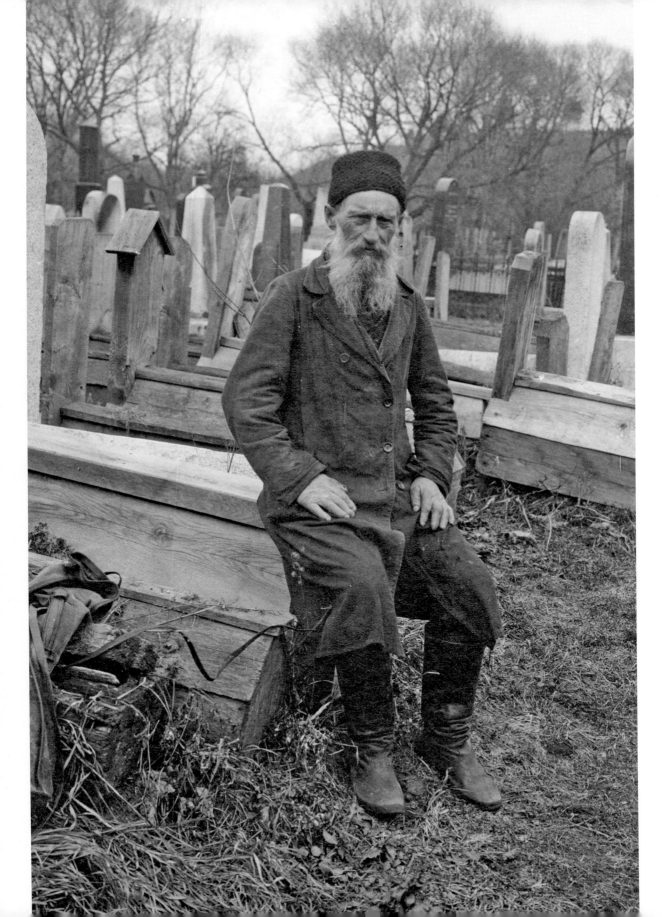

36. Tombstone engraver.

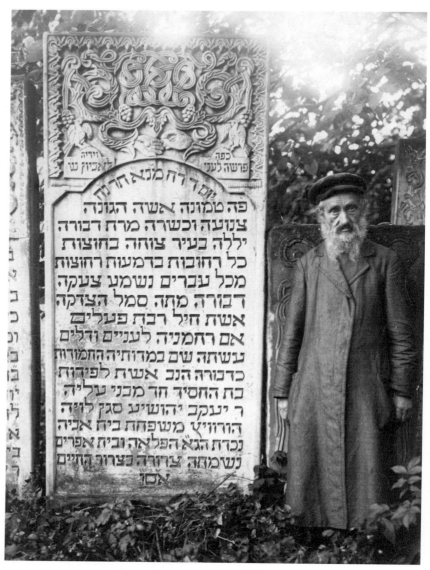

"Esther fixed her gaze on the old man, and in her memory there arose one by one, as if from the grave, the people she used to know then, and the students of old Shepe, the masters of the settlement, who had created its life. . . . And mentally examining this old, previous generation, Esther remembered life at that time in its entirety. It was also timid and frightened, bent and hopeless. It was immersed in anxiety and grief. Loud words were frightening, sharp movements; laughter was considered dissolute; songs were sad and hopeless; people sang in undertones, as if it were a crime." — *from S. An-sky's "The New Way" (1907)*

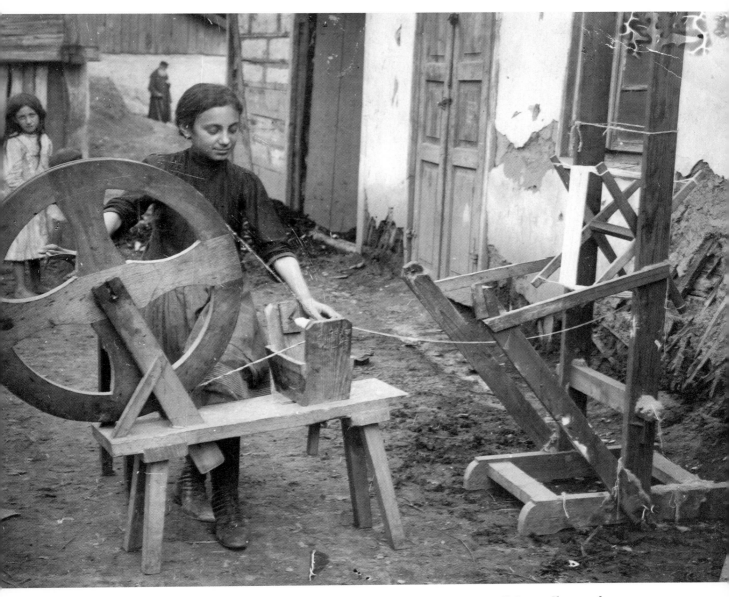

37. Spinner, Shepetovka, 1912.

38. A street shoemaker, Slavuta.

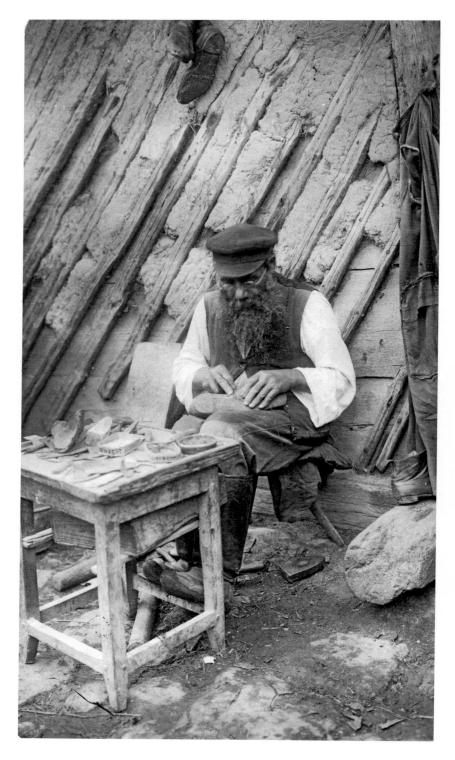

(opposite, top)
39. Tailors, Shepetovka, 1912.

(opposite, bottom)
40. Tailors.

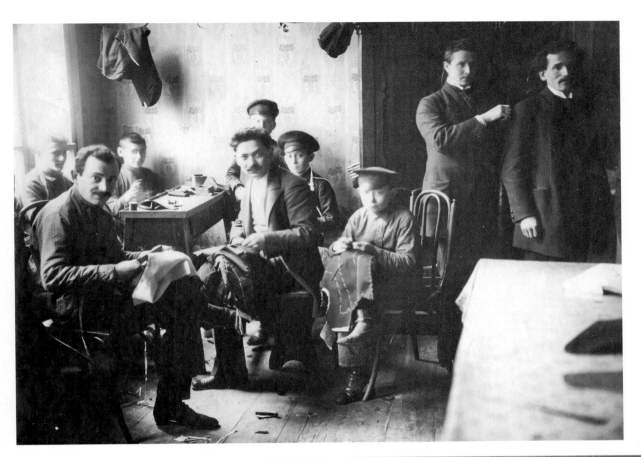

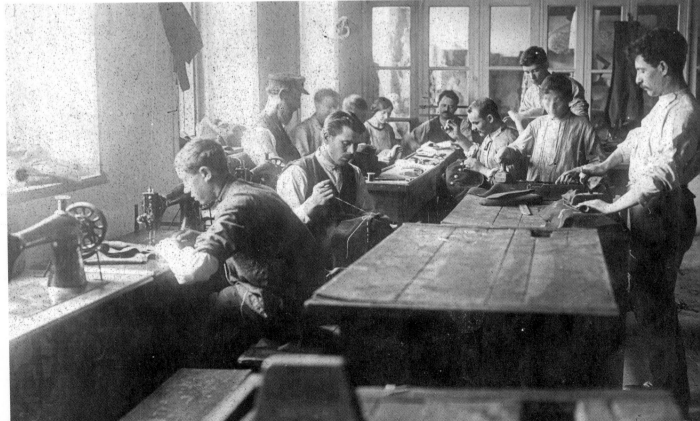

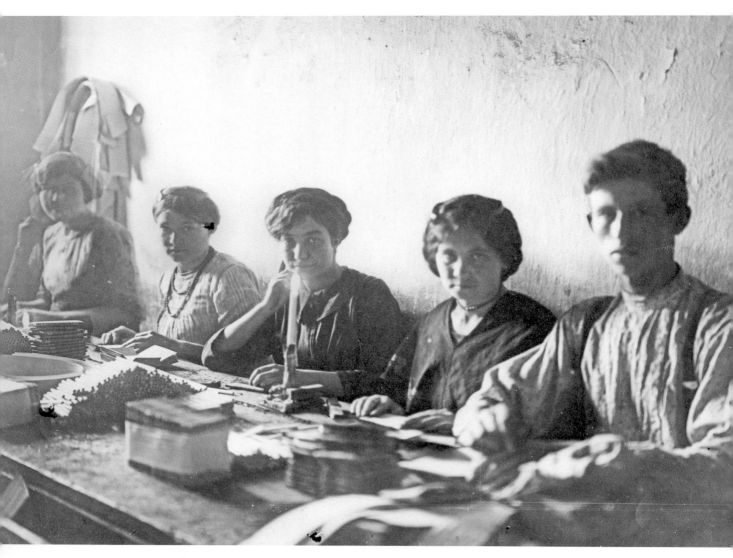

41. At a cigarette factory,
Starokonstantinov

"The women toiled in small workshops that had two, three, or five workers.
The owners of the workshops, for the most part, toiled alongside the workers.
Their wages were incredibly low. The best women workers . . . received
five and a half rubles a month. The assistants received a ruble and a half a
month." — *from S. An-sky's "The New Way" (1907)*

(opposite)
42. Weaving mill.

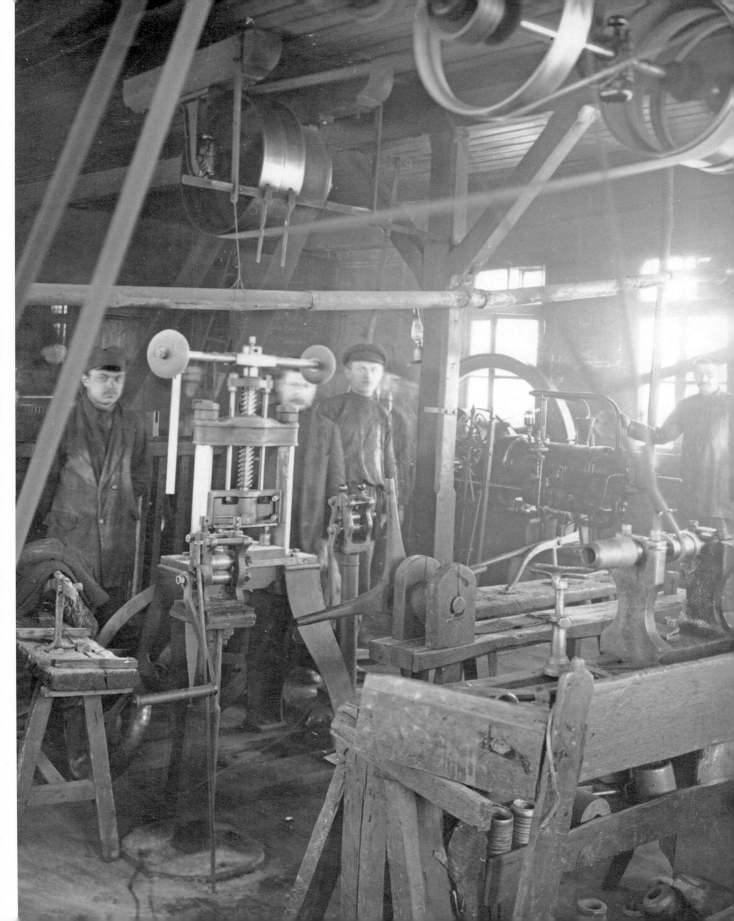

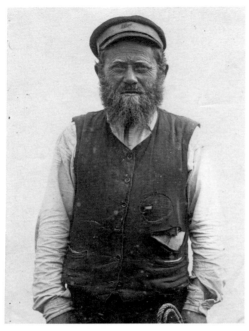

43. Rope maker, Mezhirech, 1912.

44. Rope makers, Mezhirech, 1912.

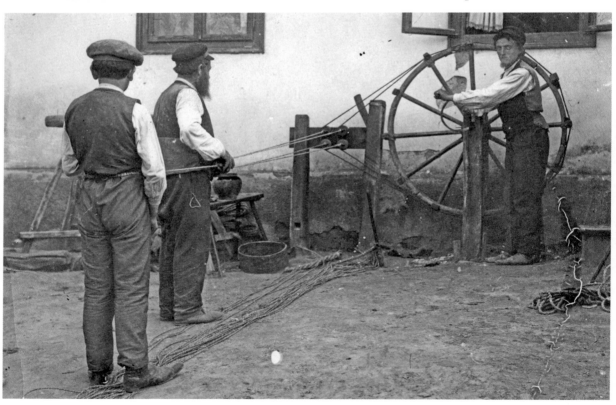

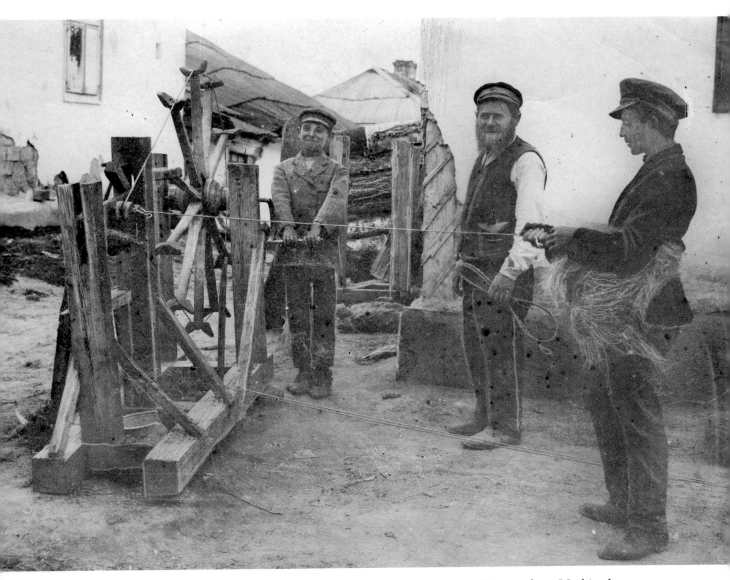

45. Rope makers, Mezhirech, 1912.

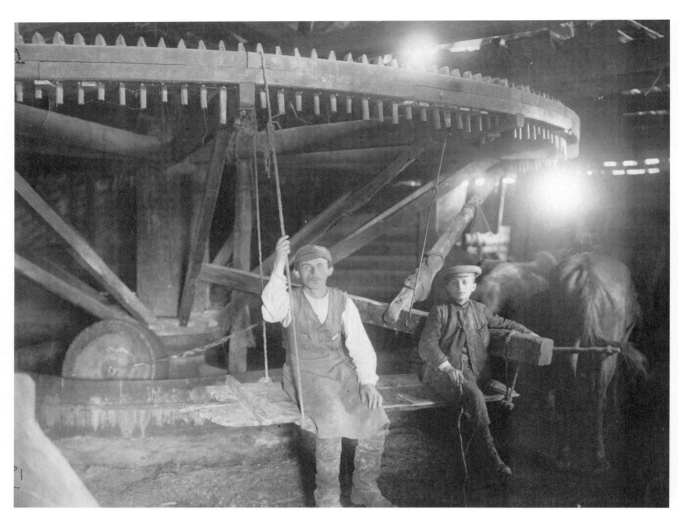

46. Hay processing mill,
Olyka, 1912.

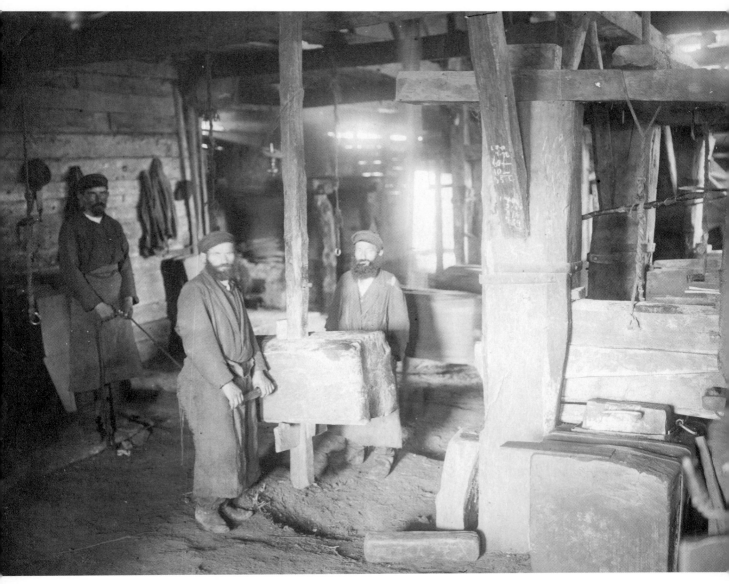

47. Hay processing mill,
Olyka, 1912.

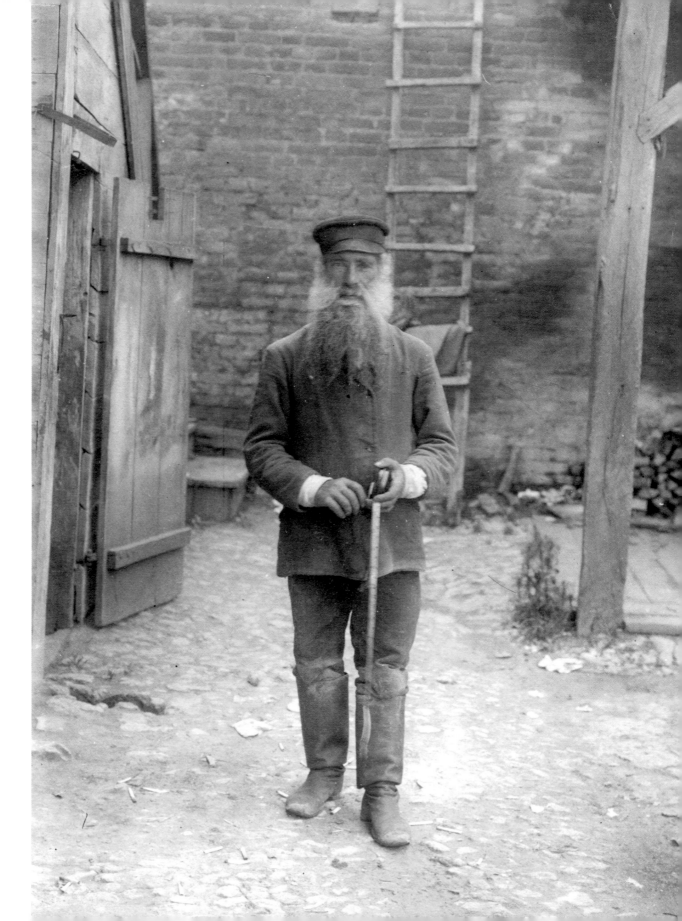

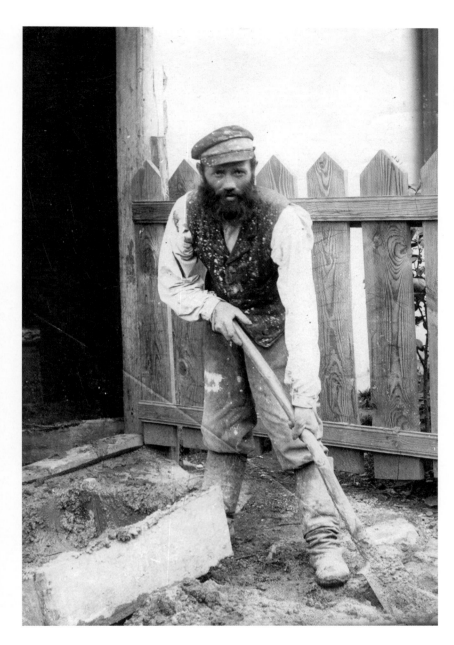

49. Unskilled laborer,
Polonnoe, 1912.

(opposite)
48. Bricklayer, Dubno.

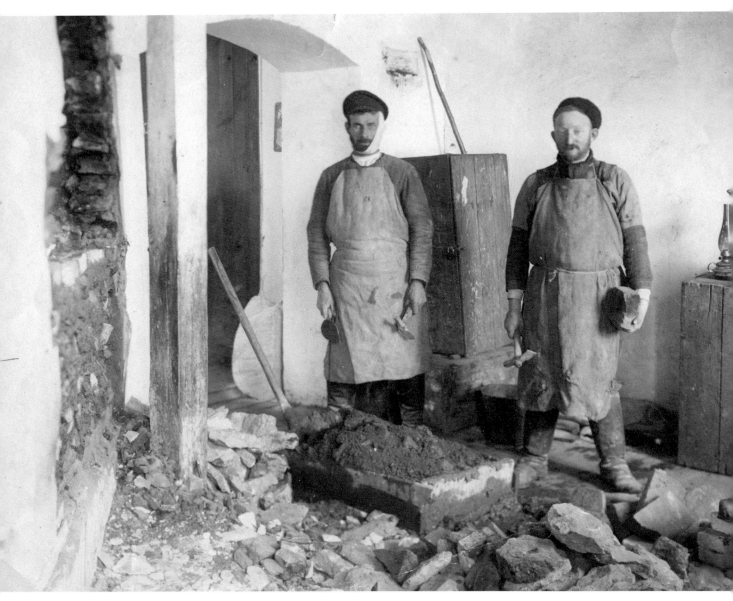

50. Bricklayers.

(opposite)
51 (top) & 52 (bottom).
At the match factory,
Rovno, 1912.

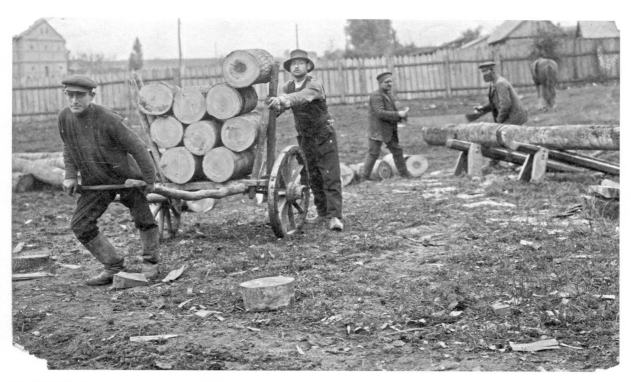

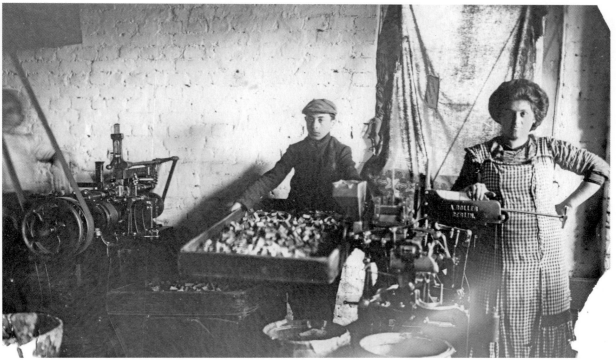

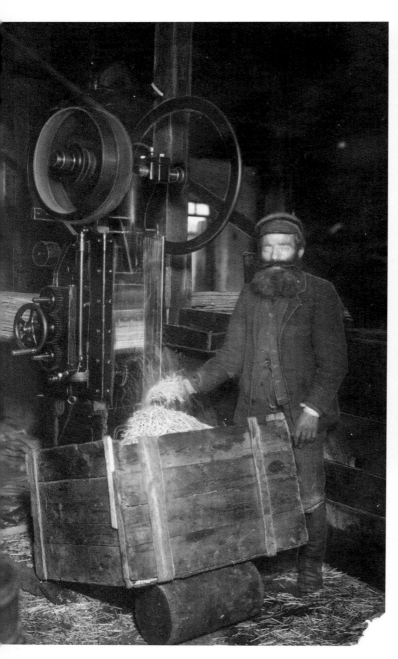

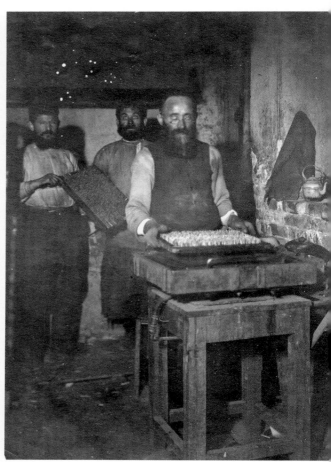

53 (left) and 54 (right).
At the match factory, Rovno, 1912.

(opposite)
55. Tobacco peddler,
Starokonstantinov, 1912.

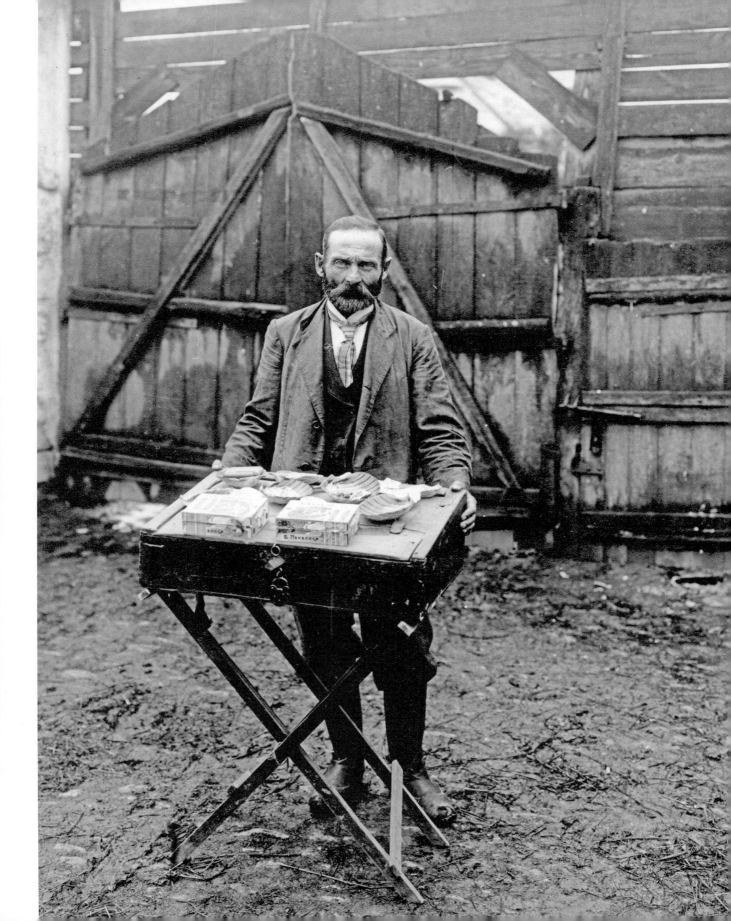

56. Tavern-keeper, Dubno, 1912.

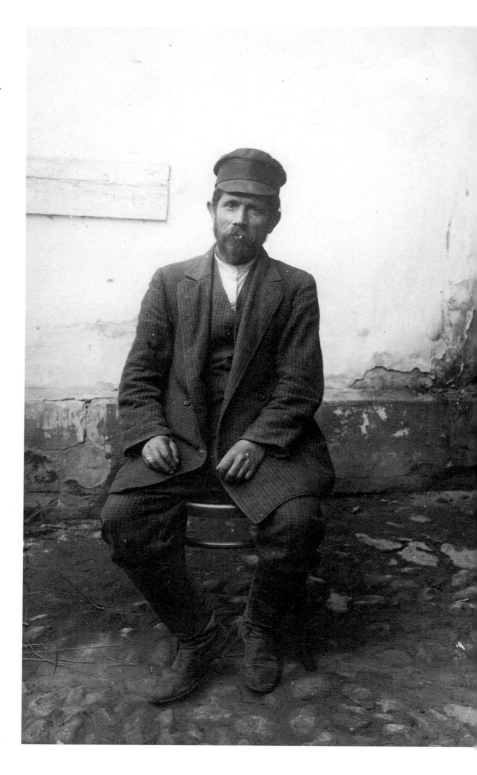

(*opposite*)
57. Shopkeepers.
58. Shopkeepers.

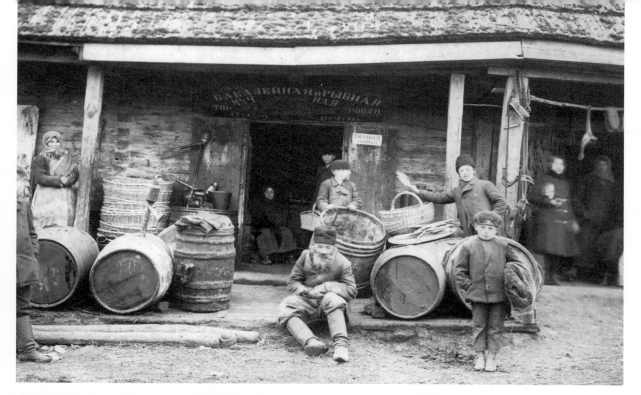

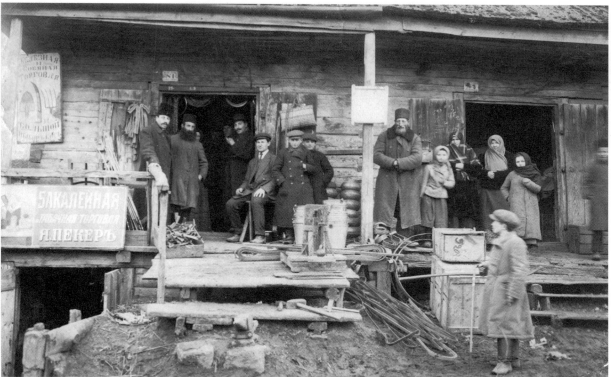

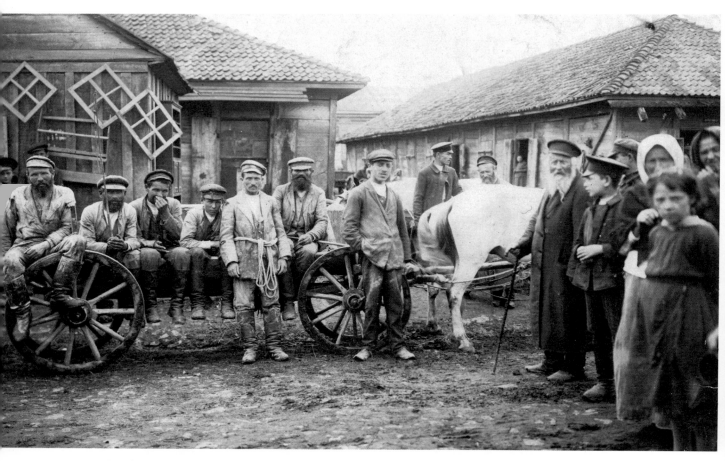

59. Coachmen, Korets, 1912.

chapter 3

"The Jewish Nursery"
Educating the Next Generation

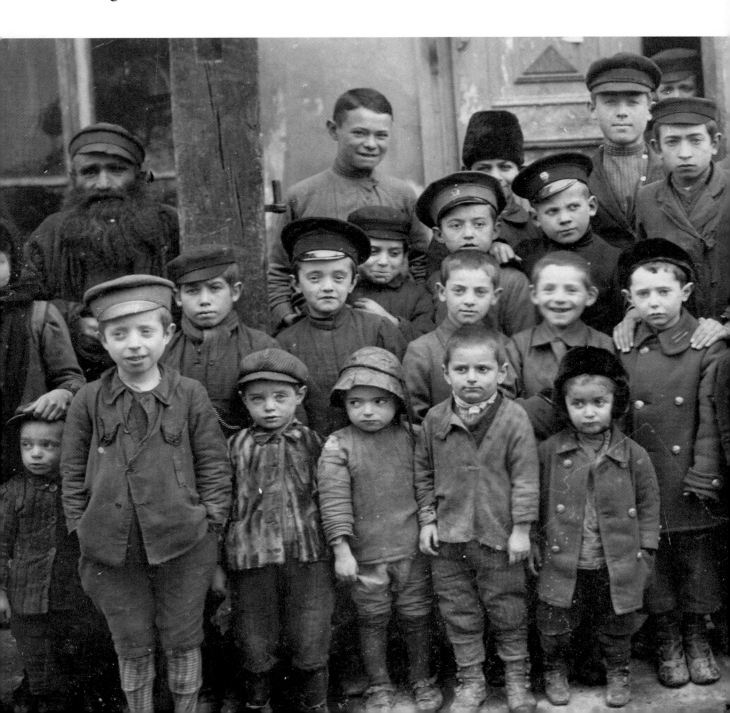

Once An-sky was visiting his "good friend, a Zionist and ardent nationalist." After being introduced to An-sky, his friend's daughter "sang 'Chizhik' ['Little Siskin,' a popular song], and recited very sweetly Pushkin's 'Tale About the Fisherman and the Fish,' and also, the Russian fairy tale 'Sister Alenushka and Brother Ivanushka' with great sensitivity. Her pure Russian accent seemed to suggest that she was not the daughter of a Petersburg Zionist, but rather, the daughter of a peasant from Kaluga." At the turn of the twentieth century, this and similar accomplishments were a source of pride for the Jewish intelligentsia, for whom the Russian language and Russian literature embodied the highest ideals of enlightenment. An-sky writes, "I sincerely praised the child, but casually asked, 'She doesn't know anything in Yiddish?' The father was abashed and quickly answered, 'No, not yet.' "[1]

An-sky and his friend were typical members of a generation of Jewish intellectuals who left the cities and towns of the Pale of Settlement, leaving behind the rigid framework of Jewish tradition. They turned instead to the subject of the future of the Jews, which became the focus of intense intellectual inquiry and discussion. It was impossible to involve children in these "grown-up" activities, and so their care was left to Russian nannies, who gave the children of the Jewish intelligentsia "their language, their psyche, their worldview." "Yes, worldview!" An-sky repeats emphatically, looking for a word that would sound convincing to people of his circle — "the worldview that is expressed in folktales and songs."[2] This situation threatened to undermine the fragile cultural tradition that the Jewish intelligentsia sought to pass on to their children. This outcome would, in An-sky's view, be a catastrophe — not a personal or group catastrophe, but a national catastrophe. He explains: "Right here in front of me, in the midst of the most heated and sincere debates about nationalism, in an environment permeated with Jewish nationality (even the food is kosher) the systematic immersion of the

Jewish child in an alien culture is taking place, the most effective assimilation is occurring."[3]

What, however, could Jewish intellectuals pass on to the next generation — the religion that they had just renounced? Or, perhaps, a new Jewish culture which they had just begun to create? They had successfully negotiated a path from the shtetl to the big city; they had made a transition from what they saw as a dying Jewish community to the nascent Jewish nation. Their life experience consisted of a break with the past. But how could they transmit to their children their own sense of this break?

Of course, sending the children to the shtetl to be brought up was out of the question. The shtetl was dying, but its religiosity was still "contagious." Forcing the children to repeat their parents' fate in full was impossible. It was possible, however, to bring the shtetl to the children, to create little models of the shtetl in the big city, "purified" of religion and reworked according to the most recent lines of scholarly inquiry — what was termed a "Jewish nursery." An-sky's ideas about how to create this model of a refined shtetl were directly informed by ethnography.

The ethnographic expeditions permitted An-sky to resolve two basic problems. In the sphere of art, both concrete images and spiritual inspiration could be sought among the "people." In the sphere of scholarship, material could be collected for a "Jewish nursery," which would at the same time become an "academy, where folklore could be studied," and which could be developed into a network of Jewish museums. Both tasks were united into one political purpose: the education of the people by the establishment of various ties between the intelligentsia and the masses, and thereby, the creation of the Jewish nation.

In the shtetl, Jewish midwives delivered Jewish children (image 60) and Jewish mothers raised them. Jewish grandmothers told them stories, and a bearded *rebbe* taught them to read. They grew up among other Jewish children — and most importantly, according to An-sky — they grew up in the Jewish religion, which for thousands of years had served as a "steel corset" (his expression), constraining their movement, but keeping them from disintegration.[4] The Jewish past — the entire world of Jewish tradition — had to be scientifically reworked and refined in order to become the inner fulcrum for the renewed Jewish nation.[5]

Jewish education, according to An-sky, had to begin from the cradle. First of all, the Jewish intelligentsia needed other nannies for their children, who would tell them Jewish stories, not Russian ones. "Let the demand appear," wrote An-sky, "and it will turn out that there are good nannies and govern-

esses from among economically disadvantaged Jews."[6] Religion would still be permitted at the cradle: "Special food is arranged for Russian Orthodox nannies who observe the fast days. Why not make it possible for the Jewish nanny to prepare kosher food for herself?"[7] In photographing female Jewish ethnographic types in the shtetl (images 2–7, 66), it is possible that An-sky was looking for precisely the "old nanny" who would correspond to Arina Rodionovna, who would serve as the governess for a future Jewish Pushkin, and would not only introduce him to the language and folklore of the Jews, but would also convey to him — in accordance with the fashionable racial theories of the beginning of the twentieth century — the Jewish national "psyche."

It was more difficult to adapt the next phase of traditional education, connected with study in the *kheyder*, to the new conditions. "When we speak of Orthodox Jewish education," wrote An-sky, "usually what comes to the foreground is the old *kheyder* with its 'ignorant' *melamed* [teacher] and his archaic method of instruction and the unhygienic environment."[8] The Hebrew word *kheyder* means "room" or "inner chamber." In the Ashkenazi tradition, *kheyder* was the name for a school that could be located in any room.[9] The *melamed* sat at a table with his students (images 67 and 68). Before each student was a book — not a textbook written especially for children, but one of the sacred books used by adults in their daily lives, including a *siddur* (prayerbook), the *Khumesh* (Five Books of Moses with commentaries and possibly a translation into Yiddish), and editions of excerpts from the Talmud. The *siddur* served as an elementary primer; many editions included a page with letters and syllables in large print. The "holy language," in which these texts were written, was studied by reading aloud after the *melamed*, who himself did not always understand the texts well. The *melamed* beat negligent students. Children who did not comprehend grammar often memorized many pages of books in a language they did not know.

Kheyder could be expensive, very cheap, or free. The latter had a special name: Talmud-Torah. The community supported them, helping indigent parents fulfill the commandment: "And ye shall teach them [the words of Torah] to your children" (Deut. 11:9). Practically all boys in a Jewish community studied in *kheyder* (and sometimes girls as well) beginning from the ages of three to five and continuing until the age of thirteen.

Attempts to reform the system of *kheyder* education continued through the nineteenth century, but were not successful. These included the introduction of the study of Hebrew grammar, modified textbooks, secular sub-

jects, educational standards for the *melamed*, and standards of hygiene for the buildings where children spent most of their day. The utter simplicity of the system — all that was necessary was an agreement between parents and the *melamed*, and any male could be a *melamed* — made it easy for this traditional institution to escape most forms of control. In contrast to the private *kheyder*, the communal Talmud-Torah was open to new influences. The photographs show spacious classrooms with desks and blackboards, intelligent teachers (images 75 and 76), and — during recess — organized games in the fresh air (images 77 and 78).

At the same time that a majority of Jewish enlighteners tried to combine traditional religious and modern secular education, An-sky showed little interest in projects to reform the "old *kheyder*" and even spoke in its defense.[10] The children of the Jewish intelligentsia studied in Russian gymnasia and schools; they did not need even a reformed *kheyder*, but a rational and national kernel of Jewish culture, which An-sky wanted to extract from the traditional system of education and upbringing.

Unlike his contemporaries, An-sky succeeded in finding a positive feature in the chief defect of the old pedagogical system, which was of key importance for his project of national construction. Children in *kheyder* did not study by means of exercises designed especially for them, but were occupied instead with activities that were immediately connected with the most important part of adult life. Traditional religious life included not only public prayer and daily Torah study (images 69–74), but also many rituals that permitted or even required the participation of children together with adults.[11] This was what was lacking in the upbringing of children of the Jewish intelligentsia. All that had to be done was to replace the religious content of public life with national content, keeping the principle intact.

It was precisely this goal — the transformation of religion into a national idea — that Jewish museums were to serve. An-sky's plan, preserved in an unpublished manuscript, was to create museums in every town. The first category of museums would be dedicated to ethnography, presenting Jewish "religion, beliefs, superstitions" and daily life. These local museums would become centers for the study of religious ritual in new, secular schools. "You can be an atheist," wrote An-sky, "but you have to know the ritual." Regional art museums would comprise the next level of institutional development. They would represent the history of Jewish art as the struggle of folk artisans against "religious prohibitions and prosecutions." The third and highest level would be occupied by a "National Historical Museum," to be built in Palestine. This would be "a museum of historic relics and monu-

ments" which would narrate the "great inquisitions and trials" of the Jews, but would also describe their "historic triumphs" and "great people."[12]

In this way the "steel corset" of religion, dismantled and reassembled into a system of Jewish museums, would be transformed into a national idea. This idea would become the inner pivot of a new Jewish life, with emphasis placed on "inner" — only a secure, interior foundation could allow for external flexibility and receptivity, because An-sky associated any exterior political or governmental control with the rigidity of the old tradition.[13] The museums would not belong to any political party and would not be subordinated to any ideology. They would become the common property of the entire nation, the shared product of a people's organic life and self-reflexive scholarly study, the meeting place of the intelligentsia and the masses.

Few of An-sky's contemporaries believed in the "educational significance" of such museums, or in the capacity of folklore to "exert an influence on the young."[14] For An-sky, however, the essence of his project was not in the immediate "influence of folklore," but rather in the common, and most importantly, spontaneous activity of the whole nation. An-sky searched everywhere for examples of this interaction. In an article that defended education which took place outside the French school system — education that was created, as he emphasized, "exclusively through private initiative" — An-sky wrote: "The main purpose of people's universities is the rapprochement of the intelligentsia with the people for the goal of higher development."[15] A distinct but nonetheless similar rapprochement between adults and children — and between the intelligentsia and the workers who together were struggling for revolution — was the main theme of his story, "The New Way." The revolution, however, even if it were to take place on the "Jewish street," was an international cause. The Jewish museums were another matter.

In An-sky's view, a transformed and aestheticized religion would unify the nation in exactly the same way as its original, "uncivilized" version. In all likelihood he imagined that this unity would benefit the Jewish people in the same way that the French cultural movement, which he greatly admired, had benefited the people of France. An-sky described "evening and Sunday courses for adults and adolescents, lectures, and popular readings," which would introduce a "definite intellectual layer into the monotony of provincial life," creating a "connection between the intelligentsia and the people, between school and the general population."[16] Or perhaps he believed in religion's magical unifying force, and attributed that force to the ritual objects that would become concentrated in museums (images 151 and 152).

In any case, it was precisely an aestheticized religion — preserved in glass cases — that would guarantee a future national unity. An-sky's vision of a transformed Judaism would serve, in its own way, as an amulet that would preserve the Jewish nation from disintegration.

An-sky frequently encountered children during the expeditions and was one of the first ethnographers to collect children's folklore. Apparently, however, the special attention that children received from the expedition was not enough for them. They followed An-sky and his staff everywhere. The photographs meant to record images of the Jewish heritage also captured curious children mischievously entering the frame (images 83 and 84). These children could not yet comprehend the national significance of the expedition's activities, nor could they know that their participation, alas, had not yet been taken into account. Without waiting for an invitation, however, they found a place for themselves in the new games these unfamiliar adults were playing.

An-sky thought of his own life in terms of the idea of the nation: "I have no wife, children, house, or even an apartment, no property, not even fixed habits. . . . The only thing that connects me with these dimensions [of daily life] closely and intensively is the nation."[17] Like the majority of the Jewish intelligentsia of his time, his personal history included a shtetl childhood, a break with religion, and a flight to a broader and more universal arena. The traditional practices of daily life were replaced by great ideologies, both secular and religious; the lost world of the shtetl became the point of departure for Jewish modernity. An-sky tried, by means of this fate, to give meaning to Jewish national history. He succeeded in part. Like so many brilliant early twentieth century projects, his dream of a spontaneous and elevated unity — of a Jewish nation sustained by Jewish museums — did not withstand the collision with real life.

Today in Russia we are once again experiencing a break with our past. We are building a new "Jewish nursery." And no matter where our movement is directed — back to religion, or forward to a new nation — we will inevitably encounter the shadow of Semen Akimovich An-sky, the literary double of Shloyme-Zanvl Rappoport, who escaped a remote shtetl and entered the world of great national and historical events. The collections acquired on his ethnographic expeditions bear the imprint of his personality. Like his ideas, they are born "between two worlds" and too vital to ignore.

Notes

1. S. An-sky, "Kolybel'naia assimiliatsiia," *Evreiskii mir*, no. 23/24 (1910): 15.
2. Ibid.,18.
3. Ibid., 16.
4. S. An-sky, letter to Khaim Zhitlovskii, cited in V. M. Lukin, "Akademiia, gde budut izuchat' fol'klor," in *Evreiskii muzei*, ed. V. A. Dymshits and V. E. Kel'ner (St. Petersburg: Simpozium, 2004), 59–60.
5. In the photographs (images 62–64), it is obvious that this "Jewish antiquarium," which An-sky wanted the Jewish intelligentsia to love, had already entered modernity. Even the old shtetl kept up with changes in lifestyle that came from the city, primarily in women's and children's fashions, and in the habit of summer trips to the dacha.
6. Contrary to An-sky's opinion, it was not so easy to find Jewish "nannies and governesses." In Vil'na, for example, Jewish wetnurses were often difficult to obtain, and when they were available, they were fairly expensive to hire because networks of Jewish women who organized wetnursing had turned it into a lucrative business. See ChaeRan Freeze, "Lilith's Midwives: Wetnursing and Jewish Newborn Child Murder in Vil'na," *Polin* 25 (forthcoming).
7. An-sky, "Kolybel'naia assimiliatsiia," 20.
8. An-sky, "Narodnye detskie pesni," *Evreiskaia starina*, no. 3 (1910): 391.
9. There is a large literature on the *kheyder*. Concerning issues discussed here and for additional bibliography see Shaul Stampfer, "Heder Study, Knowledge of Torah, and the Maintenance of Social Stratification in Traditional East European Jewish Society," *Studies in Jewish Education*, no. 3 (1988): 271–289; Steven J. Zipperstein, "Imagining Russian Jewry: Memory, History, Identity," (Seattle: University of Washington Press, 1999): 41–62; Mordechai Zalkin, *From Heder to School: Modernization Processes in Nineteenth Century East European Jewish Education* (Heb.), (Tel Aviv: Hakibbutz Hameuchad, 2008).
10. Isaac Lurie, "V evreiskom literaturno-nauchnom obshchestve." As cited in Lukin, "Akademiia, gde budut izuchat' fol'klor," 89–90.
11. From these rituals An-sky singled out Simchas Torah, when "children were given printed flags with pictures showing an edifying content; with these flags, to which burning candles were attached, children walked in processions *together with adults* [emphasis in original], in the synagogue and sometimes on the street. Lag B'Omer is the only exclusively children's holiday, during which excursions with archery and picnics for everyone were arranged. Other children's holidays included: a boy's first haircut [*opsherinish*], his first day at *kheyder*, the transition to the study of the Bible, and then to the Talmud." See An-sky, "Narodnye detskie pesni," 391–92.
12. Lukin, "Akademiia, gde budut izuchat' fol'klor," 89–92.
13. This belief manifested itself in part in An-sky's relation to Zionism and Territorialism. As quoted in Lukin above, An-sky argued, "It is impossible to replace this

steel corset with another, with Palestinian messianism or the idea of territory. The people have to be trained for national life. And then, as in a healthy organism, the people themselves will start yearning for territory, and for a state government." An-sky was also very critical of the party discipline of the Bund, and of attempts to subordinate spontaneous popular revolution to any doctrine (as is evident in his story, "The New Way").

14. Lukin, "Akademiia, gde budut izuchat' fol'klor," 73.

15. S. An-sky, "Kul'turnoe dvizhenie na pochve vneshkol'nogo obrazovaniia vo Frantsii," *Zhurnal dlia vsekh*, no. 2–3 (1902): 348.

16. Ibid.

17. F. Shargorodskaia, "O nasledii An-skogo," *Evreiskaia starina*, no. 11 (1924): 306.

illustrations

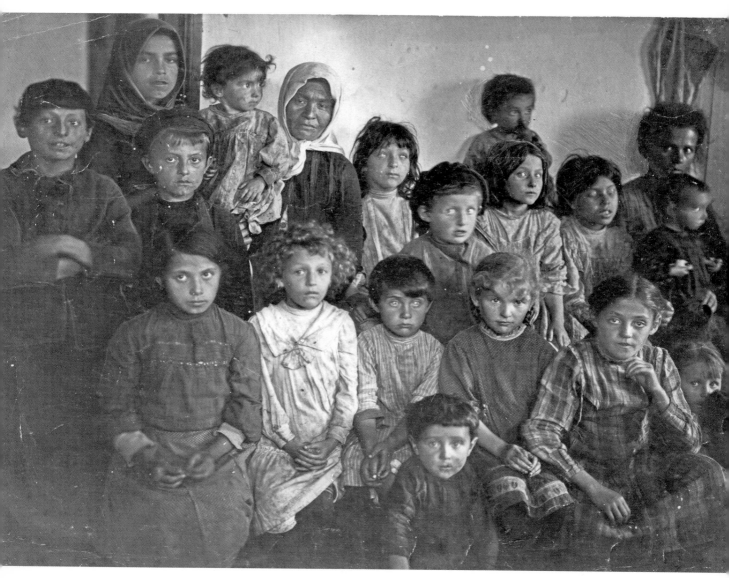

60. A midwife with her "grandchildren."

The models for Jewish midwives are the Biblical Shiprah and Puah, who refused to fulfill the cruel order of the Pharaoh. Therefore, God "made them houses" (Exodus 1: 15–21). In the folkloric tradition of Eastern European Jews, individuals kept life-long ties with the midwife who delivered them, and were considered her "grandchildren." The more "grandchildren" the midwife had, the larger was her share in the world to come.

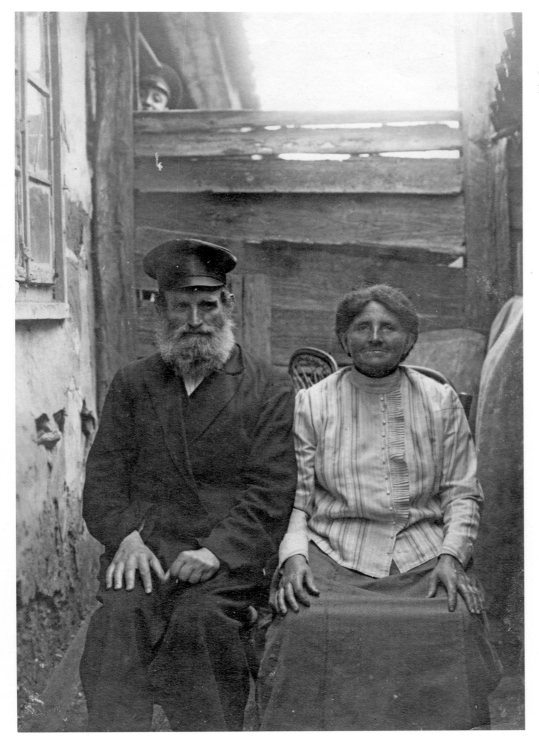

61. Cantor and
his wife.

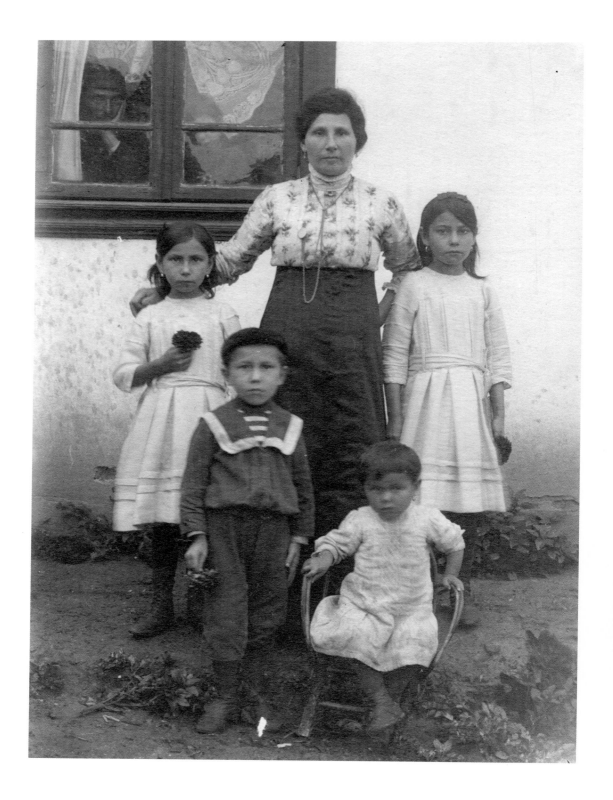

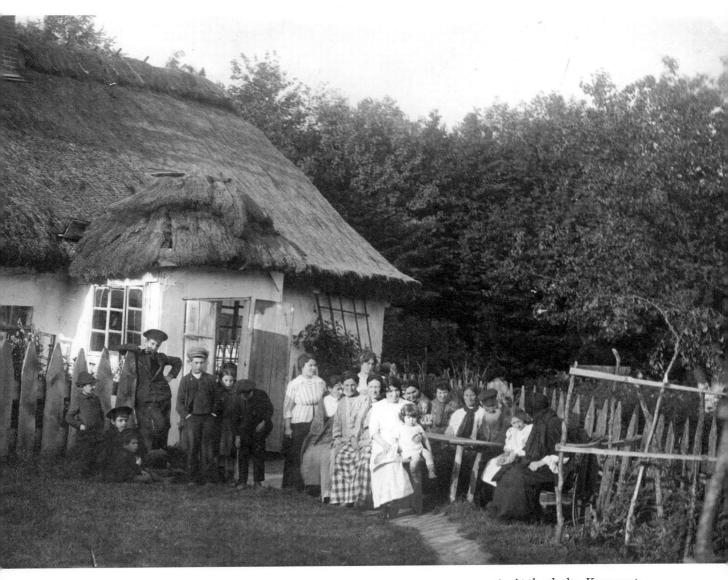

63. At the dacha, Kremenets.

(*opposite*)
62. A family.

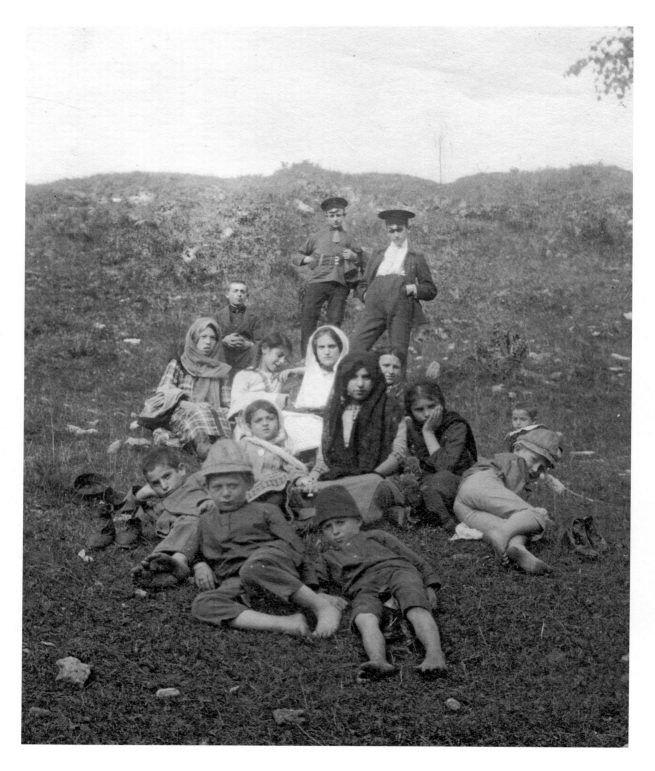

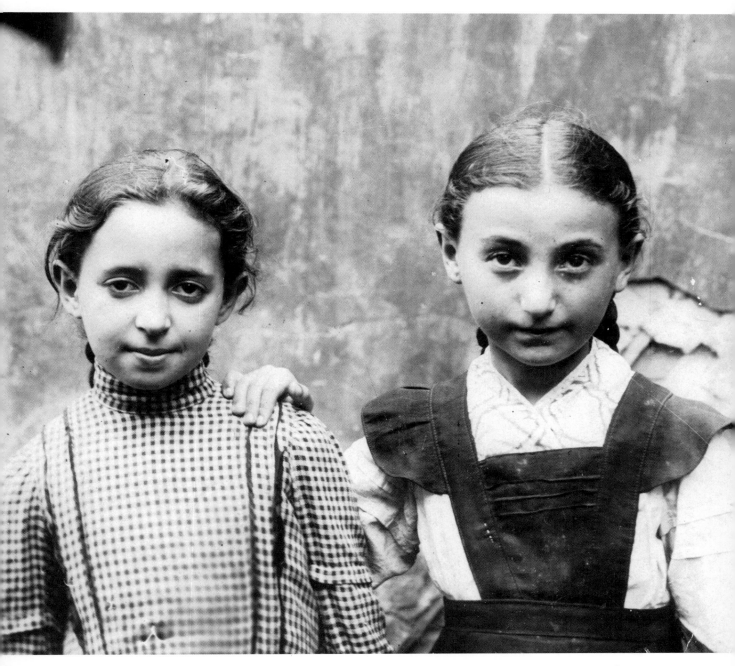

65. Sisters.

(opposite)
64. Group of young people,
Kremenets.

66. Elderly woman.

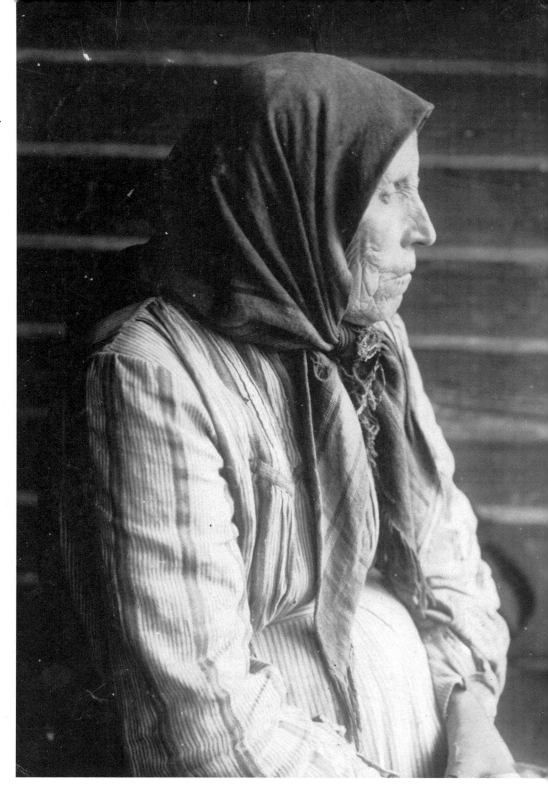

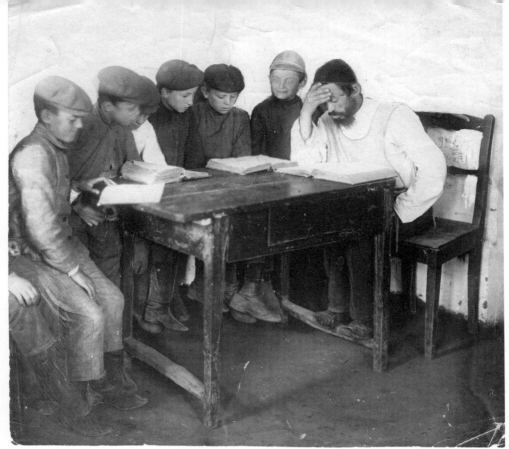

67. In a *kheyder*,
Slavuta.

68. *Kheyder.*

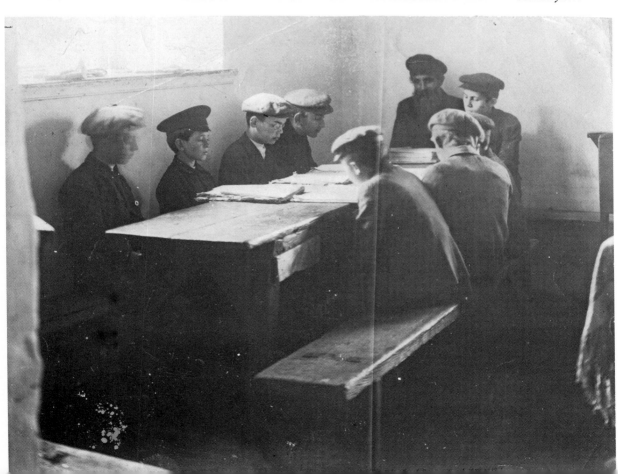

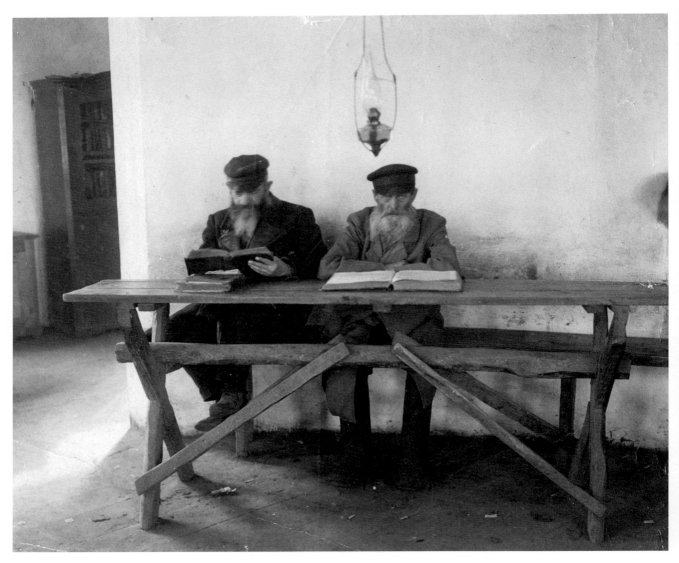

69. In the *beys-medresh*, Kovel.

(opposite)
70. In the old people's home, Proskurov.

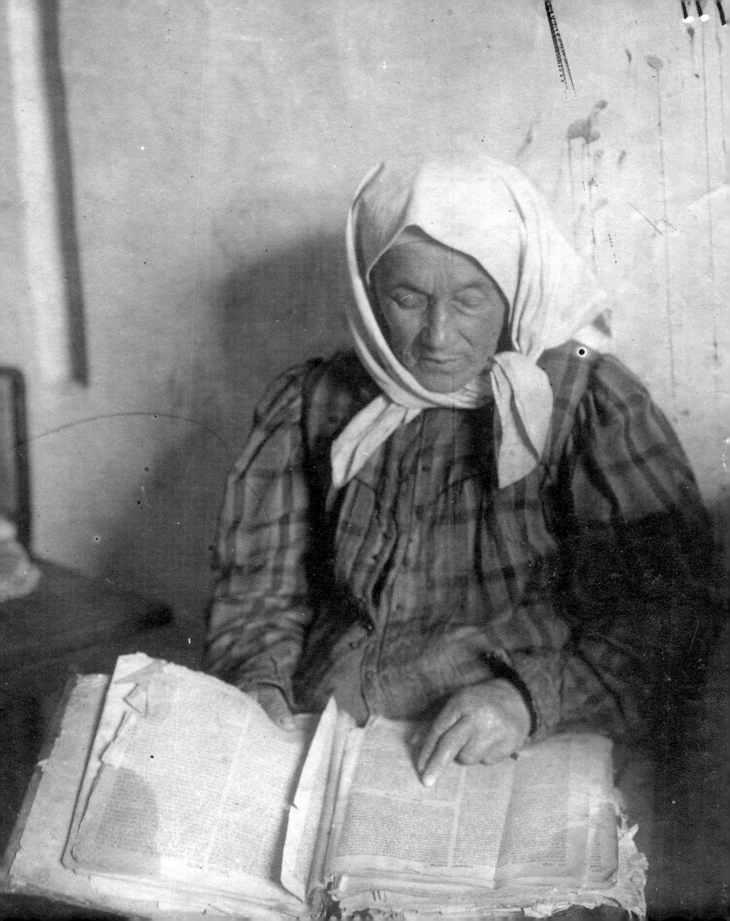

71. Man with book.

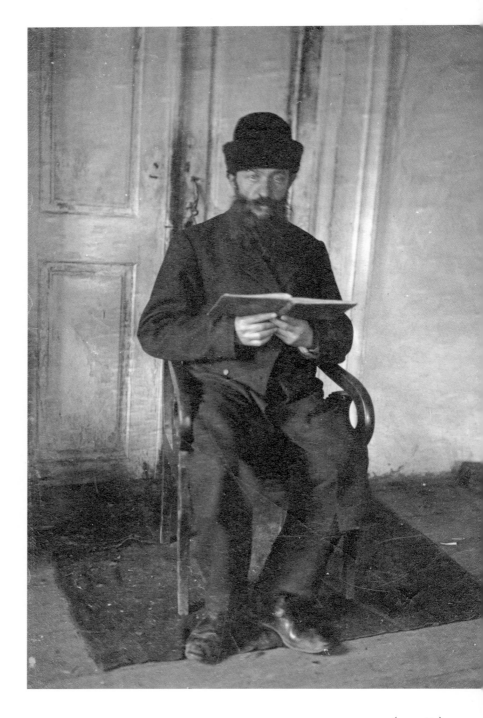

(opposite)
72. Man in synagogue.

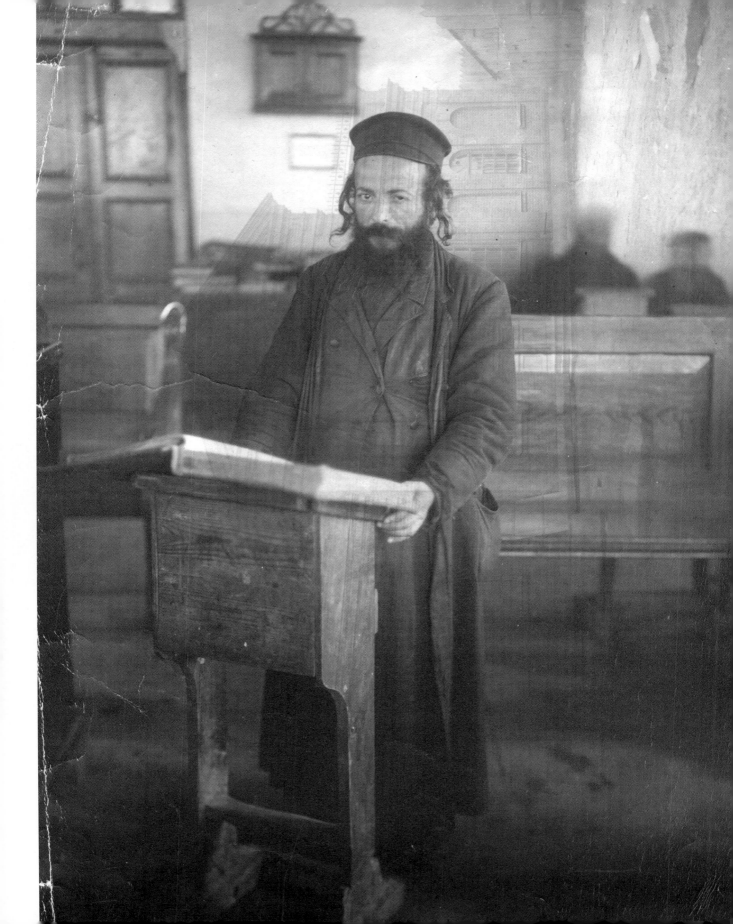

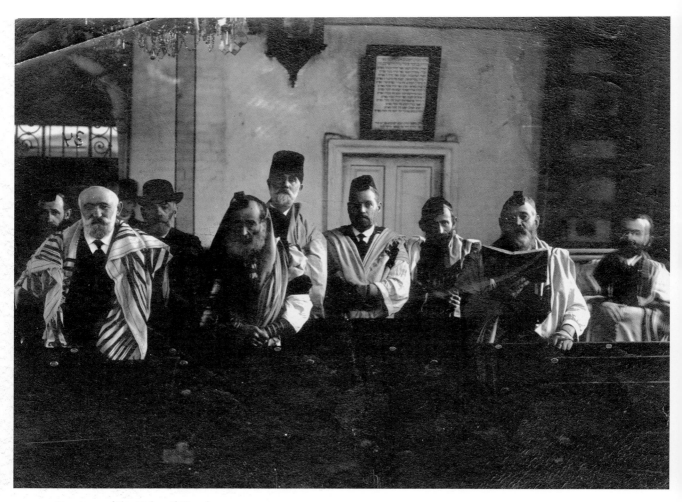

73. Trustees of the Talmud-Torah.

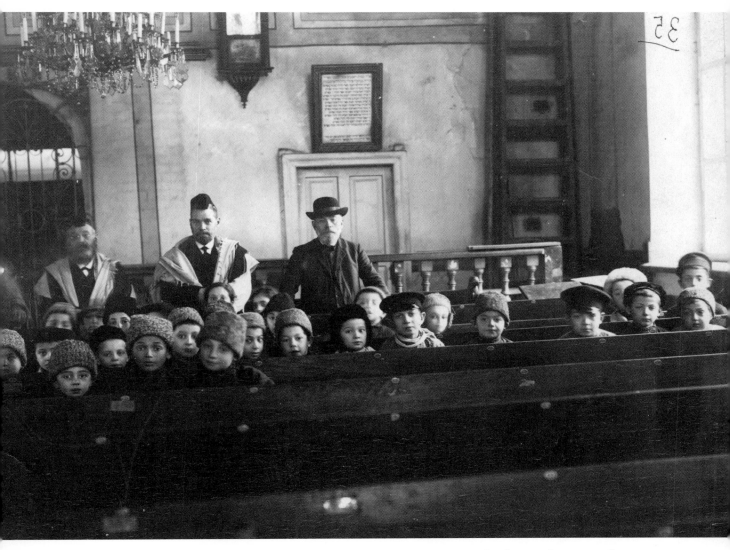

74. Students and trustees of
the Talmud-Torah after morning
prayer.

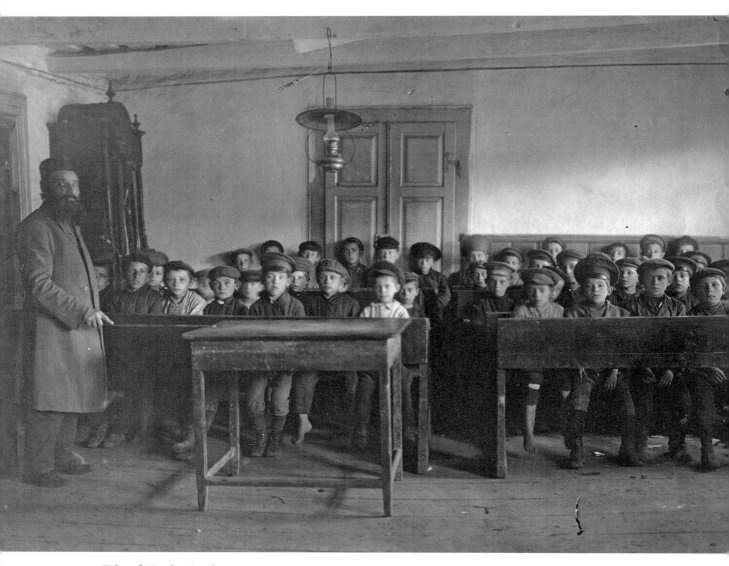

75. Talmud-Torah, Kovel.

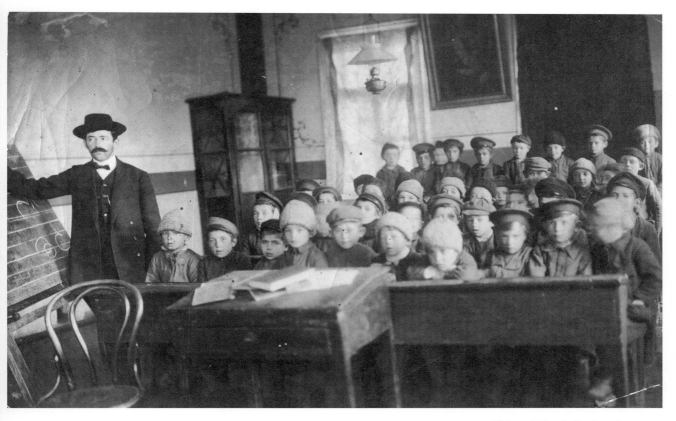

76. Talmud-Torah during class.

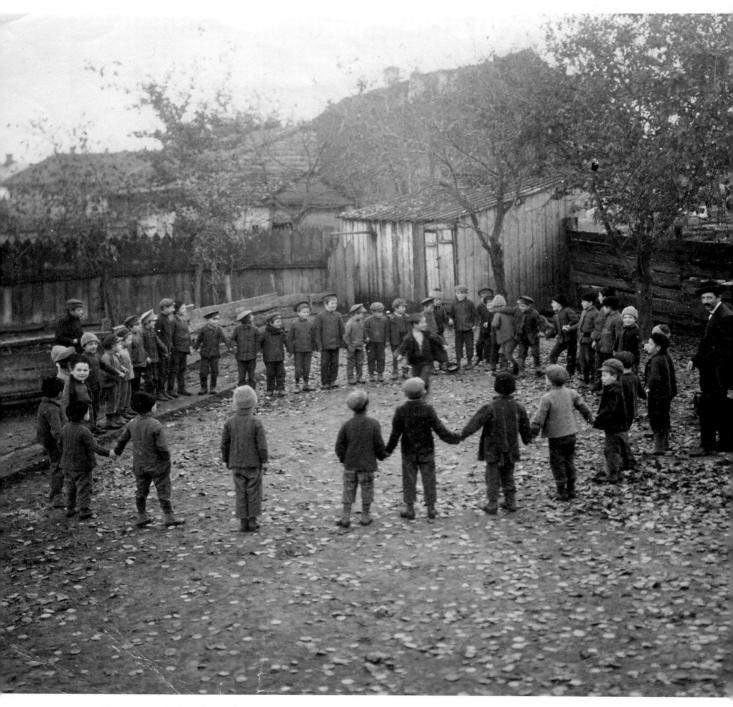

77. Recess at a Talmud-Torah.

122

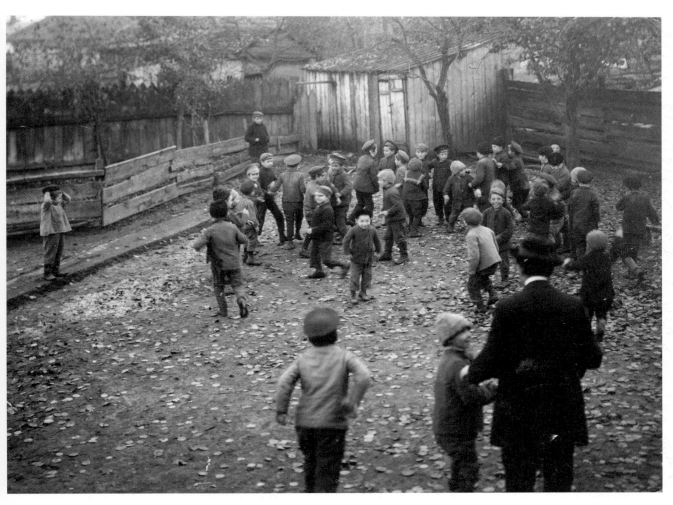

78. Recess at a Talmud-Torah.

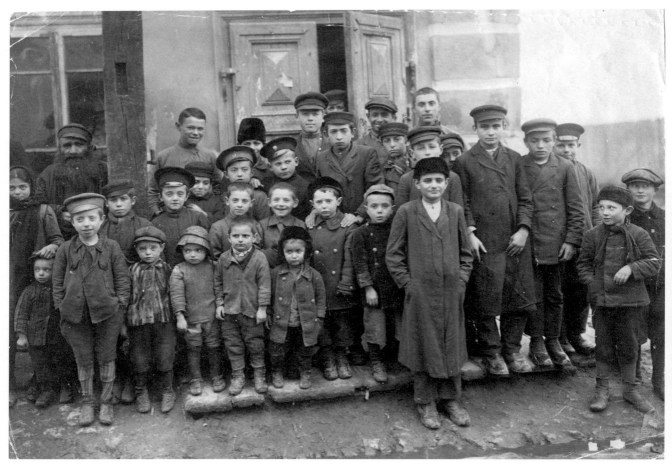

79. Students in a Talmud-Torah, Dubno.

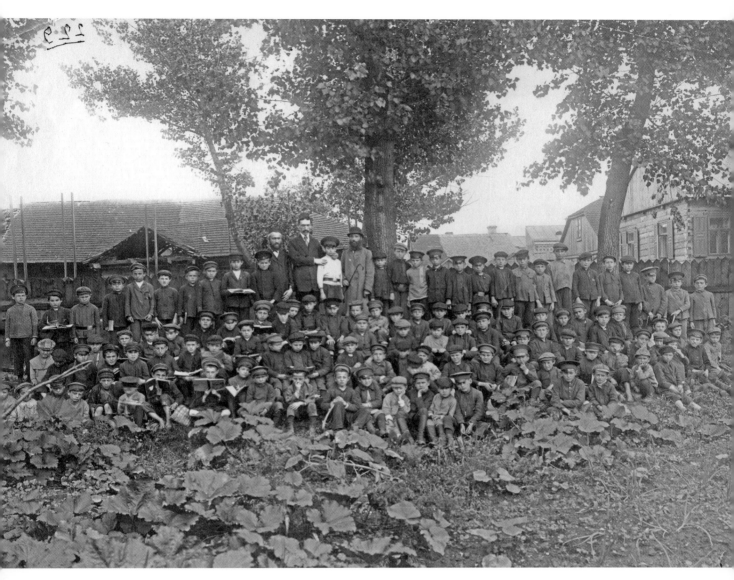

80. Talmud-Torah, Kovel.

125

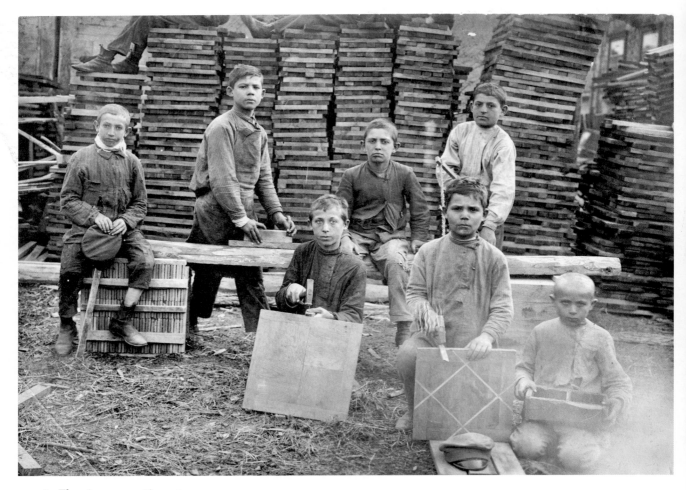

81. Flooring apprentices at a
vocational school, Polonnoe.

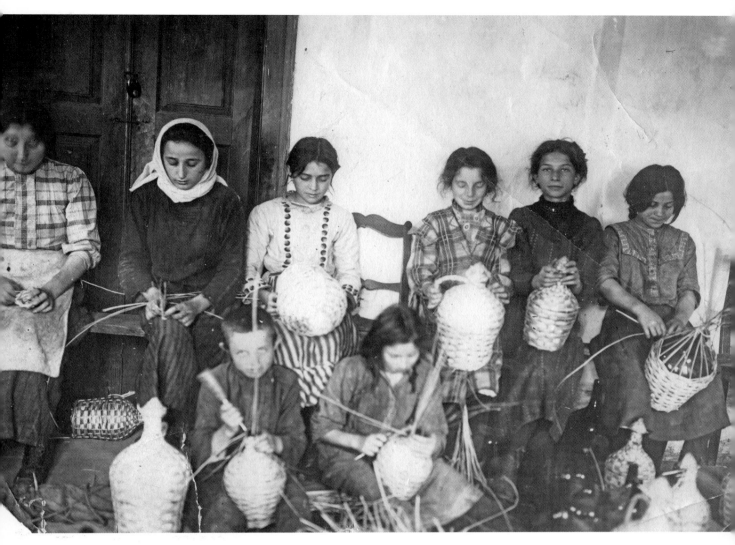

82. Apprentices.

83. A rich man with
mischievous children.

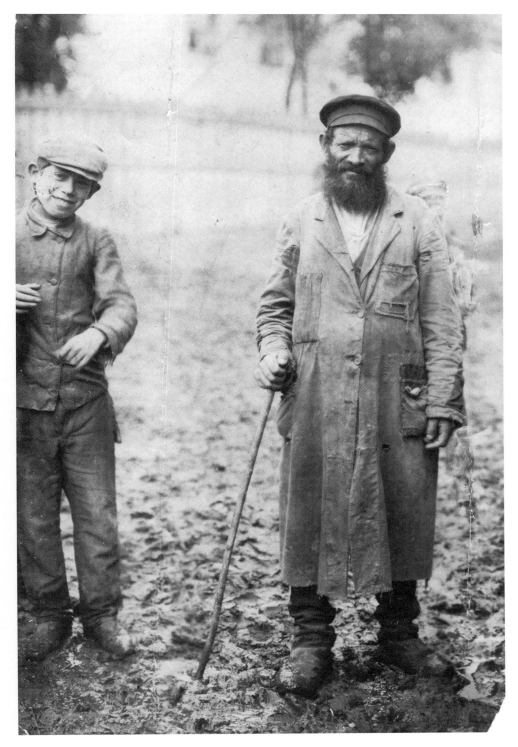

84. Beadle, Ruzhin.

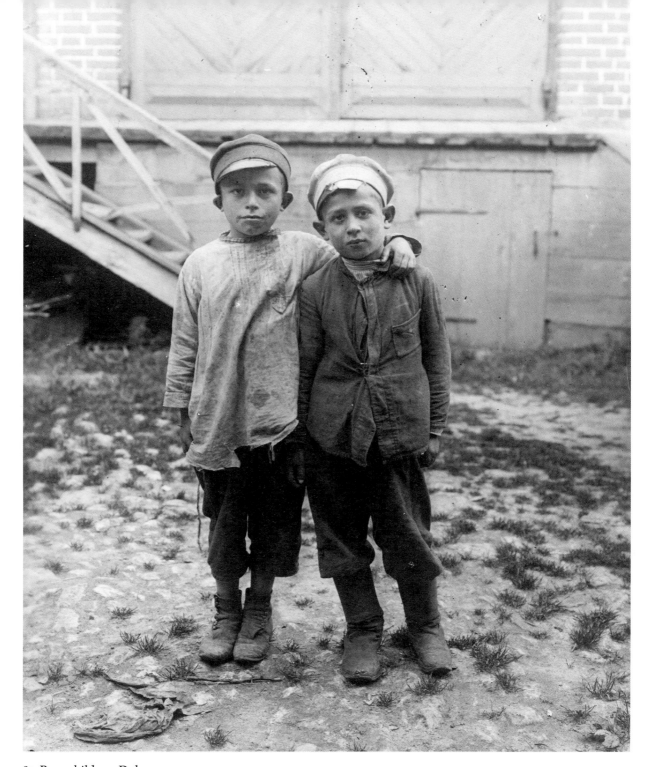

85. Poor children, Dubno.

The Space of Jewish Tradition

Sacred and Profane Places

Planning his first ethnographic expedition to Volynia, to those "places of the oldest Jewish settlement," Semen Akimovich An-sky defined the goals and drew up the plan for the work that lay ahead.[1] One line was underscored: "to take photographs of [ethnographic] types, historical places, memorials, old or noteworthy buildings, objects, and so forth."[2] An-sky intended to present to the public the photographs taken in the course of three expeditionary seasons, from 1912 to 1914, in a work to be titled *Al'bom evreiskoi khudozhestvennoi stariny* (An Album of Jewish Artistic Heritage).

At the end of the nineteenth and the beginning of the twentieth centuries, Russian ethnographers, art historians, and admirers of "folk art" often used the term *starina* to refer to material and verbal artifacts that embodied the national artistic heritage. Having come to the conclusion that the capital cities had been modernized and therefore had lost traditional culture, they turned to the provinces in search of original works that reflected the artistic past, including folk production. The provinces were understood to be a space of tradition, capable of preserving these types of artifacts. As a result of these expeditions, many publications showcased recently discovered cultural treasures.

An-sky's "Album" was not published. The meaning he ascribed to the concept of Jewish artistic heritage, however, can be ascertained from his brief descriptions of the album's five projected volumes and from the mock-up of the first volume. In addition to the works of Jewish graphic art contained in that first volume,[3] An-sky planned to include approximately six hundred photographs. The second volume would document up to one hundred "synagogues and their internal decoration, Torah arks, ornaments"; the third volume, up to one hundred objects "used in daily life and religion that had artistic value"; and the fourth, up to two hundred "gravestones of

important people, people of historical significance, and gravestones with original ornaments."[4]

From these descriptions, it is clear that An-sky considered works of architecture and plastic art as part of Jewish heritage. Together, these objects and buildings constituted the space of traditional Jewish life, connected first and foremost with the fulfillment of religious rituals. This model corresponded to the generally received notion of artistic heritage in circulation at the time.

An-sky proposed that the fifth volume would contain up to two hundred "ritual and daily life scenes and [ethnographic] types" (images 2–7). He may have thought that the beauty essential to the development of Jewish artistic heritage could be seen in the very faces of those Jews who remembered "valuable pearls of folk art: folk tales, legends, parables, spells, and beliefs."[5] Invoking the planned volume, art critic Abram Efros suggested that Jewish writers and artists who created what he called "clean-shaved and close-cropped Jewish art" would be able "to see beauty in side-curls and discover aesthetic value in a *lapserdak* [long frock-coat]."[6]

Efros and other art historians were interested primarily in the aesthetic features of architectural and artistic works of the past. An-sky, however, was not searching the Pale of Settlement for remnants of the past, but rather for a living Jewish tradition, for a past that continued to be vital in the present. In other words, An-sky hoped to find objects of Jewish cultural heritage that continued to function dynamically, not archeological artifacts torn from their proper context. He wanted to immerse himself in the space of traditional Jewish culture. This immersion would permit him not only to present photographs of unique objects of Jewish cultural legacy to his coreligionists during public lectures, but furthermore to talk about the relation between these objects and their host communities, the Jewish people for whom these objects represented their familiar and ordinary surroundings. An-sky paid special attention to those habits and concepts that served traditional Jewish communities as a means of communication with their own environment.

As a result, An-sky considered all structures mentioned in Jewish legends and tales worthy of documentation, including Catholic cathedrals.[7] A note written in Yiddish on the back of one photograph reads, "The Polish cathedral in Olyka. The Poles say that the picture found in the cathedral shows the Eternal Jew; and when a holiday comes, they scramble up the wall and beat him with birch rods." A local legend also might explain the photograph of a stone in a synagogue (image 96). The note on the back reads, "the stone

lying under the lectern in the synagogue in Starokonstantinov," without providing any other details as to its significance.

A house located on the market square of Korostyshev occupies a special place among the "remarkable buildings" photographed during the expedition. Not long before Solomon Iudovin photographed this house (image 116), the famous historian of architecture Georgii Lukomskii drew a picture of it.[8] Lukomskii had traveled to Galicia and Volynia to describe and draw original works of old architecture which revealed "national stylistic particularities."[9] He titled the drawing "Rabbi's House," probably after the local usage. The building was allegedly owned by R. Moshe, the second son of R. Mordechai from Chernobyl, the founder of the Chernobyl Hasidic dynasty. Only a name of this sort could have attracted the attention of someone like Lukomskii, an admirer of the artistic past. An-sky would have been interested in this building for the same reason. The expedition's photographs allow us to understand that the Rabbi's house was located in a row of other buildings which let out onto an enormous market square, and that it was the most representative of them.

An-sky probably categorized the house labeled "Yeshiva in Skvira" (image 115) as belonging to the series of buildings "where famous people were born or lived."[10] In his memoirs of the first expedition, composer Iulii Engel' noted that this building, then "an abomination of desolation, had once housed a yeshiva," and had once belonged to "R. Yisroel [who lived in the middle of the nineteenth century] the most famous of the dynasty of *tsadikim* in Skvira."[11] Engel' further noted that this house, slated for destruction, continued to be referred to as a *hoyf*, the Yiddish word for "court" (in this instance, the *tsadik's* court). It is possible that he wanted to emphasize that Skvira's Jews considered this building a monument of the Jewish past.

During the second expedition, An-sky planned to "take pictures of synagogues and their internal decorations."[12] The expedition photographs show monumental stone buildings, modest wooden structures, and simple brick constructions. In the planned album, synagogues and their decorations did not receive as much space as gravestones, for example, probably because An-sky did not acknowledge the artistic value of most of the synagogue buildings. In his story "The New Way" (1907), he counted the "old synagogue of the city of N. [Vitebsk] as a local attraction only because it was built during the time of Catherine, and was witness to the French attack, several pogroms and many fires."[13] In An-sky's opinion, this synagogue was "without any architecture, without a dome, without decoration, without any

exterior distinguishing marks." He was at a loss as to how, in spite of these facts, "every passerby recognized it from the first glance as a synagogue."[14]

In their attempts to define features of what they considered the "Jewish style," art historians who examined synagogue architecture at the beginning of the twentieth century focused mainly on decorative components. Lukomskii wrote of discovering among the synagogues of Galicia "examples of marvelous buildings, true, without strictly national stylistic characteristics, but nonetheless very curious."[15] He wrote that the synagogues of Zaslav seemed to be "very characteristic of the particular features of their architecture"[16] and, surveying the synagogues in Dubno and Kremenets, he observed that they all demonstrated "the [Jews'] love for bright colors."[17]

Although Iudovin photographed both the interiors and exteriors of these monumental stone synagogues (images 86–88, 90–93, 101), this does not mean that An-sky was preoccupied with the search for the "Jewish style" of these buildings. An-sky, it seems, agreed in part with the judgment of the well-known art critic Vladimir Stasov, who argued that Europe lacked monuments of Jewish architecture worthy of entering the treasure-house of Jewish artistic heritage.[18] Among An-sky's unpublished drafts, there is this statement: "[A]fter the Jews lost their country, works of architecture and sculpture were no longer possible."[19] Stasov used a similar argument in "On Synagogue Construction," published in the second volume of the journal *Jewish Library* in 1889. From that time, it had become common practice to cite his article as the basis for similar conclusions.

Doubts about the history of these synagogues also troubled An-sky. One local legend might attribute the construction of a stone synagogue to the city's ruler,[20] while another might recount a miraculous discovery by children who were "playing in an empty field and found a cupola, began to dig, and uncovered a synagogue."[21] Even as An-sky transcribed these stories, it was important to him to precisely delimit the range of works that were truly the product of the Jewish artistic past — works that, without any doubt, were made by the hands of Jewish craftsmen. His "Program of Research into Local History" included the following questions: "Did you have at some time a famous Jewish artist or engraver living here? Does anyone have any of his work?"[22]

In An-sky's opinion, the intelligentsia who were occupied with the creation of Jewish art had been torn from their roots. In order to reconnect themselves with an authentic tradition, they would have to acquaint themselves with the kinds of work made by Jewish craftsmen, because only these craftsmen possessed "their own artistic line, their own colors."[23]

Although An-sky did include massive stone synagogues in his inventory of significant sites of Jewish national legacy, the expedition did not ignore other forms of architecture. Abram Rechtman, an expedition participant, noted that a stone synagogue "in its majesty and brilliance, its sacredness and mystery" towered over the "low little wattle-and-daub houses, sunk into the ground."[24] But in his opinion, it was the wooden synagogues, "with their intricate cornices and wings" that possessed a unique and singular architecture. It is hardly an accident that that An-sky's play *The Dybbuk* features a wooden synagogue. On the inside, it is "low, with tear-stained walls, impossible to whiten"; on the outside, "lofty, blackened, with a whole system of roofs, one on top of the other."[25] Rechtman thought that the "ancient beauty" of synagogues was to be found in their interior paintings. An-sky, in all likelihood, held the same opinion. On his way to Volynia in 1913, he stayed back in Mogilev-on-the-Dnieper in order to photograph a wooden synagogue famous for its wall-paintings (images 128–132).[26]

Decorated Torah arks and gravestones also provided ample material in the search for "ancient" (that is, primordially Jewish) beauty. Because of their many Hebrew engravings, it was understood by default that only Jews could be their authors. The photograph of a richly decorated Torah ark in a synagogue in Starokonstaninov (image 97) was taken on the first expedition, with An-sky's direct participation. It was customary to evaluate similar objects for their correspondence to the "norms of folk art."[27] The photograph of the Torah ark in a synagogue in Pavoloch (image 104), however, could also serve as a formal community portrait.

The criteria for selecting photographs of gravestones can be ascertained, to a certain degree, from the order in which they were supposed to appear in the fourth volume of the planned album. Gravestones of "great and historical people" were to receive priority. Although it seems strange in a publication dedicated to the Jewish artistic heritage, unique works of folk art were to yield their place to memorials acknowledged as "historical."[28]

A note published in April 1918 describes the following plans for the "Album." After the *mizrakhim* (decorative plaques indicating the eastern wall), which made up the first volume, it would publish "photographs of rare old gravestones of great men and holy martyrs"; after that, "ritual utensils and objects, synagogues and historic buildings, and their interior decoration, decorated ceilings, drawings on walls and columns, Torah arks, pulpits, ethnographic types, and ritual and daily life scenes."[29] In this new description, however (possibly written by An-sky himself), the arrangement of the material has changed. In the section designated for "gravestones,"

mention of "original ornament" disappears, perhaps due to the fact that the "rare old" gravestones (from the sixteenth century, for example) were often completely without decoration. Apparently, it did not trouble An-sky that these monuments could not be presented as impressive samples of the art of stone engraving. Works from the second half of the nineteenth and beginning of the twentieth century could, however, fit this description (images 140 and 141).

In his lecture "The Legends of Old Stones: Jewish Folk Production in the Plastic Arts," given in Odessa in 1916, An-sky showed depictions of gravestones which he considered works of folk art. This lecture was devoted not only to the artistic value of the gravestones but also to traditions about Jewish cemeteries and "scenes at the cemetery," that is, rituals connected with visiting cemeteries.[30] It is possible that An-sky chose this method of presenting gravestones to bring to light their ritual functions, which permitted him to demonstrate to the public that these works of folk art were integral attributes of the traditional Jewish world.

An-sky undoubtedly considered the two-seated "chair of Elijah the prophet," found on the *bima* in a synagogue in Dubno (image 93), to embody these attributes. It was made in simple fashion from two office chairs that had probably been donated to the synagogue by a member of the congregation. The influence of the Rococo on its design was too evident to consider the chair folk art, but it was nonetheless worthy of being photographed. This is evidence that, for An-sky, the very fact of an object's use for ritual purposes — that is, its place in the space of Jewish tradition — had a decisive meaning for its selection.

An-sky broadly defined the circle of objects to be photographed to include those that would show "all sides of the old daily life of the Jews."[31] It is possible that his Populist ideas influenced the expedition photographer's focus on the ordinary houses, squares, and streets that defined the appearance of the little market towns in the Pale of Settlement (images 117–123). In all likelihood, An-sky was ready to see "Jewish features" just as much in architectural realia as in the faces of the local inhabitants.

A note on the back of a photograph — "Shulhoyf," Yiddish for synagogue courtyard — allows us to consider what the inhabitants of Olyka called either the small area formed by the turn in the street that skirted the wooden synagogue, or the street itself (image 126). Judging from the photograph, it is difficult to define the boundaries of this space. Its center might have been the square at the walls of the old synagogue, or more likely, the structure of four wooden poles used as a *khupa*, since the *shulhoyf* was the traditional

place for conducting this part of the wedding ceremony. As was often the case in the Pale, a new stone synagogue has been built near the older one, probably at the end of the nineteenth century. In this example, the photograph not only permits us to arrive at a conceptualization of individual buildings, but also enables us to interpret the broader surroundings — in other words, the architectural space — which the buildings embody.

In the photographs of Kozin, it seems that place names might have interested An-sky more than the local traditions of building, although the images do shed light on the architectural features of these houses, crudely made out of local materials (images 120–122). An-sky may have been seeking examples of the old "Jewish dwelling places" described by Russian travelers at the end of the nineteenth century. Mikhail Karinskii, who made a trip to Podolia in the 1880s, concluded that all Jewish houses in this region were "built according to one and the same architectural type." Karinskii called this the Jewish *zaezd* (a house with a hallway), and defined the building's fundamental layout.[32] The essential element is a passageway under the roof that connects two parallel streets. Both the passageway and the house itself were referred to in Yiddish as *anfur* (the word *zaezd* is Russian), and because such houses often contained rooms set aside for lodgers, both the Yiddish and the Russian terms were frequently used to signify an inn. One of the photographs taken in Kozin emphasizes the contrast between the "old construction" (the so-called Jewish *zaezd*) and the building whose longer facade fronted the square like the mansions of the local gentry (image 123). That building shows clear signs of modernization; for example, its roofing is done in the then-fashionable Austrian style.

The photographs of decrepit buildings with peeling walls and of streets and squares with "impassible mud" were necessary to An-sky for his depiction of the world of "the poor shtetl" (images 118 and 119).[33] Nearly all of the places visited by the expedition fit this description. In a 1915 report on Jewish folksongs, for example, Iulii Engel' noted that Pavoloch was bigger than Ruzhin, but just as poor. In a letter to Baron Gintsburg, who financed the expedition, An-sky himself wrote, "this whole time we traveled throughout the most obscure little towns," although later in the same letter he says that they traveled to "twenty-five places, including eight district centers in Volynia province."[34] Even when his destinations were not "obscure," the populist An-sky used this language because he hoped to find the most valuable objects of Jewish artistic heritage precisely in the places that embodied Jewish poverty, the "obscure shtetls."

In his play *The Dybbuk*, An-sky represented an "old and poverty-stricken"

synagogue as a treasure trove, in which there could be found "the oldest Torah ark curtains" and "soft velvet embroidered with pure gold, showing lions and eagles . . . the oldest and most valuable hangings."[35] During the period from 1910 to 1930, artists who turned to images of the poor shtetl often depicted wooden synagogues with high multi-tiered roofs, bowed with age. No doubt An-sky and Rechtman considered the wooden synagogue found in Korytnitsa as a unique example of architecture (image 136).[36] The architectural forms of the monumental stone synagogues of the seventeenth to the nineteenth centuries, which flourished in the Pale of Settlement, were less suitable for this purpose — although, by the beginning of the twentieth century, even poor people usually prayed in such buildings.

The expedition photographs of synagogues and other architectural monuments give the abstract concept of the Jewish past a concrete figural and spatial dimension. Through the selection of particular forms, the Jewish past is thereby transformed into the space of a lost Yiddishland. Looking at these photographs provides the experience of the "effect of presence" — the illusion of immediacy — in An-sky's imagined world of Jewish tradition.

Notes

1. This is how P. Marek substantiated his opinion that Volynia province was the most suitable place for the beginning of the expedition work. He stated this opinion at a general session of the Jewish Historical-Ethnographic Society in 1908. See V. M. Lukin, "Ot narodnichestva k narodu (S. A. An-skii — etnograf vostochno-evropeiskogo evreistva)," in *Evrei v Rossii: Istoriia i kul'tura*, ed. Dmitrii A. Eliashevich (St. Petersburg: Peterburgskii evreiskii universitet, 1998), 132.

2. As cited by A. Kantsedikas, *Al'bom evreiskoi khudozhestvennoi stariny Semena An-skogo* (Moscow: Mosty kul'tury, 2001), 37–38.

3. In the first volume, An-sky included fragments of handwritten *haggadot* from fourteenth-century Spain and from an eighteenth-century Eastern European prayer book, both of which belonged to a synagogue in Tarnovo (Galicia); several Italian *ketubbot* from the seventeenth to eighteenth centuries and one from Greece from the eighteenth century; and also folk woodcuts (*lubki*), pages from *pinkasim*, and *mizrakhim*, made in the nineteenth century in Ukraine. See Kantsedikas, *Al'bom evreiskoi khudozhestvennoi stariny Semena An-skogo*, 318–35.

4. S. An-sky, "Ot evreiskoi etnograficheskoi ekspeditsii," *Evreiskaia zhizn'*, no. 30 (April 1917), 33–35.

5. S. An-sky, "Evreiskoe narodnoe tvorchestvo," *Perezhitoe* 1 (1908): 314.

6. Abram Efros, "Lampa Aladdina," in *Al'bom evreiskoi khudozhestvennoi stariny Semena An-skogo*, 215.

7. In An-sky's "Program of Research into Local History," questions about syna-

gogues were followed by questions about "old fortresses, towers and palaces, both those that remained whole and those that were in ruins." See S. An-sky and A. Iuditskii, *A ortige historishe program* (St. Petersburg, 1913).

8. G. K. Lukomskii, *Volynskaia starina* (Kiev, 1913), 30.

9. G. K. Lukomskii, *Galitsiia v ee starine: Ocherki po istorii arkhitektury xii–xviii vv.* (Petrograd, 1915), 96.

10. This subject figured in questions 24 and 25 of the "Program of Research into Local History."

11. Iu. Engel', "Evreiskaia narodnaia pesnia: Ethnograficheskaia poezdka," *Paralleli: Russko-evreiskii istoriko-literaturnyi i bibliograficheskii al'manakh*, no. 4–5 (Moscow: Dom evreiskoi knigi, 2004), 296.

12. Expedition plan of March 21, 1913, cited by Lukin, "Ot narodnichestva k narodu," 136.

13. S. An-sky, "V novom rusle," in *Pervyi evreiskii sbornik* (Moscow, 1907), 251.

14. Ibid.

15. Lukomskii, *Galitsiia v ee starine*, 96.

16. Lukomskii, *Volynskaia starina*, 29.

17. At this time Lukomskii had not yet come to believe in the "unique charm of the form of synagogue architecture, particularly wooden architecture in Poland," which the well-known journalist Solomon Poliakov-Litovtsev discerned in Lukomskii's book on synagogues. See S. Poliakov-Litovtsev, "Foreword," in G. K. Lukomski, *Jewish Art in European Synagogues* (London: Hutchinson, 1947), 12.

18. V. Stasov, "Po povodu postroiki sinagogi," *Evreiskaia biblioteka* 2 (1889): 435–454.

19. V. M. Lukin, "Akademiia, gde budut izuchat' fol'klor," in *Evreiskii muzei*, ed. V. A. Dymshits and V. E. Kel'ner (St. Petersburg: Simpozium, 2004), 91.

20. S. An-sky, *Gezamelte shriftn*, 15 vols. (Vilnius, 1920–25), 15:248–49.

21. S. An-sky, "Perepiska Semena Akimovicha An-skogo s Vladimirom Goratsevichem Ginstburgom," in *Arkhivna spadshchyna Semena An-s'kogo u fondakh natsional'noi biblioteky ukrainy imeni V. I. Vernads'kogo*, ed. Irina Sergeeva (Kiev: Dukh i litera, 2006), 448. An-sky named this legend "about the found synagogue."

22. Questions 43 and 64 in An-sky and Iuditskii, *A ortige historishe program*.

23. S. An-sky, "Izdanie evreiskoi etnograficheskoi ekspeditsii," *Evreiskaia nedelia*, no. 11/12 (1918): 78.

24. Abram Rechtman, *Yidishe etnografye un folklor: Zikhroynes vegn der etnografisher ekspeditsye ongefirt fun Sh. An-ski* (Buenos Aires: YIVO, 1958), 38.

25. S. An-sky, "Mezh dvukh mirov," in *Polveka evreiskogo teatra 1876–1926: Antologiia evreiskoi dramaturgii* (Moscow: Dom evreiskoi knigi, 2003), 329.

26. Letter from An-sky to Lev Ia. Shternberg, August 6, 1913. Russian Academy of Sciences, St. Petersburg, f. 282, op. 2, d. 246.

27. Efros, "Lampa Aladdina," 227.

28. An-sky, "Ot evreiskoi etnograficheskoi ekspeditsii," 33–34.

29. An-sky, "Izdanie evreiskoi etnograficheskoi ekspeditsii," 21.

30. The concluding statement in the summary of this lecture reads: "Cemeteries, memorials, scenes at the cemetery." See Sergeeva, ed., *Arkhivna spadshchyna Semena An-s'kogo*, 88.

31. An-sky, "Evreiskoe narodnoe tvorchestvo," 314.

32. Mikhail Karinskii, "Putevye ocherki: Podolia," *Kievskaia starina*, no. 7 (1884): 364–65.

33. Engel', "Evreiskaia narodnaia pesnia," 293.

34. Sergeeva, ed., *Arkhivna spadshchyna Semena An-s'kogo*, 447.

35. An-sky, "Mezh dvukh mirov," 338–39.

36. Rechtman, *Yidishe etnografye un folklor*, 38.

illustrations

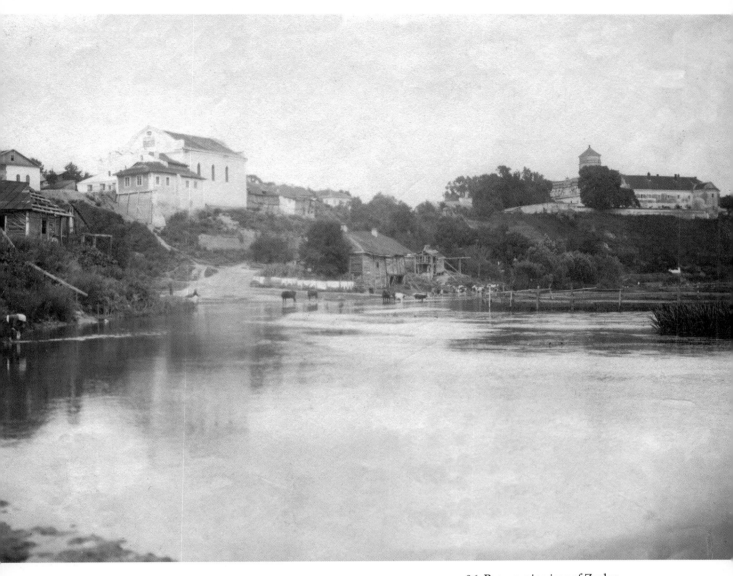

86. Panoramic view of Zaslav
(synagogue in background, on
left).

87. Door handle to synagogue, Zaslav.

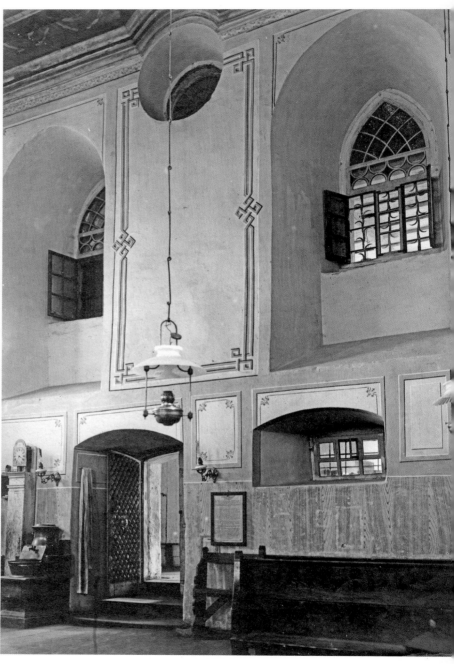

88. In a synagogue, Zaslav.

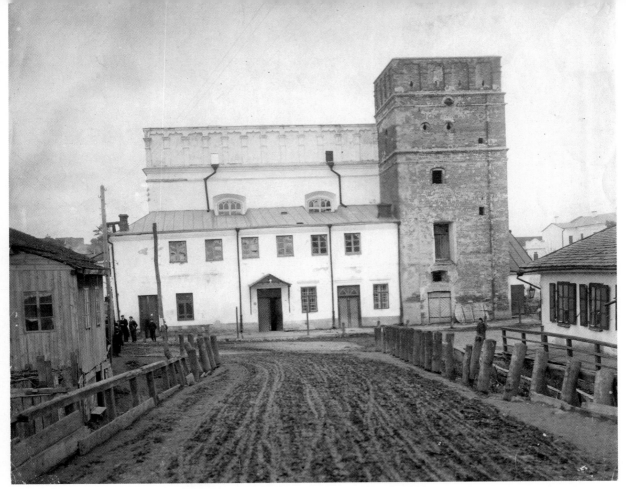

89. Synagogue from 1629, Lutsk.

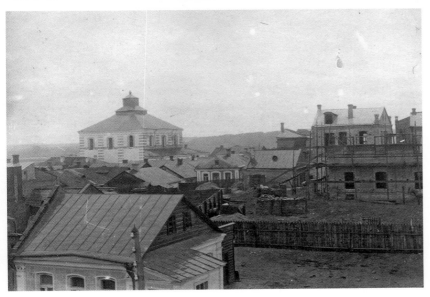

90. Panoramic view of Dubno
(synagogue from 1784 in
background, on left).

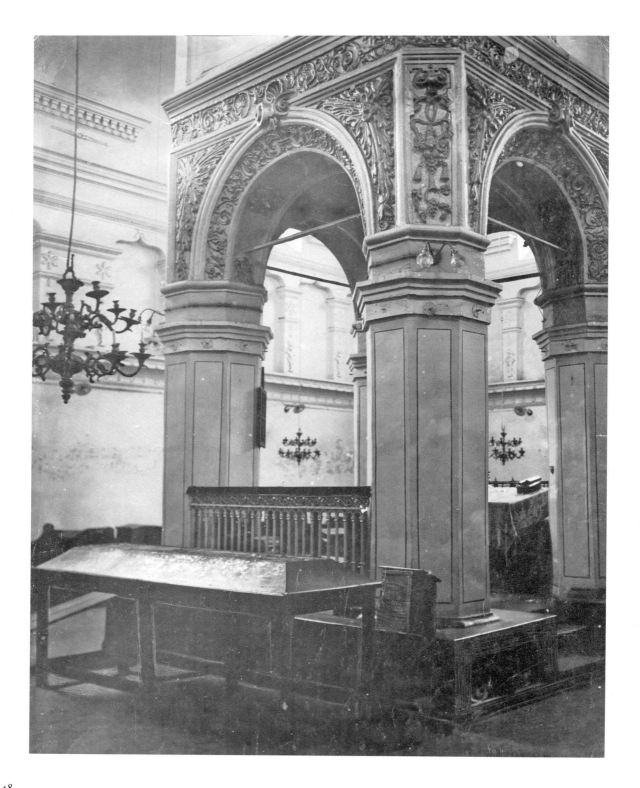

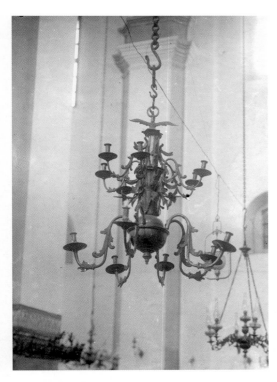

92. Chandelier in a synagogue, Dubno.

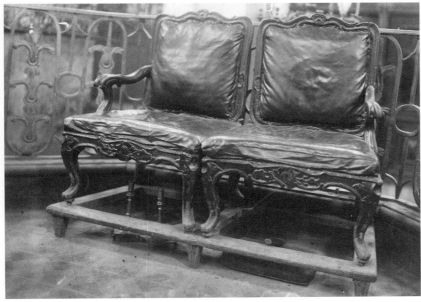

93. "Chair of Elijah the Prophet," placed on *bima* in synagogue (for circumcision).

(opposite)
91. *Bima* of synagogue, Lutsk.

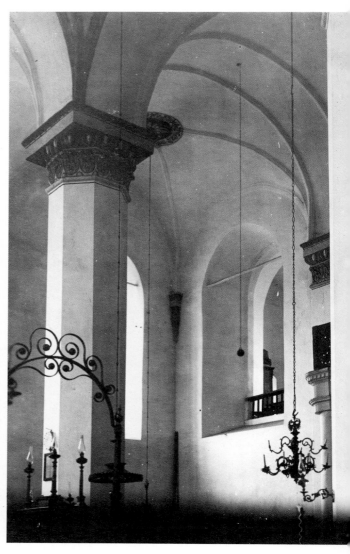

94. In a seventeenth-century synagogue, Starokonstantinov, 1912.

95. In a seventeenth-century synagogue, Ostrog.

96. Stone under *omed*,
Starokonstantinov, 1912.

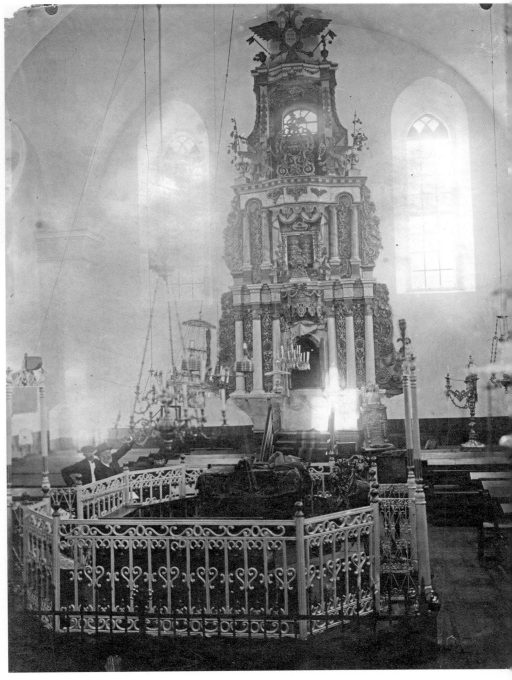

97. Torah ark in a synagogue, Starokonstantinov, 1912 (An-sky assists the
photographer by holding the chandelier with his cane).

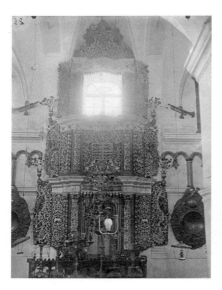

98. Torah ark in a synagogue
from 1781, Matseev.

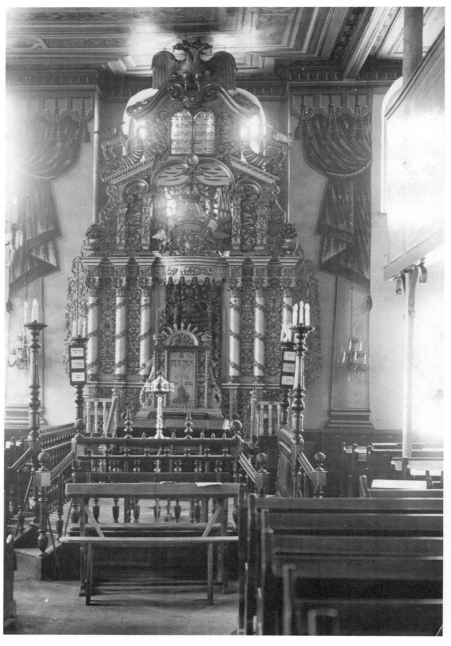

99. Torah ark from 1900.

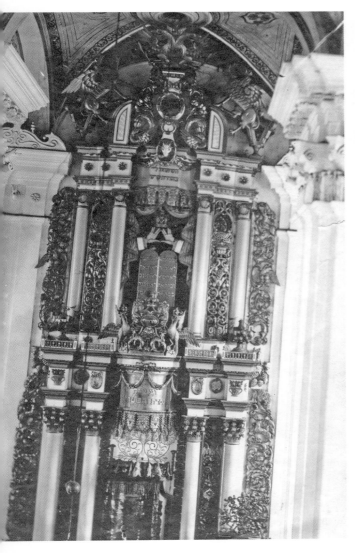

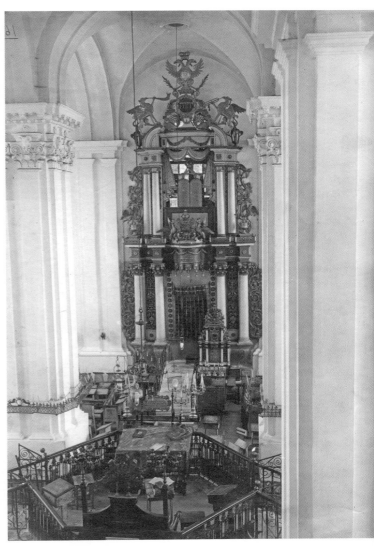

100. Torah ark from the nineteenth century, Berestechko.

101. Torah ark from the nineteenth century, Kremenets.

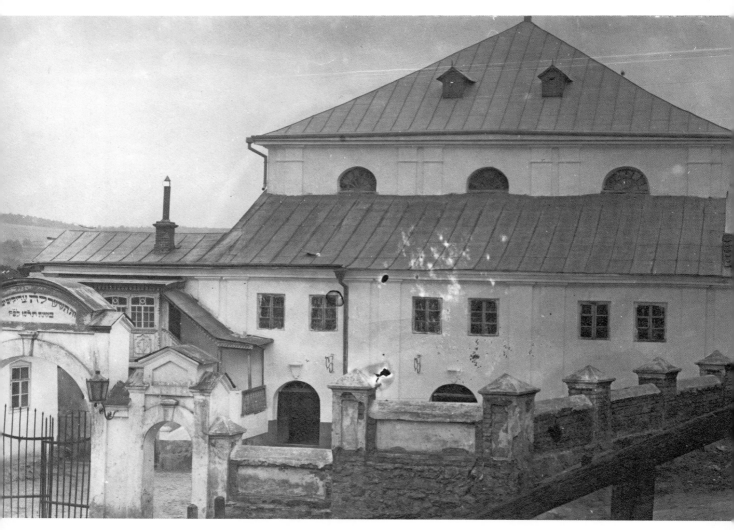

102. Synagogue from the
eighteenth century, Vishnevets.

(opposite)
103. Torah ark, Vishnevets.

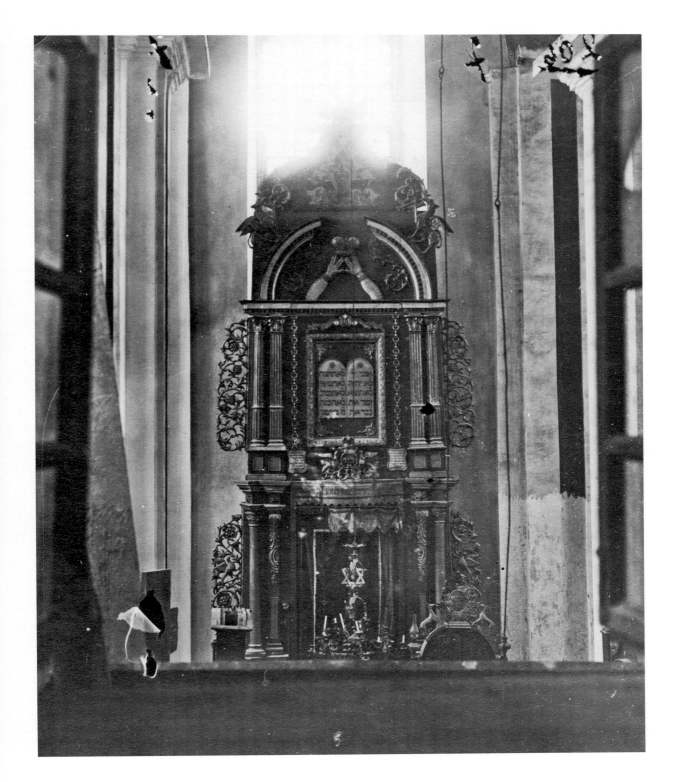

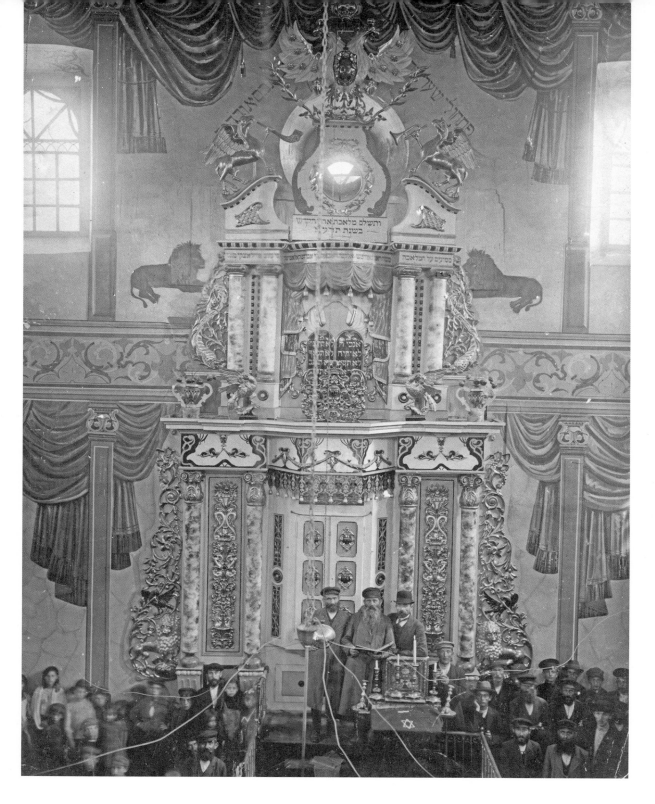

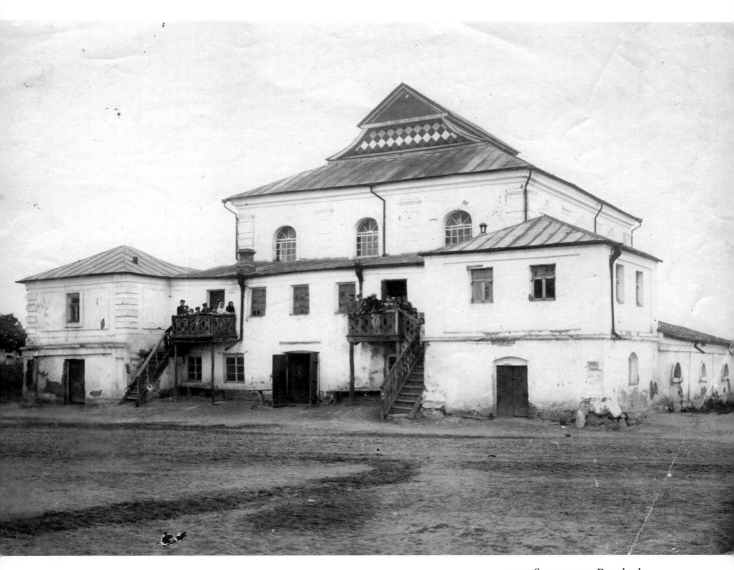

105. Synagogue, Pavoloch.

(opposite)
104. Torah ark, Pavoloch, 1912.

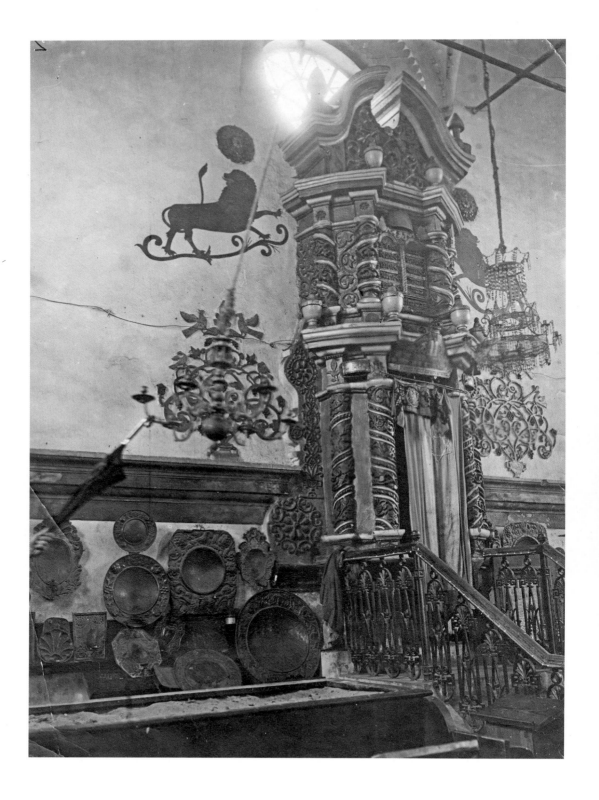

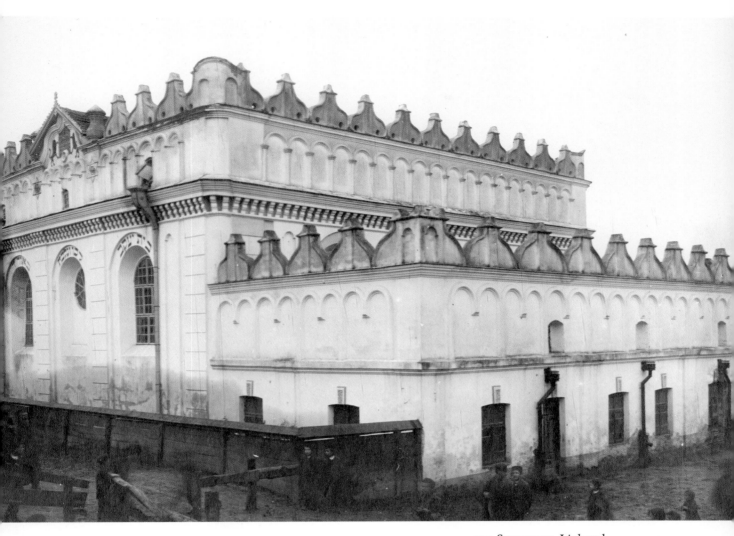

107. Synagogue, Liuboml.

(opposite)
106. Torah ark, Liuboml.

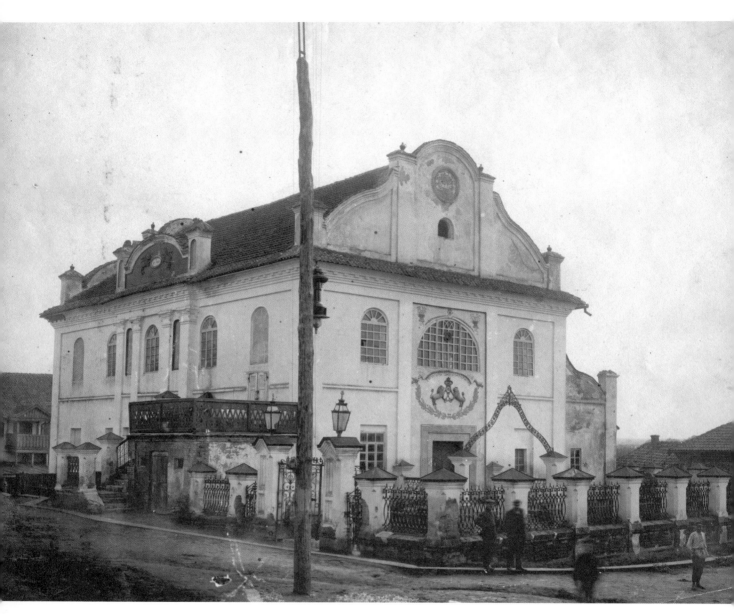

108. Synagogue from nineteenth
century, Shepetovka.

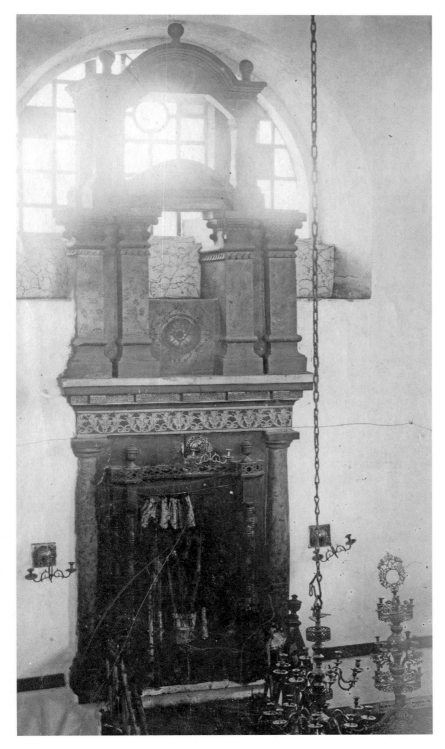

109. Torah ark, Shepetovka.

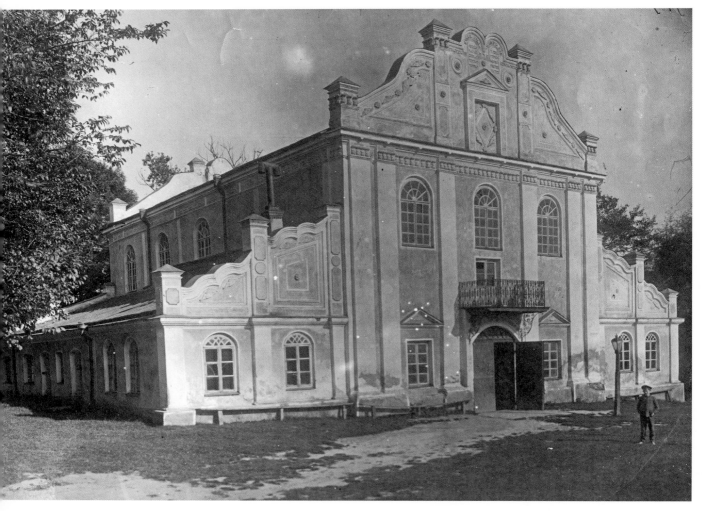

110. Synagogue, Liubar.

(opposite)
111. Synagogue from the
nineteenth century.

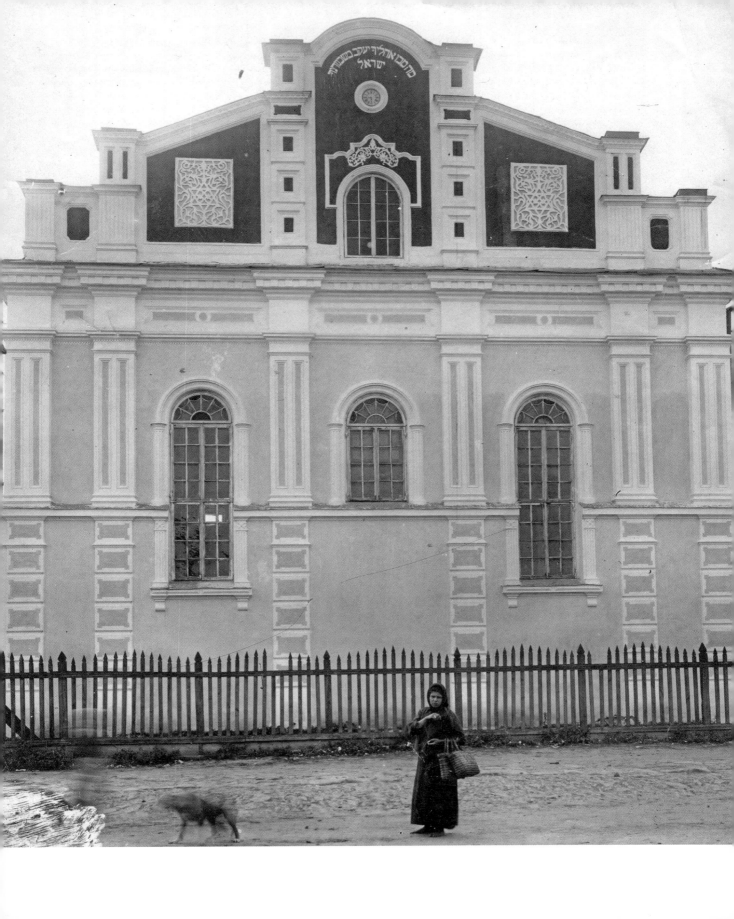

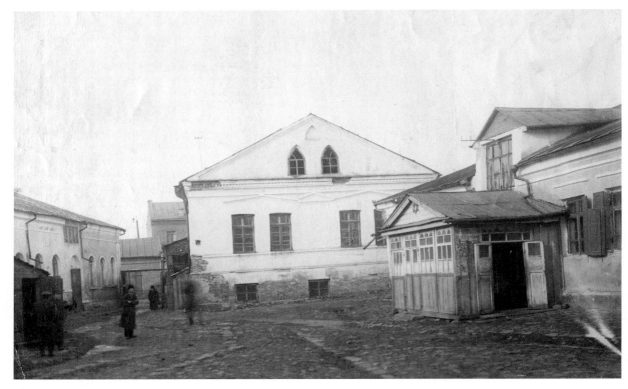

112. Synagogue courtyard,
Korets.

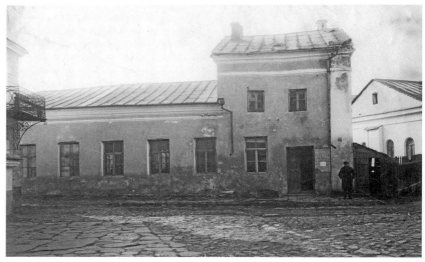

113. Town square with synagogue on right.

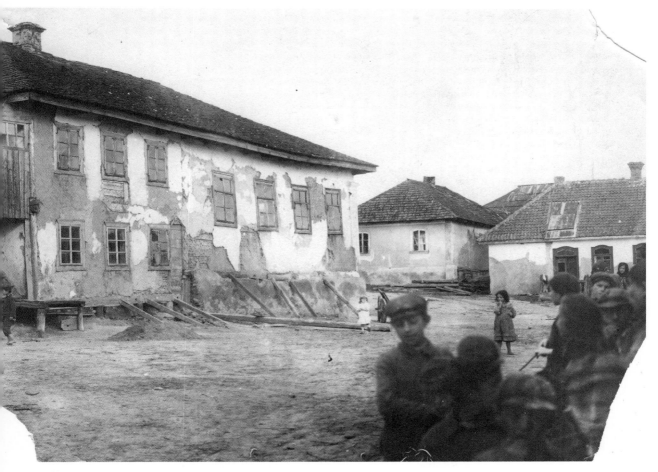

114. Town square
with synagogue on left,
Shepetovka.

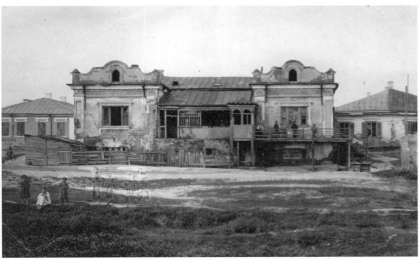

115. Yeshiva, Skvira.

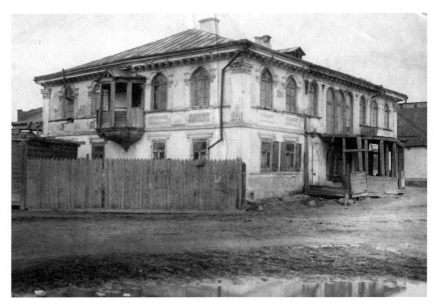

116. Rabbi's house, Korostyshev.

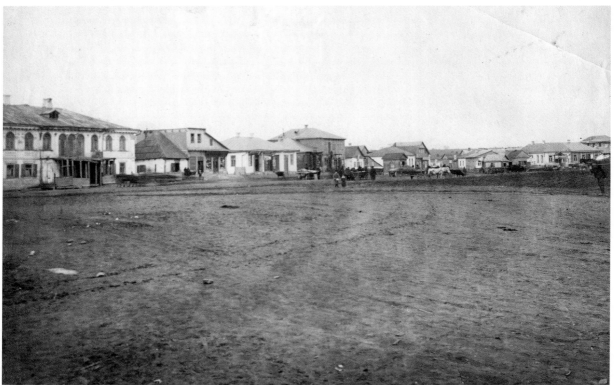

117. Marketplace with rabbi's
house (see image 116) on left.

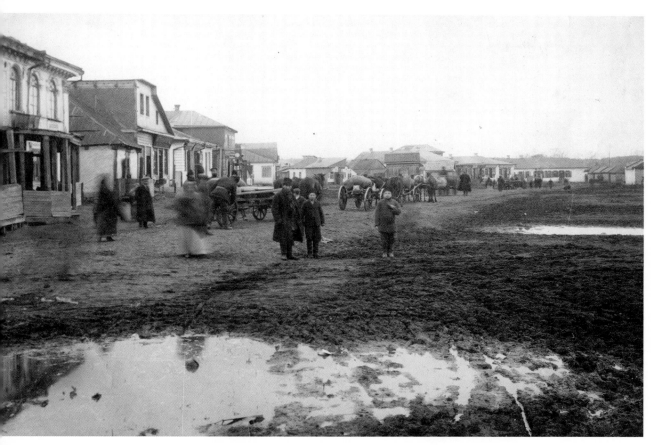

118. Marketplace with rabbi's house (see image 116) on left. On the back of the photograph, An-sky made note of the large puddle.

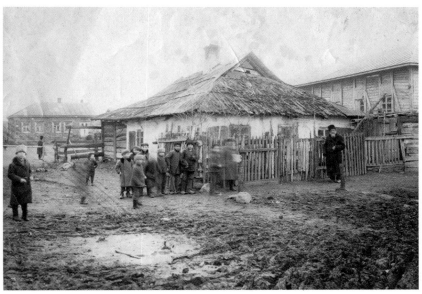

119. An old house.

120. Courtyard, Kozin.

121. *Kloyz*, Kozin.

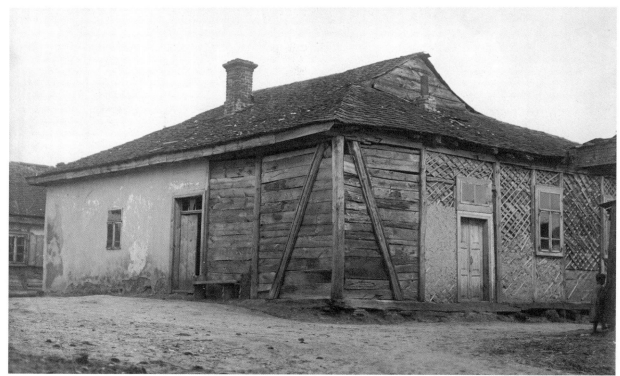

(opposite)
122. House, Kozin.
123. Houses, Kozin.

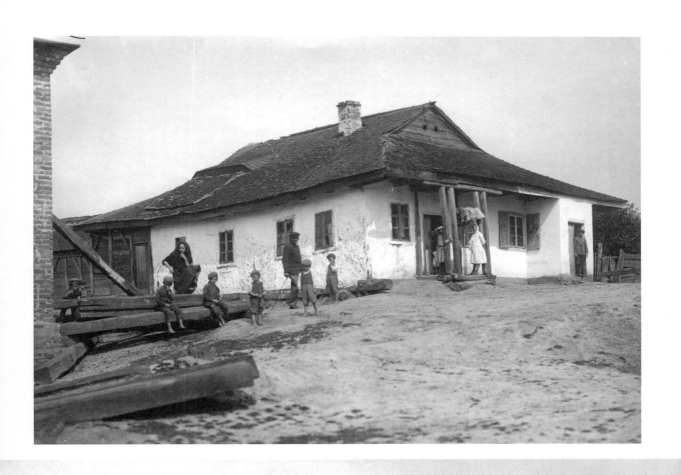

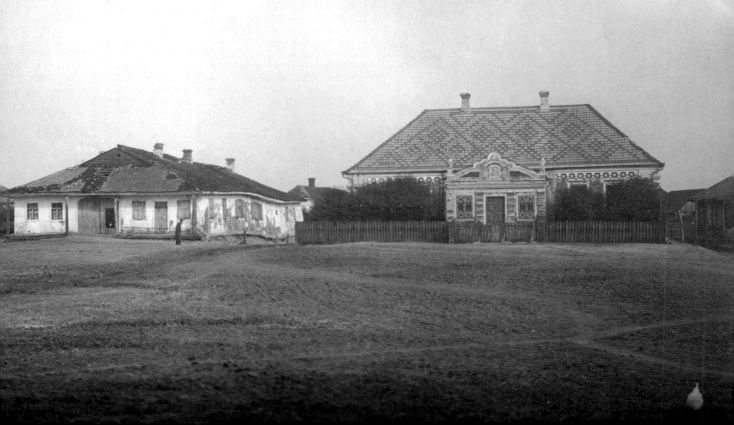

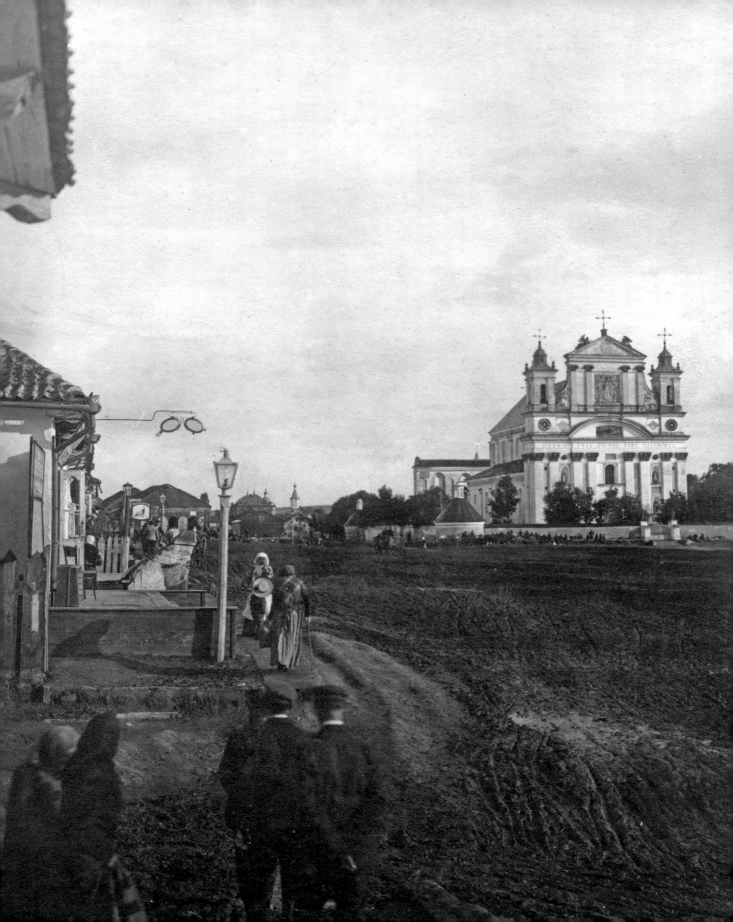

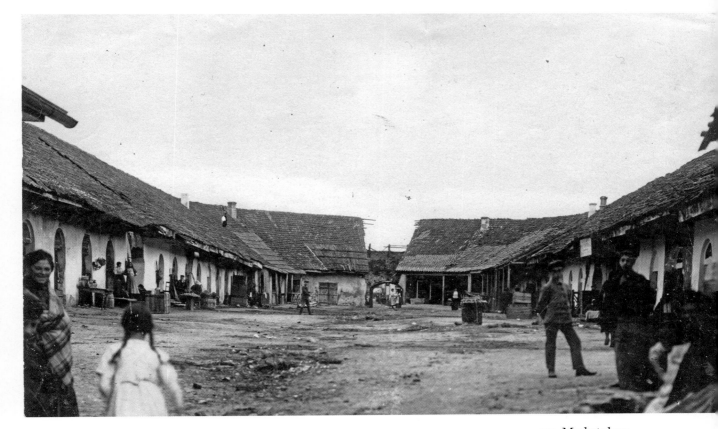

125. Marketplace.

(opposite)
124. The Polish cathedral seen
from town center, Olyka.

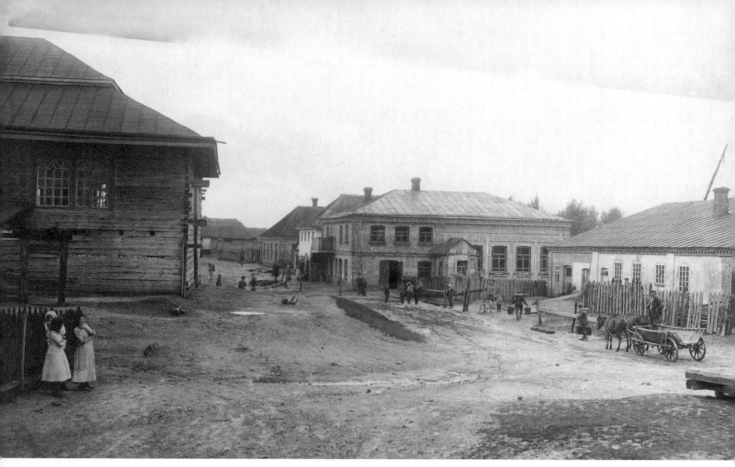

126. Town square with wooden synagogue on left and stone synagogue in background, Olyka.

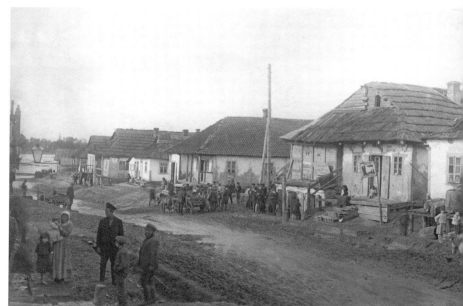

127. Street, Olyka.

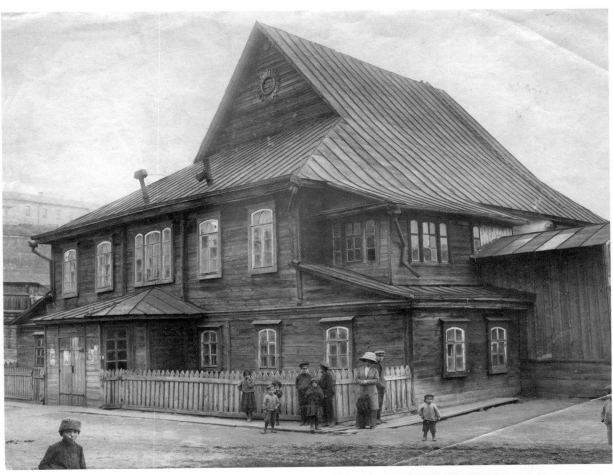

128. Synagogue, Mogilev-on-the-
Dnieper, Mogilev Province, 1913.

129. Interior with wall paintings
by Khaim Segal (1740).

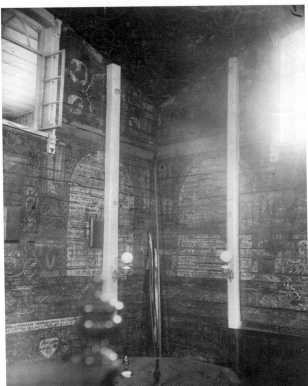

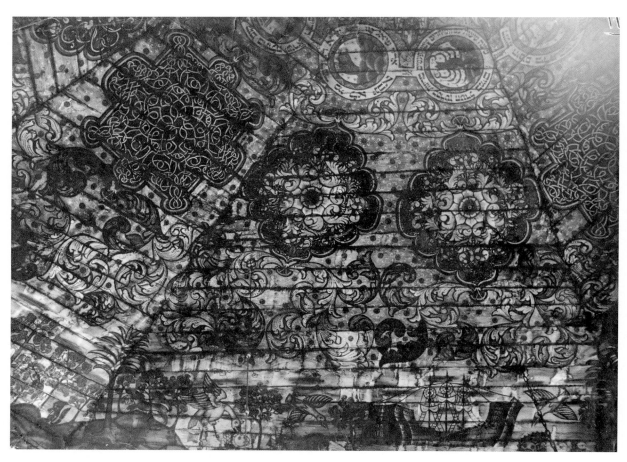

130. Southern section of
synagogue dome; wall paintings
by Khaim Segal (1740),
Mogilev-on-the-Dnieper, 1913.

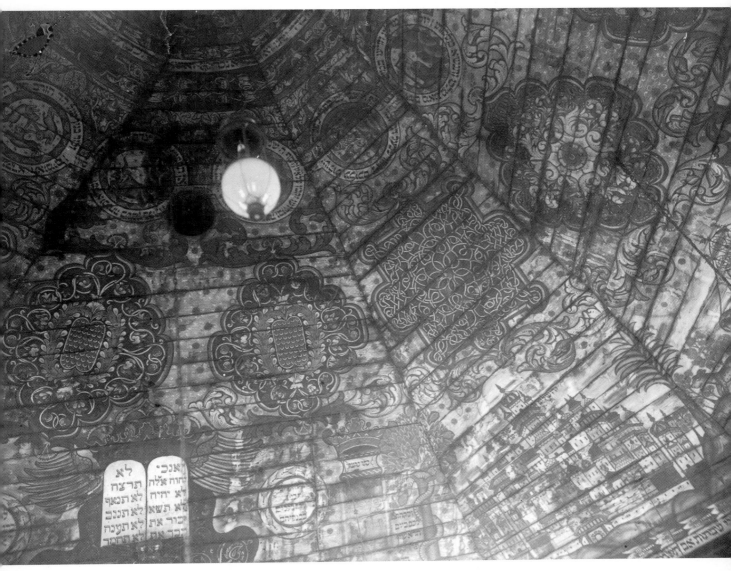

131. Eastern section of dome.

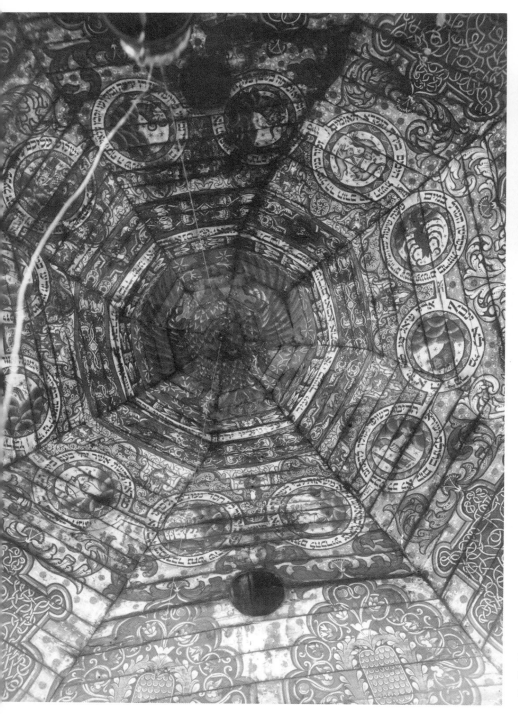

133. Leviathan, dome of
a wooden synagogue,
Chernoostrov.

132. Central section of synagogue
dome, Mogilev-on-the-Dnieper,
1913.

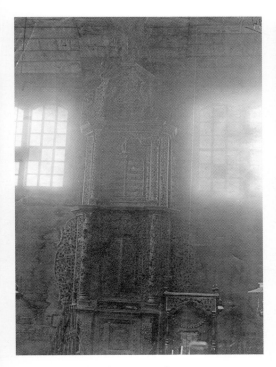

134. Torah ark, Ostropol.

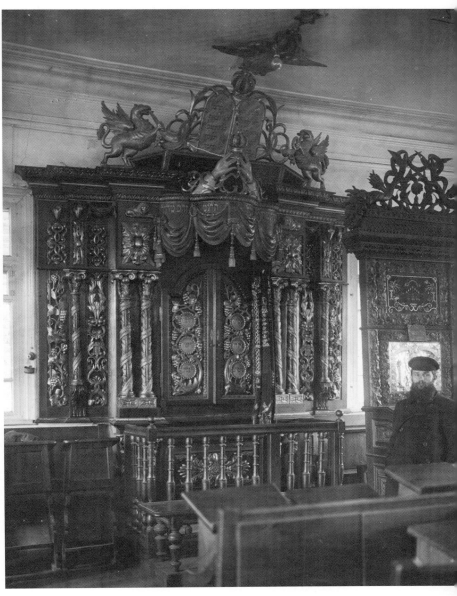

135. Torah ark from 1899.

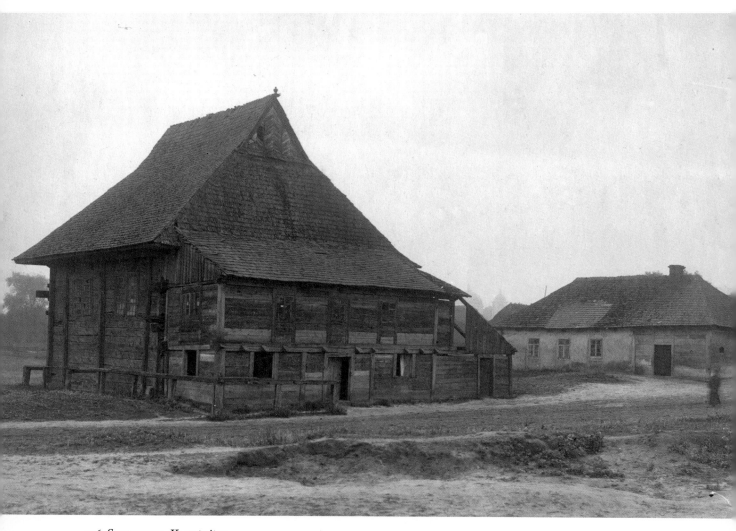

136. Synagogue, Korytnitsa.

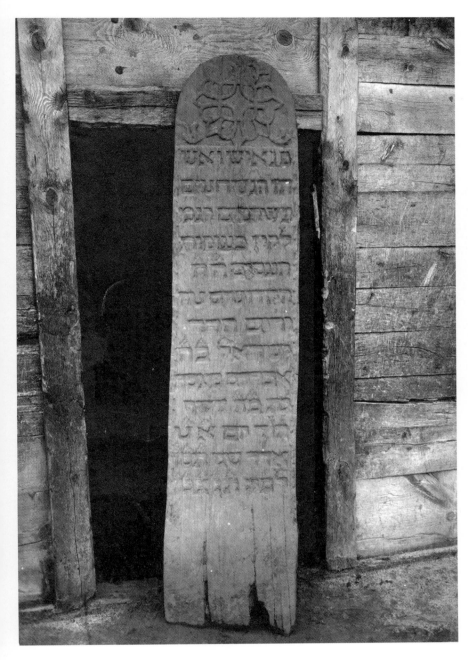

137. Tombstone, Korytnitsa.

The epitaph reads:
"Here lie a husband and wife who were robbed, burned, and beaten by heathens. The holy and pure R. Yisroel the son of R. Avraam and the daughter of R. Yosef, on the first day [Sunday], the 9th of Adar the second, [5]464 [1704]. May they be bound up in eternal life."

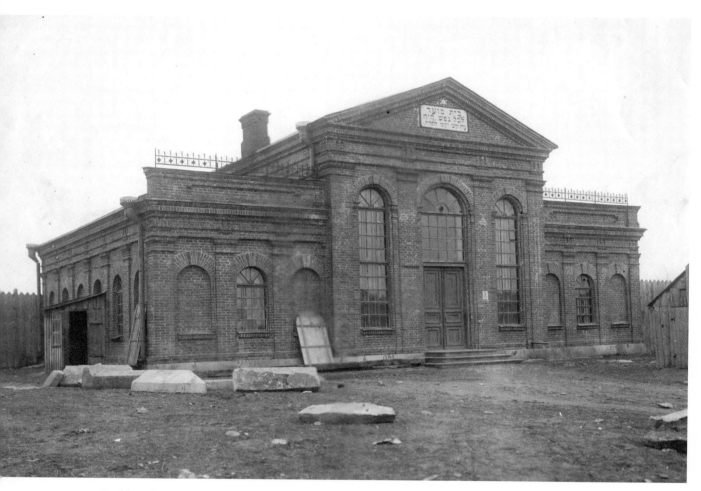

138. Building for ritual ablution
of the dead.

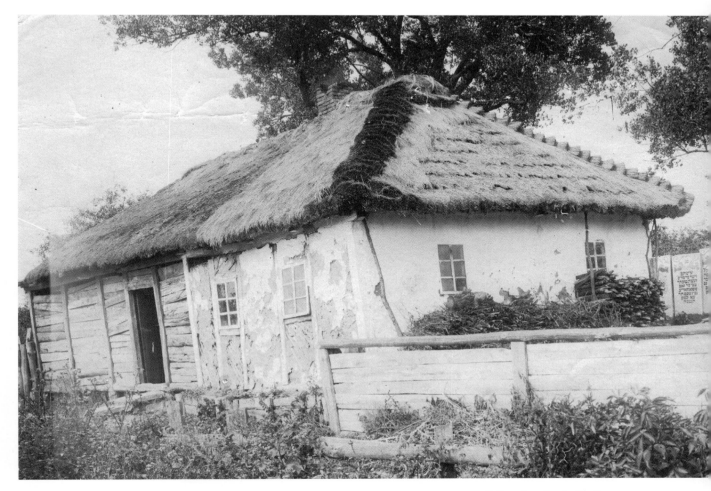

139. Building for ritual ablution
of the dead.

140. Tombstone, Radzvilov.

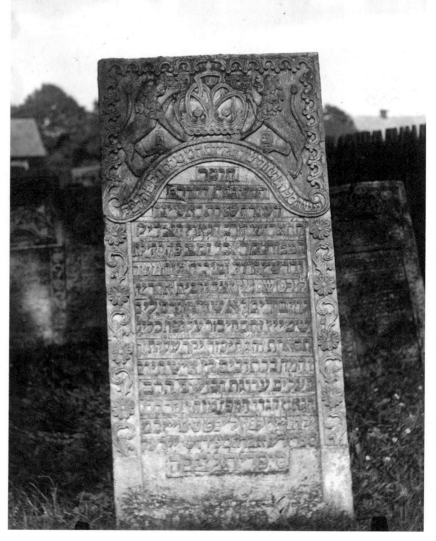

The epitaph reads: "With a bitter heart, here lies Moshe, a great ornament
of Israel, on the 5th day [Thursday] the 9th of Tevet, [5]585 [1825], he fell, the
crown and ornament of our head, the garland of garlands. A great preceptor,
rabbi, genius, righteous man, renowned, the head of the rabbinic court, and
the righteous teacher of our community, a great interpreter and commentator,
our teacher, R. Moshe Likhtenshtayn, may the memory of the righteous man
be blessed. . . . He was the son of the rabbi and genius, the great famed teacher
R. Efraim Yekutiel-Zalman Liktenshtayn, the author of the book *The Seeds
of Abraham*, a valuable commentary on Sifre. May his soul be bound up in
eternal life."

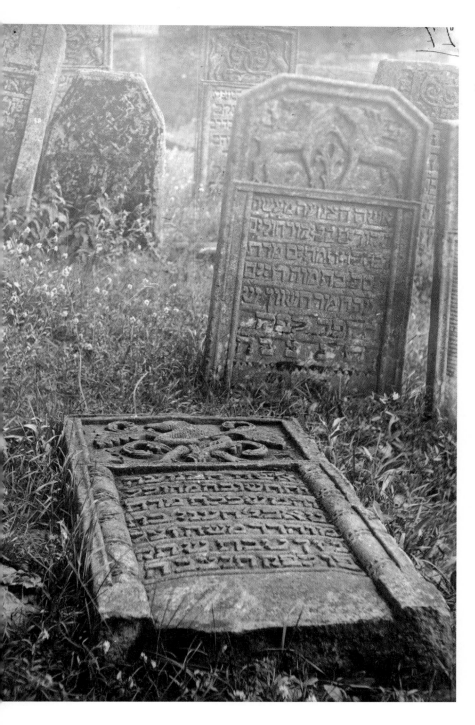

141. Tombstone, Radzvilov.

142. Tombstone from the destroyed Jewish cemetery, Kozin.

143. Old tombstone.

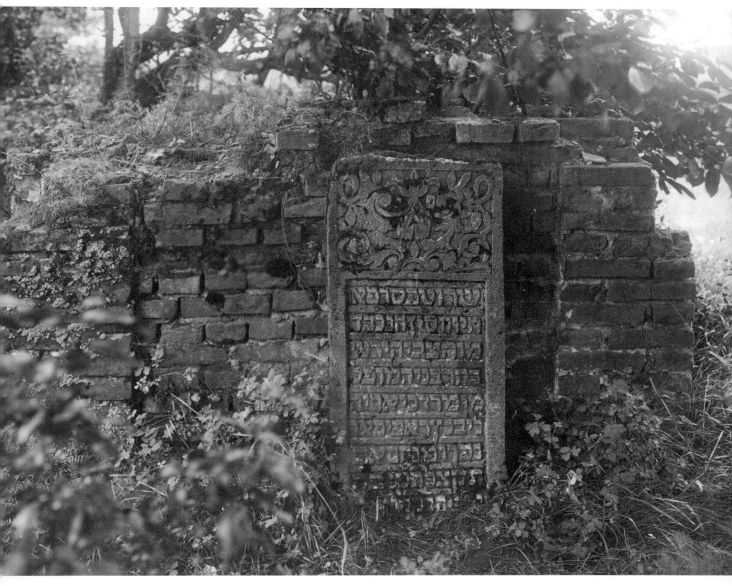

The epitaph reads: "Here lies a prince and founder of healing, of noble descent, our respected teacher R. Tsvi-Hirsh, son of the noted Torah scholar, our teacher Mordechai Arye-Leyb Kats Rapoport. He died 26 Menachem Av [5]590 [1830]. May his soul be bound up in eternal life."

144. Tombstone of a doctor, Korytnitsa.

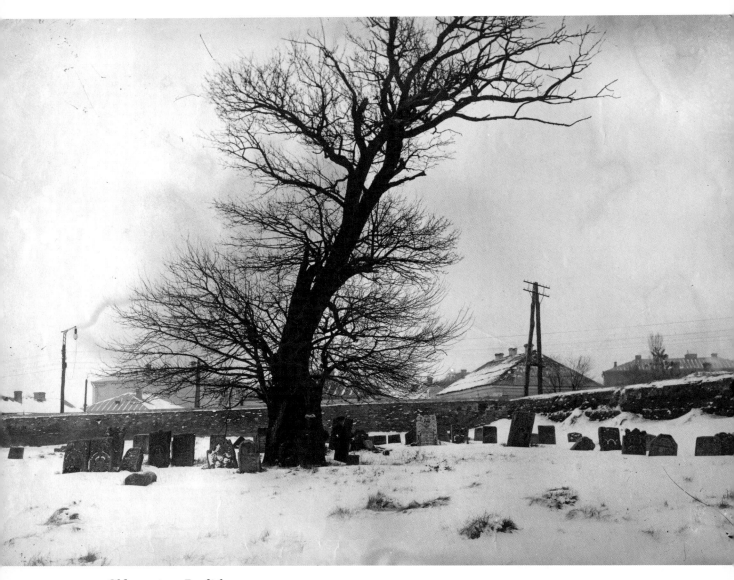

145. Old cemetery, Berdichev
(R. Liber's tombstone to right
of tree).

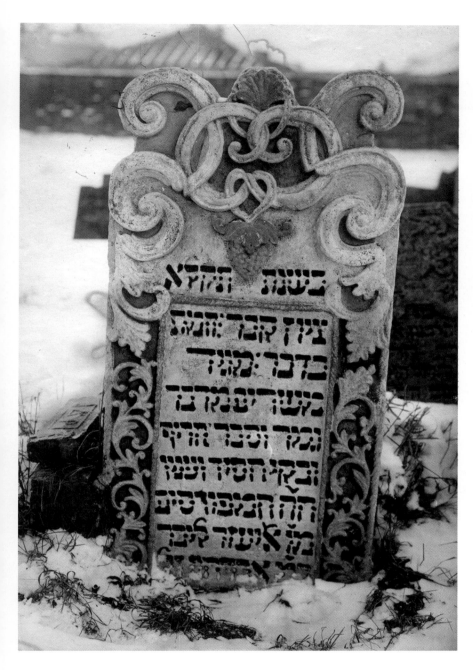

146. Tombstone of the great R. Liber.

The epitaph reads: "In the year [5]531 [1771], a memorial on the grave of the victim of the epidemic. A renowned preacher whose words were a blessing, and a profound interpreter, wise, a modest doer of good, a great leader, a famous teacher, our Eliezer-Liber, son of our teacher Avraam, of blessed memory."

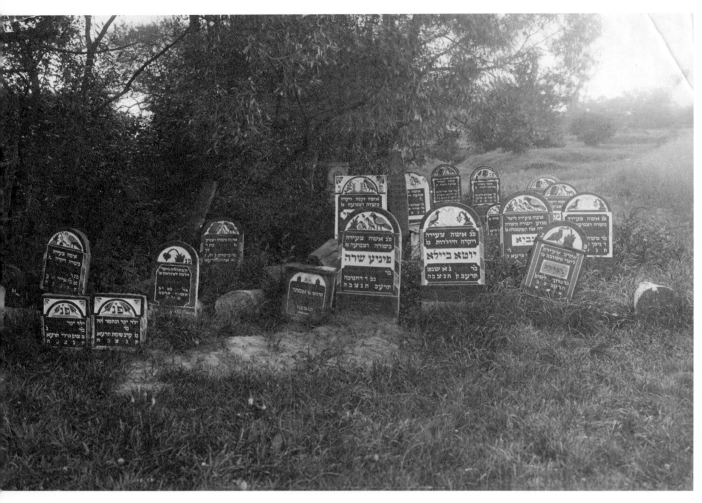

147. Tombstones from 1911
to 1913.

188

The First Jewish Museum

On April 19, 1914, on the premises of the Jewish Historical-Ethnographic Society (JHES), located in the building of the Jewish almshouse on the Fifth Line of Vasilevskii Island, an exhibit of the collection gathered during two field seasons (1912 and 1913) of the An-sky expeditions was shown for the first time.[1]

The creation of a museum was one of the programmatic purposes of the JHES from its inception. It was only due to the An-sky expeditions that this goal could be fully realized. The opening of the exhibit was timed to coincide with the session of the ethnographic section of the JHES during which An-sky read his report "The Findings of the Ethnographic Expedition in the Name of Baron H. O. Gintsburg," which had investigated more than sixty locations in Volynia and Podolia provinces.[2] An-sky's expedition officially bore the name of the financier and philanthropist Horace Gintsburg, whose son, Vladimir Gintsburg, contributed the basic means for its execution. The opening of the exhibit can be considered the beginning of the work of the Jewish Museum, although the collection acquired during the expeditions was not officially transferred to An-sky as the property of the JHES until the end of 1915.[3]

The exhibit displayed more than eight hundred objects and manuscripts. In addition to stands and glass cases with artifacts, the exhibit rooms also held a collection of communal record books (*pinkasim*) and sound recordings on phonographic cylinders.

An-sky was one of the pioneers in the use of sound recording in the collection of folklore. He was so taken with this technology that he had a phonograph placed in the vestibule of the museum, to be used as a guestbook, and on which he recorded the speeches of distinguished visitors, including public figures, artists, and writers. Sholem Aleichem recorded his entry on May 14. An-sky, Iudovin, and M. A. Ginsburg, the sponsor of the almshouse, had themselves photographed with the great author. Both the photograph

(which appears in the front matter of this volume) and the sound recording have been preserved.

An-sky's collection became the kernel of the museum's holdings. World War I (which began on August 1, 1914) interrupted the work of the expeditions at the peak of the third field season. The holdings of the museum continued to expand nonetheless, due to the efforts of the JHES staff, who carried on in spite of the war taking place in the western regions of the empire. The museum was the place where ritual objects from synagogues on the frontline could be preserved. Boris Rubshtein, a staff member, returned with objects from the northwestern region of the Pale, while An-sky himself evacuated materials from Volynia and Galicia.

Photographs of the exposition of 1914 and lists of the expedition materials that An-sky gave to the Russian Museum for temporary safekeeping give us some idea of the special features of the collection. It is clear that An-sky collected much more than the "obvious" museum-quality Judaica, including documents and ritual implements, primarily goldsmithery. Ethnographic materials — in the broadest sense of the word — interested him no less: native dress (and not only formal wear), objects for use in daily life, children's toys, and printed works. For example, in the collection of *mizrakhim* (plaques indicating the eastern wall of a synagogue or a private house), there are not only handmade objects, but also *lubki* (prints of folk woodcuts), and among the implements there are objects that have been adapted for ritual use, so-called "second-tier Judaica."

In acquiring objects for his collection, An-sky was guided not merely by the criterion of artistic or historical value. He was interested, above all, in the narratives in which these objects figured. In essence, An-sky was collecting relics of national memory rather than future museum exhibits. In fact, some of the items on the lists of expedition acquisitions — "crumbs of matzo from the caftan of the Kaidansk *tsadik*," a skull of a victim of the Khmelnitskii uprising, the amputated finger of a Jewish recruit who wanted to avoid army service — were relics in the literal sense. These strange things gave An-sky's collection something of the flavor of a *Kunstkammer* or "cabinet of curiosities."

An-sky was not the first collector of Judaica, but having become the first Jewish ethnographer, he was the first to compile a Jewish ethnographic collection. The abundance of valuable ethnographic objects distinguish An-sky's expedition collection from Jewish museums that hold primarily artistic works, most of which are objects used for ritual purposes. In contemporary Jewish museums, cult implements are better represented than

Jewish ethnographic materials. The twentieth century dealt mercilessly with the stuff of traditional Jewish daily life. It is impossible to fill this blank space in existing holdings. The ethnographic character of An-sky's collection makes it completely unique.

The 1914 exhibit was open only for a few months.[4] An-sky himself understood its temporary character and also understood that the collection's display demanded more serious exposition principles and a more complete museum facility. He attempted to transform his exhibit into a "real" museum. In 1916 An-sky wrote to Abram Rechtman, one of the expeditions' participants, who was then located in the United States: "I have been here in Petrograd for two weeks, I am working a lot. I've begun the reworking of the material, I am trying to set up the museum. A special case has been constructed that costs a thousand rubles."[5]

The new exposition was developed for a broad public viewing in the spring of 1917. In addition to An-sky himself, Isaac Lurie, the caretaker of the collection, and Solomon Iudovin participated in the exhibit's curation.[6] In September of the same year, the dangers of revolutionary upheaval forced An-sky to close the exhibit. In May 1918, he gave a part of the collection to the Ethnographic Section of the Russian Museum for safekeeping.[7] Only in 1923 did the newly constituted Jewish Museum begin to function on a long-term basis. The museum (together with the JHES) was closed in 1929. Its collection was dispersed to various museums and archives in Russia and Ukraine. At present a small portion of objects from An-sky's collection can be seen in the Russian Ethnographic Museum.

The 1914 exhibit became the point of departure for a series of Jewish museums and exhibits in the Soviet Union in the 1920s and 1930s. In addition to the museum of the JHES, these included the Mendele Moykher Sforim Museum in Odessa, the Museum of the Bukhara Jews in Samarkand, the Jewish Museum in Tbilisi, the exhibit "Jews in Tsarist Russia and the USSR," which ran from 1939 to 1941 in Leningrad's Museum of Ethnography of the Peoples of the USSR, and many Jewish exhibits in various local museums in Berdichev, Nikolaev, Vinnitsa, and other cities in the former Pale of Settlement. A Jewish Museum was created in Minsk, but it never opened. The Jewish Museum movement in the Soviet Union deserves further research.

Although subsequent museum initiatives in many ways surpassed An-sky's exhibit, his work remained a reference point for them. The curators of these later museum projects could have viewed themselves as continuing An-sky's work, or as criticizing it, but they could not have been indifferent to it. In fact, many of the figures who worked to create Jewish museums

in the Soviet Union were immediately connected to An-sky and had participated in the JHES. For example, the heads of the museums in Odessa and Samarkand, Boris Rubshtein and Isaac Lurie, were former colleagues of An-sky. Solomon Iudovin, the irreplaceable photographer of the An-sky expeditions, remained the main curator of the museum of the JHES until its closing. He participated as an artist in the exhibit "Jews in Tsarist Russia and in the USSR" at the Museum of the Ethnography of the Peoples of the USSR. I. M. Pul'ner, the exhibit's curator and head of the museum's Jewish section, also began his career in the JHES, at the end of the 1920s. In his article, "Questions of Museum Organization" he accused former Jewish expositions of preserving the "remnants" of the ideas of their founders, *narodniks* (Populists) who were "falsely idealizing minorities."[8] These ritual accusations apparently were aimed at An-sky. In the meantime, Pul'ner used the ethnographic questionnaire that An-sky had compiled in 1914, "The Jewish Ethnographic Program: The Person," for his own dissertation, "The Jewish Wedding Ritual."

In spite of the importance of the An-sky expeditions and the materials they collected, the history of the collections is rather sad. Over the course of three seasons (from 1912 to 1914), the members of the expedition — according to Rechtman's memoirs — "collected treasures of our past everywhere: they transcribed stories, legends, accounts of historical events, curses and incantations, stories of *dybbuks* and demons, songs, edifying tales, proverbs and sayings; recorded old melodies, prayers, and folk songs, photographed old synagogues, historical places, gravestones, prayer houses of *tsadikim*, ritual scenes; and collected and bought rare old things, documents, *pinkasim*, objects used in religious ritual, decorations, and clothes for the Jewish Museum."[9]

The sudden outbreak of war cut short all this activity. The materials were in a dangerous situation. Rechtman wrote: "At the end of 1914, in the heat of World War I, the artist Iudovin and I were arrested in Zhitomir on the charge of espionage. What led to this was that because of our work we would walk around with a camera and openly take pictures. We were both taken into custody and the police confiscated the materials we had with us, including the photographic plates. At that time An-sky was in Petrograd, and we informed him of our arrest by telegram. An-sky immediately got in touch with Lev Shternberg, a staff member of the Museum of Anthropology and Ethnography at the Academy of Sciences in the name of Peter the Great. With Shternberg's help, An-sky succeeded in getting a document that said we had been sent on the expedition by the Imperial Museum of

Anthropology and Ethnography. As soon as this document arrived at the Zhitomir police department, we were freed and the confiscated materials were returned to us. We packed everything up and sent it to Petrograd."[10]

Nonetheless, an essential portion of the expedition's materials was lost. Rechtman explains: "In 1915, when I left . . . for America, I could not bring along an enormous collection of ethnographic photographs (around fifteen hundred), or two hundred notebooks about the expeditions. All of this remained in my native city of Proskurov and was destroyed there during the Petliura pogroms."[11] We know now that the photo collection was preserved in part, but the archive of the expeditions was irrevocably lost.

In May 1918, worried about the fate of the collection — which the Commissariat on Jewish Affairs was trying to obtain — An-sky transferred more than four hundred items and documents to the Ethnographic section of the Russian Museum for safekeeping. [This became the Museum of the Ethnography of the Peoples of the USSR and is now the Russian Ethnographic Museum (REM)]. The transfer agreement included the provision that, if their owner (An-sky) did not claim the materials within a year, then they would become the museum's property. However, An-sky never arrived to sign it — either because he could not or did not want to — and the agreement was never formalized. In the fall of the same year, An-sky had to hurriedly and illegally quit the territory of Soviet Russia. He could not claim his rights to the collection during the stipulated year, because he did not return to Russia. He died in Warsaw in 1920.

The JHES resumed its work only with the beginning of the New Economic Policy, when it became possible once again for non-governmental organizations, including both political and economic entities, to use private donations. In 1922 the JHES used various arguments to claim their right to the collection that had been transferred to the Russian Museum. The Ethnographic Section, however, was in no hurry to part with An-sky's materials, claiming that they were necessary for the museum's own exhibits. The correspondence on this issue dragged on for several years, ending in May 1929 when the Russian Museum finally agreed to return a little less than half of the collection (one hundred ninety items), including, for the most part, objects used for religious ritual. Even this partial success, however, did not ensure the future of the Jewish Museum. It was soon closed and the collection dispersed.[12]

A part of the exhibit, primarily of an ethnographic character, again returned to the Ethnographic Section of the Russian Museum. These items, along with the ones that had not been returned in the first place, constituted

that museum's Jewish collection. After many years of neglect, the materials traveled around the world in triumph; at the present time, they are part of the permanent collection of the Russian Ethnographic Museum.

Another part of the collection was sent to Ukraine, where at that time a powerful center of Soviet Jewish scholarship and culture was formed. The collections of phonographic cylinders and *pinkasim* were placed in the Institute of Jewish Proletarian Culture of the Ukrainian Academy of Sciences. They fortunately survived World War II and the years of Stalinist repression and are presently housed in Ukraine's Vernadsky National Library.

A third portion of the materials, including primarily religious objects, went to the Mendele Moykher Sforim Museum in Odessa. Subsequently, some fine crafts work somehow made its way from Odessa to Kiev. Recently removed from storage, these objects are currently displayed in Kiev, at the Museum of Historical Treasures of Ukraine. A large part of what was transferred from Leningrad to Odessa was destroyed in the Romanian occupation of Odessa during World War II. The photo archive was also scattered. Separate fragments are located in various museums and archives in Russia, Israel, and the United States. Petersburg Judaica holds the most representative part of An-sky's photo archive.

Today there are many different types of Jewish museums, with new ones under construction. Given this state of affairs, it is all the more interesting for a contemporary viewer to consider the initial development of Jewish museums in Russia, and to acknowledge the symbolic meaning of the 1914 exhibit — an important landmark in the history of Jewish culture in Russia.

Notes

1. "Izvestiia EIEO," *Evreiskaia starina*, no. 7 (1914): 511.
2. The expeditions had also researched some points in Kiev Province.
3. V. M. Lukin, "Akademiia, gde budut izuchat' fol'klor," in *Evreiskii muzei*, ed. V. A. Dymshits and V. E. Kel'ner (St. Petersburg: Simpozium, 2004), 86.
4. Lukin, "Akademiia, gde budut izuchat' fol'klor," 86.
5. Abram Rechtman, *Yidishe etnografye un folklor: Zikhroynes vegn der etnografisher ekspeditsye ongefirt fun Sh. An-ski* (Buenos Aires: YIVO, 1958), 19.
6. Lurie went on to serve as the director of the Museum of the Bukhara Jews in Samarkand.
7. E. Pevzner, "The Story of One Collection," in *Pinkas: Annual of the Culture and History of East European Jewry* (2008), 120–71.
8. I. Pul'ner, "Voprosy organizatsii evreiskikh etnograficheskikh muzeev i evreiskikh

otdelov pri obshchikh etnograficheskikh muzeiakh," *Sovetskaia etnografiia*, no. 3/4 (1931): 156–63.

9. Rechtman, *Yidishe etnografye un folklor*, 24.

10. Ibid.

11. Ibid. Proskurov is present day Khmelnitskii (Ukraine).

12. For a detailed discussion, see Pevzner, "The Story of One Collection," 120–71.

illustrations

148. The M. A. Ginsburg Jewish almshouse (architect Ia. G. Gevirts),
which housed the Jewish Historical-Ethnographic Society and exhibited
the materials of S. An-sky's expeditions.

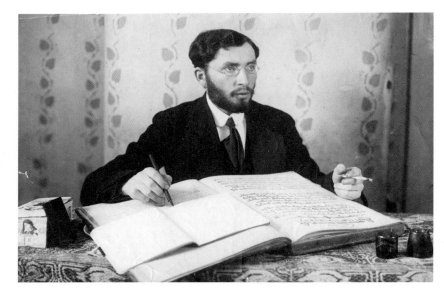

149. Abram Rechtman, participant in the 1913 and 1914 expeditions.

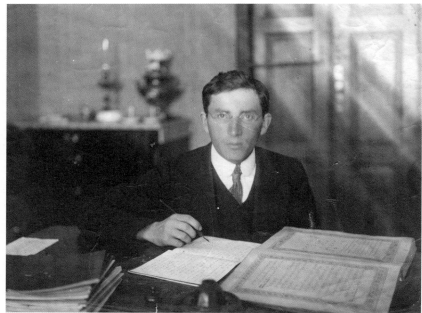

150. Isaac Fikangur, participant in the 1913 expedition.

(opposite)
151. Torah shields and crowns, Kremenets.

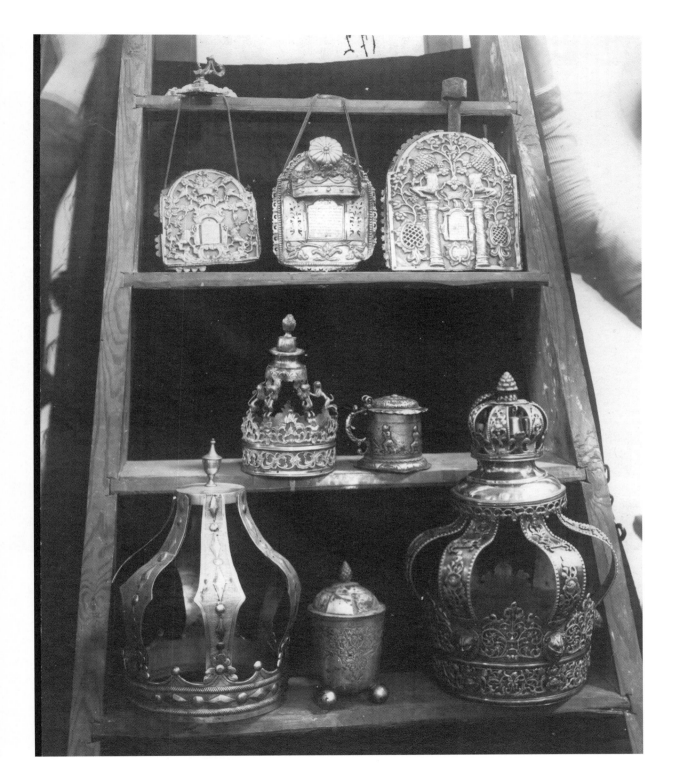

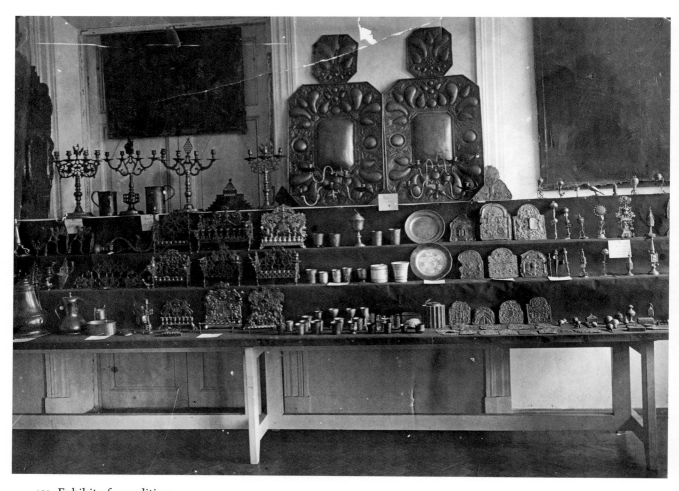

152. Exhibit of expedition
materials, including candlesticks,
menorahs, and kiddish cups, St.
Petersburg, 1914.

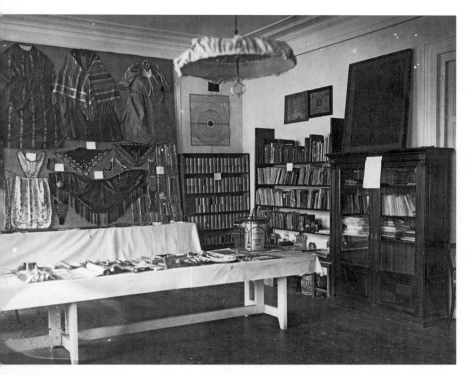

153. Museum exhibit, St. Petersburg, 1914. The left wall displays a collection of women's holiday dress, with a *brustikhel* (bodice piece) on the lower right. In the right corner of the room is a rack with wax cylinders and a phonograph. The table holds a Megilla of Esther and a noisemaker, both used during the celebration of Purim, and a calendar for the counting of the Omer (the forty-nine days from Passover to Shavuot).

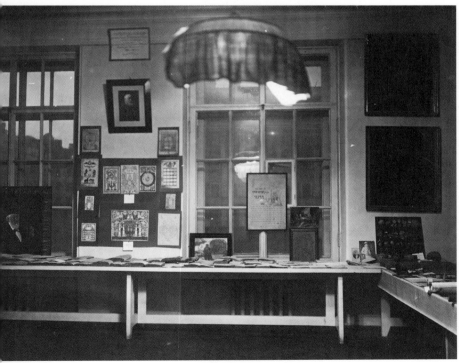

154. Museum exhibit, St. Petersburg, 1914. A *mizrakh* (indicating the eastern wall of the synagogue) is located in the center of the stand, together with copies made by Solomon Iudovin of the title pages of *pinkasim* (Jewish communal record books).

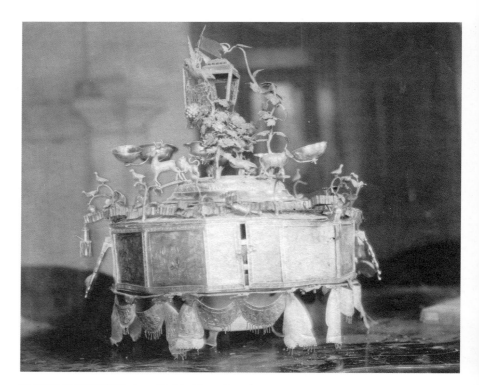

155. Three-tiered Passover seder plate.

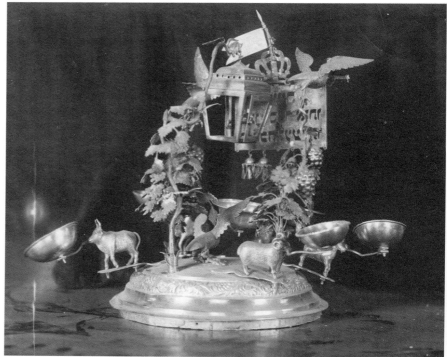

156. Passover seder plate.

157. Seder plate with inscription:
"As we had the merit to conduct
this seder, may we have the merit
to go forward henceforth."

158. Spicebox used for *Havdala.*

159. Torah shield.

160. Torah crown and two
Torah shields.

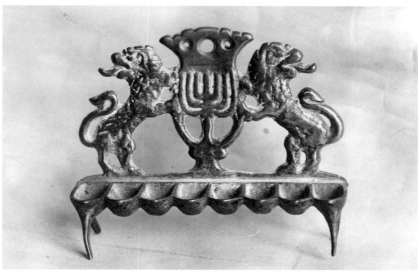

161. Hanukah menorah.

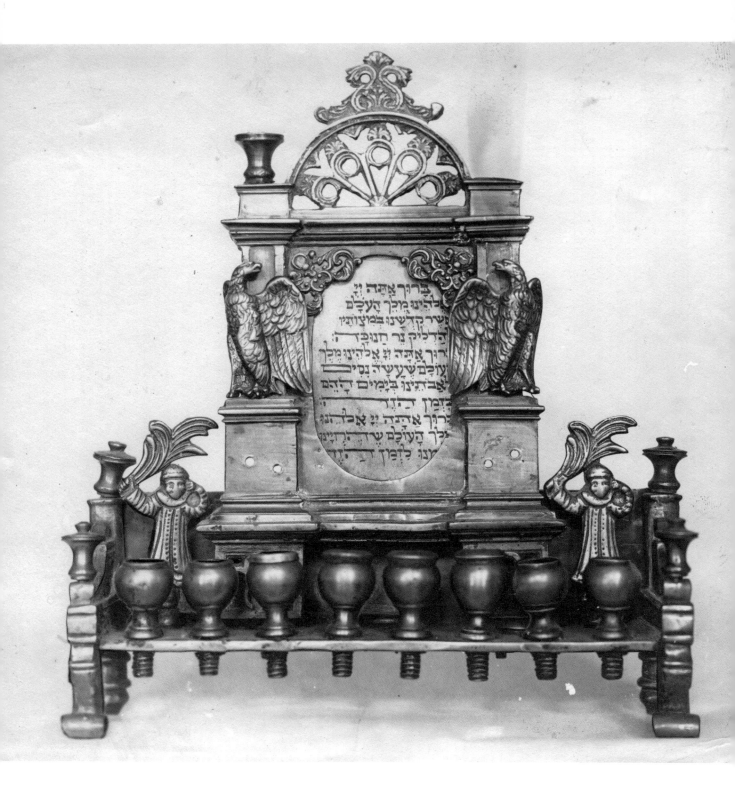

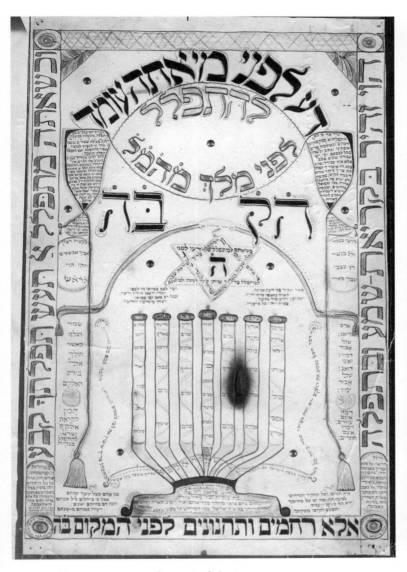

163. Decorative screen for cantor's lectern.

164. Decorative screen for cantor's lectern.

(opposite)
162. Hanukah menorah.

165. Decorative screen for cantor's lectern from 1887.

166. Title page from *pinkas* of the communal organization "Ner Tamid Hadasha" (New Eternal Light) from 1850, Starokonstantinov.

167. Page from *pinkas* of the communal organization "Ner Tamid Hadasha," Starokonstantinov.

167b. An-sky's note about the *pinkas* in Yiddish.

168. Letter from R. Nakhman of
Bratslav to his daughter.

169. Torah ark curtain from 1727, Dubno.